The Metropolitan Museum of Art Symposia

Early Netherlandish Painting
at the Crossroads

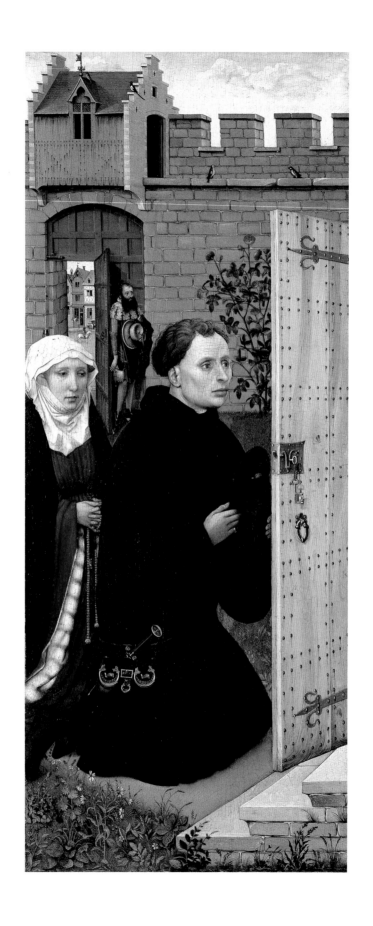

The Metropolitan Museum of Art Symposia

Early Netherlandish Painting at the Crossroads

A Critical Look at Current Methodologies

Edited by
Maryan W. Ainsworth

THE METROPOLITAN MUSEUM OF ART

YALE UNIVERSITY PRESS

This publication is made possible, in part, by the
Mary C. and James W. Fosburgh Publications Fund.

Published by The Metropolitan Museum of Art, New York
John P. O'Neill, Editor in Chief
Ellen Shultz, Editor
Elisa Frohlich, Production Manager
Minjee Cho, Electronic Publishing Assistant

Design implemented by Minjee Cho based on a format
established by Tsang Seymour Design Inc.

Cover and frontispiece: Robert Campin and Assistant.
The Annunciation Triptych (details of plate 1)

Library of Congress Cataloging-in-Publication Data

Metropolitan Museum of Art Symposia (3rd : 1998 : New
York, N.Y.)
 Early Netherlandish painting at the crossroads: a critical
look at current methodologies / edited by Maryan W.
Ainsworth.
 p. cm.
 Papers presented at the Symposium on Nov. 7, 1998, at
The Metropolitan Museum of Art, New York, N.Y.
 Includes bibliographical references.
 ISBN 1-58839-010-1 (pbk. : alk. paper)—ISBN 0-300-
09368-3 (Yale University Press)
 1. Painting, Dutch—Congresses. 2. Painting,
Renaissance—Netherlands—Congresses. 3. Painting,
Flemish—Congresses. 4. Painting, Renaissance—
Flanders—Congresses. 5. Painting—Research—
Methodology—Congresses. I. Ainsworth, Maryan Wynn.
II. Title.

 ND635.M48 1998
 759.9492'09'024—dc21 2001044651

Printed in Spain

Contents

Introduction

In the course of organizing the 1998-99 exhibition "From Van Eyck to Bruegel," drawn from four collections as diverse as those housed at The Metropolitan Museum of Art, I was struck by the vast range of artistic endeavor in this field. The Museum's holdings encompass the peaks and the valleys of individual achievement (and a good deal in between), the status quo as well as astonishing new inventions in representing traditional subject matter, and advances in the history of materials and painters' techniques. Giving primacy to the work of art allows it to present its own questions, which require an ever-widening approach to the uncovering of the circumstances underlying its creation and its meaning.

Taking into account the recent intellectual accomplishments in the field of Early Netherlandish painting, the problem then becomes not how to shed new light on the interpretation of a given work but how to limit the discussion to the pertinent issues alone, rather than indulging all of the various approaches that are currently in vogue. The growing interdisciplinary activity in this area has both enriched and confounded our endeavors to find answers to our inquiries.

We are having our comeuppance and recognizing that the deeper we delve into the matters at hand, the more there is to discover.

It is all too clear that the straitjacket approach of previous generations and the pat explanations that served for so long as the solutions to complex problems are no longer viable. I am, of course, overgeneralizing and oversimplifying here to make a point. In the past decade and at an ever-increasing pace, the field of Early Netherlandish painting has become the focus of burgeoning scholarship. Archives are still full of documents awaiting study and more accurate interpretations, which will give rise to new findings concerning the broader circumstances surrounding the creation of these works of art. Hand in hand with archival research is a renewed attention to socio-economic factors, particularly the impact of art markets in the late fifteenth and early sixteenth centuries on the production of paintings. There is, as well, a considerable amount of new material regarding the technical investigation of works of art—leading to the realization time and again that the meaning of the work is inextricably bound to its method of manufacture. Fresh interpretations are the result of a closer look at contemporary texts, together with an acknowledgment of the audience for which individual works were intended and the function such works served for that audience.

It is time, I believe, to take stock of how far we have progressed of late in what has

Early Netherlandish Painting at the Crossroads

become a field of interdisciplinary research. The essays that follow deal with those areas where there has been notable activity in recent years—that is, with inquiries into the relationship of text and image, archival work, economic/art market developments, and technical examinations. Every topic of inquiry is considered in two parts: The first summarizes the history of the approach thus far, along with proposed guidelines for current research; the respondent in each case then comments on the model presented, prompting us to consider new directions for subsequent investigations. Our aim is to generate discussion on our methodology as we begin to map out future explorations of Early Netherlandish painting.

I am most grateful to Philippe de Montebello, Director of The Metropolitan Museum of Art, who continues to support a forum for scholarly debate through the ongoing program of symposia at the Museum. These discussions enrich the understanding of our collections and enhance the ability of curators and scholars alike to present the most recent and informed views in our respective fields to the public audience. The contributors to this symposium are to be congratulated for their thought-provoking essays, which undoubtedly will spark further meaningful discourse.

This volume is the third in the series of Metropolitan Museum symposia inaugurated by John P. O'Neill, Editor in Chief. I am especially indebted to him and to his fine staff in the Editorial Department for this handsome book. Ellen Shultz, Editor, gave the texts her customary careful and discerning attention; Peter Antony, Chief Production Manager, oversaw the production of the book, the details of which were efficiently carried out through the efforts of Elisa Frohlich, Production Manager, and Minjee Cho, Desktop Publishing Assistant.

We depend on the generosity of donors to bring such endeavors to fruition, but these public-spirited individuals could not be enlisted without the help of the Museum's Development office. I sincerely thank Christine Scornavacca, Deputy Chief Development Officer for Government and Foundation Giving, for her tireless and enthusiastic pursuits in this regard.

We are likewise indebted to the Mary C. and James W. Fosburgh Publications Fund for making this publication possible.

Maryan W. Ainsworth

The Metropolitan Museum of Art Symposia

Early Netherlandish Painting
at the Crossroads

Reindert Falkenburg

The Household of the Soul: Conformity in the *Merode Triptych*[1]

In the last ten to fifteen years, it has become customary among historians of Early Netherlandish painting to decry a symbolistic interpretation that, in earlier decades, had earned Erwin Panofsky great fame. Based on an investigation of relevant iconographic, theological, and literary traditions, he had unveiled a world of "disguised symbolism" in apparently naturalistic, down-to-earth representations of Mary and Jesus and other holy figures in paintings by Robert Campin, Jan van Eyck, and their followers.[2] Whereas some authors before him had only commented in more general terms on the religiosity that seemed to be reflected in these paintings, Panofsky was the first to associate individual pictorial motifs with specific medieval theological concepts, such as Mary's virginity, her *humilitas,* and other Mysteries of Faith.[3] Thus, he alerted the modern viewer to a wealth of religious meaning that seemed to be "hidden" behind the apparent realism of the image.

At first, Panofsky's view won approval, however, due to the imitations of industrious but unimaginative epigones (and changes in methodological fashion, which I cannot explore here), his approach began to lose its attraction among modern interpreters. Some art historians pointed out that for fifteenth-century viewers certain pictorial motifs would have had specific symbolical connotations, such as the white lilies in Robert Campin's *Merode Triptych* (plates 1, 2), an allusion to Mary's chastity, or the Virgin's seated pose on the ground, a reference to her humility. Yet, there was nothing "disguised" or "hidden" about the symbolical nature of these motifs, and their meaning was altogether clear.[4] Others argued that there is no evidence that contemporary viewers associated these pictures with any theological thought or symbolism and that, for example, in Campin's *Virgin and Child* in London (fig. 1) the fire screen

Plate 1. Robert Campin and Assistant. *The Annunciation Triptych (Merode Triptych)*. The Metropolitan Museum of Art, New York, The Cloisters Collection, 1956 (56.70)

behind Mary's head is not a materialized halo, as Panofsky had suggested, but simply a useful and otherwise "meaningless" piece of furniture belonging to the earthly environment of the mother of Jesus.[5]

This is all well known, as are other forms of criticism that have been launched against the symbolistic reading of Panofsky and his followers. What deserves special attention here is the increasing skepticism regarding their reliance on textual sources as support for iconographic interpretations, and their supposition that a preconceived theological program determined the painter's choice of

motifs. Modern interpreters, conversely, often argue that "visual culture" and "textual culture" are distinct and different realms of human activity within society as a whole.[6] Paintings and texts, they say, each have their own semantics, syntax, and rhetoric. Therefore, an interpretation of a painting cannot be "authorized" by a textual source. They also maintain that the lay audiences of Jan van Eyck's and Robert Campin's paintings were unfamiliar with the type of scholarly theological writing used by Panofsky to support his argument.[7] Amid these reservations regarding religious texts and their usefulness

for our understanding of Early Netherlandish painting, I wish to call attention to a body of texts, written in the vernacular, that are unexplored in this context. These are devotional texts, designed to stimulate prayer and meditation, which were read by lay audiences and religious men and women alike. These writings underscore recent findings in the study of Late Medieval devotional culture in northern Europe that, in the realm of spiritual reading and private devotion, the distinctions between lay people and religious professionals were far less clear-cut than has been assumed.[8] Often, texts that originally may have been written for monastic circles were copied and adjusted to new audiences over the course of time, and became known to a lay public in some version.[9] The importance of these texts for our understanding of religious culture in the fifteenth century—including devotional imagery in paintings by Campin and van Eyck, among others—lies in their potential to teach us something about a widely shared "technology of inwardness." Images were integral parts of this culture, as much as texts were; each medium sustained and affected the other in its capacity to support prayer, meditation, and other devotional practices. I believe that by studying certain Late Medieval religious texts, we can better understand the peculiarities of the *visual* rhetoric of devotional images and the processes of "experiencing" and then communicating religious meaning in Early Netherlandish painting. Below, I will elaborate upon these connections, concentrating on what is perhaps the best-known devotional painting, Robert Campin's *Merode Triptych* at The Cloisters—which is key to discussions of religious meaning in Early Netherlandish art.

In most recent publications, interpreters of the *Merode Triptych* have focused mainly on identifying the patron and his wife on the left wing, using the coats of arms that decorate the stained-glass windows depicted in the central panel.[10] These identifications have helped us to reconstruct the rather complicated steps that led to the triptych's creation.

The catalogue to the 1998–99 exhibition "From Van Eyck to Bruegel" at The Metropolitan Museum of Art in New York gives a well-balanced summary of the process, taking into account important findings resulting from technical research. The triptych probably was produced in three phases, in the first of which the central panel may have been conceived as an autonomous painting, showing Mary seated in her chamber, or cubiculum, awaiting the Annunciation, reading the Holy Scriptures. In this phase, the windows in the back wall were painted gold, masking the interior from any contact—even eye contact—with, or from, the outside world; the left wing with the open door did not yet exist. This would have been in accordance with how vernacular devotional treatises like *TLeven Ons Heren Jhesu Cristi* (dating to about 1400) described the event,[11] emphasizing that

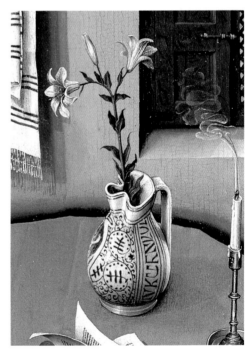

Plate 2. Lilies in a majolica pitcher (detail of plate 1)

Early Netherlandish Painting at the Crossroads

Mary's room remained sealed during the Annunciation and that the Angel Gabriel entered the room without opening or disturbing the door. Contemporary writers of devotional texts equated the enclosed architecture of Mary's cubiculum with the condition of her body, thus guaranteeing Mary's virginity at the moment of the Incarnation. In other words, by implication, the room in the center of the *Merode Triptych* originally was meant to echo the state of Mary herself—or, specifically, that of her womb—which remained undisturbed and pure even as she received the Christ Child, who penetrates the room through a window without breaking it, descending along seven rays of golden light from Heaven.[12] In the second phase of production, wings were added to the central panel. Initially, the left wing only showed the figure of the male donor, who kneels in a flowery garden enclosed by a high, crenellated wall. He has been identified as Peter Inghelbrechts (Engelbrechts), a merchant from Mechlin; a stained-glass window with his coat of arms—and a naturalistic sky—was painted over the gold ground below, in the central panel. According to one theory, the woman behind Inghelbrechts is Margarete Scrynmakers, whose portrait (and coat of arms?) was added slightly later.[13] Only then was a meaningful coherence among the three panels achieved, since "Inghelbrechts" and "Scrynmakers" are canting names in Dutch for the Annunciation ("Angel brings") and for Joseph, the Carpenter ("Cabinetmaker").

Recent studies of the triptych as a whole lead us to conclude that since it was composed in successive phases that were not preplanned, there was no preconceived iconographic program underlying the painting, as Panofsky suggested. This process of composing in stages appears to have resulted in iconographic anomalies that seem to deny that any serious intention existed on the part of the artist or his patron to furnish the image with a coherent symbolic content, be it hidden or open. The most striking of these anomalies are the coats of arms that were painted in

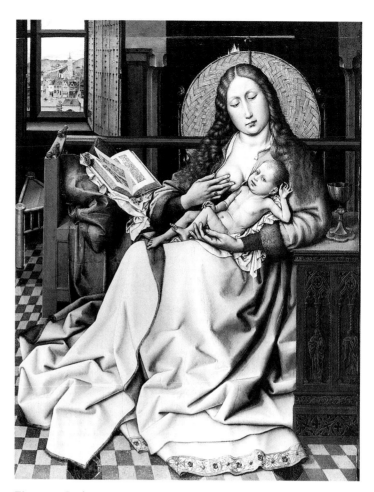

Figure 1. Robert Campin. *Virgin and Child before a Fire Screen*. National Gallery, London (NG 2609)

during the second phase of production. They proclaim, according to Late Medieval usage, that Inghelbrechts and his wife are the lawful owners of the house in which Mary is seated. This notion is rather at odds, to say the least, with the interpretation of the setting as Mary's house, or room—or even as the symbol of the Annunciate's body. Another example of this iconographic confusion is the open door through which Inghelbrechts and his wife witness the Annunciation; this detail fundamentally undermines the traditional convention

that the Annunciation took place in a closed room, therefore reflecting Mary's undisturbed virginity—a concept that contemporary religious texts clearly stress.

It is these devotional texts that, I suggest, reveal the degree of iconographic laxity that we really are dealing with. I will focus on a group of them that shows some remarkable thematic and structural correspondences with the *Merode Triptych*. Since the time of Saint Bernard of Clairvaux, the Annunciation frequently was regarded not only as the moment of the physical Incarnation of Christ but also as the spiritual marriage of Mary's soul with her Heavenly Bridegroom. This union was believed to exemplify the joyous spiritual bond with God open to every human being, given the proper preparation through prayer and meditation.[14] The steps leading to the consummation of a spiritual marriage with the Heavenly Bridegroom were described in various devotional texts, hymns, and prayers from the Late Middle Ages. The soul (anima) was believed to be the place where the inner self entered into the bridal union with the Beloved. Many texts, therefore, helped the devout to create an image of their soul that gave an imaginable shape or form to its location. Two of the most-often employed images of this inner place, or space, were the soul as a house or the soul as a garden. Both the house and the garden already occur in the Scriptures as metaphorical meeting places with the Divine—as, for example, in the Song of Songs. In monastic circles, they served later as tropes, or "blueprints," for meditation, during which they aided the devout in mentally erecting a garden or house of the soul.[15] Thus, such concepts became very popular in Late Medieval devotional "do-it-yourself" manuals, which instructed the reader in how to create a garden or house for his or her own soul as an appropriate place to meet the Heavenly Bridegroom. These manuals described and prescribed the layout and interior decoration of such a garden or house of the soul, equipped with a myriad of symbolic details—plants and furniture—that

referred to the history of Salvation, the Mysteries of Faith, episodes in the lives of Jesus and Mary (the Incarnation or the Passion), and the physical and mental qualities they displayed during these events (humility, compassion, perseverance in belief, love for mankind, and other virtues), which the reader could internalize (implant) in his or her own soul through a process of meditation.

One of these meditation manuals, a text written in the vernacular by Hendrik Mande in the fifteenth century for adherents of the *devotio moderna*, is entitled *Here Begins a Devout Book on the Preparation and Decoration of the Dwelling of Our Heart (Hier Beghint een Devoet Boecskijn van der Bereydinghe ende Vercieringhe onser Inwendiger Woeninghen).*[16] It takes the form of a tour through a house and an adjacent garden, which are described in great detail as examples for the reader to follow in constructing a similar dwelling in his or her own soul. The text, which mentions the same kind of household utensils and furnishings that are depicted in the bourgeois interior of the *Merode Triptych,* relates how the dwelling in our heart should be cleaned, prepared, furnished, and decorated, with the expectation that the Heavenly Bridegroom will inhabit this "bridal suite." Individual objects and pieces of furniture are explained as, or in relation to, desirable properties of the soul: These comprise a broom and a wastebasket, for cleansing the soul; a bundle of myrrh, to inspire meditation on the sufferings of Christ; and precious tapestries depicting scenes from the life of Christ. These scenes are called Christ's "coat of arms," which, as the text says, we desire to see in our inner dwelling as a sign that he is the Lord of this abode. We should decorate this house with sweet-smelling herbs and flowers and furnish it with a "bed of inner peace," its mattress symbolizing devout submission, and a pillow, devout hope; two clean white sheets connoting compassion and a white cloth, true belief; and, on top, a blanket, which "in its shape and form encompasses all other virtues," representing love. There should also be a table, set

Early Netherlandish Painting at the Crossroads

to serve a roast lamb of godly love, seasoned with the salt of spiritual modesty, and a lit candle burning with love and desire for Christ. In addition, an adjacent garden is evoked, containing fragrant herbs intended to satisfy his taste. Thus ends this text, leaving the description of the actual union of the soul and Bridegroom to the imagination of the reader.

I have summarized this passage at some length because it involves a kind of inner perception that parallels the reading and viewing of devotional paintings such as the *Merode Triptych*. The imagery in this meditation text is rich in detail and content, paradoxically employing rather banal and trivial everyday objects as the focal points for rather lofty concepts, such as the Mystery of Salvation and the Cardinal Virtues of Faith, Hope, and Love. Its language is derived from descriptions of the *unio mystica* by such nuns and Beguines as Hadewych, Mechtild of Magdeburg, and other visionary authors. It is adapted, however, to the daily experiences of ordinary men and women; instead of involving its readers in the esoteric pleasures of mystical rapture, this *devotio moderna* text remains down to earth in an effort to elevate the minds of those believers who were mystically less gifted through such humble processes of "spiritual housekeeping" as meditation. The spatially, physically, and functionally related objects that constitute the furnishings of the "house of the soul" comprise a series of interconnected elements upon which to meditate—not unlike the ancient rhetorical exercise of retrieving mnemonic items stored in a "memory palace."[17] Thus, the text inspires the reader to ponder the meaning of a burning candle on a table—as noted above, a reference to the burning desire for Christ that is "supported" by penance—or of a blanket of true love that "covers" the bed of virtuousness. The formal layout of this spiritual household is intended to model the inner self of the reader by "furnishing" it with Christian virtues, bits of theological wisdom, and a sense of interconnectedness with the Heavenly Bridegroom. As the reader reflects on the

formal arrangements of this symbolic environment, his soul will take shape accordingly.

Returning to the *Merode Triptych*, we see that the relationship between this image and Mande's text is not one of "source"—nor of coincidental similarity of otherwise divergent expressions of visual and textual culture. It is one of a commonly shared culture of devotion in which both text and image serve as instruments of spiritual self constitution through meditation and inner visualization. Several authors have suggested that devotional paintings in the fifteenth century functioned as "Rezeptionsvorgaben," by inviting the viewer to meditate on the pictorial image, following the example of the donor, or patron, depicted in the work.[18] If we interpret the central panel as it initially was conceived, as a self-contained image, it is Mary who, here, is the exemplar of meditation. She is absorbed in reading, meditating on the words of the angel, while she receives Christ in her womb and the "house" of her soul. When we view the central panel, we look right into her heart, so to speak, which is furnished with the symbols of her virtuousness. These symbols are not (disguised) abstract notions, but the "embodiments" of the properties of Mary's soul that—similar to the effect of Mande's text—serve as prototypes for the viewer to shape his inner self while meditating on the image.[19] If the spectator scrutinizes the interior of the house of Mary's soul, halting at each object and article of furniture—the candle, the flowers, the pitcher and towel, and the bench against which Mary reclines[20]—and ponders their symbolic meanings (for example, Mary's purity and humility, or the references to redemption), he appropriates these connotations and decorates the house of his own soul with the same virtues that adorn Mary's.

The relevance of contemporary texts to our understanding of the devotional image as a visual template for the viewer's spiritual self constitution can be further clarified if we examine another trope for meditation in the *Merode Triptych*—the "garden of the soul." The roots of this image go back to the sensuous

metaphorical description in the Song of Songs of the union of a bride and groom in a garden, or orchard.[21] This biblical love poem was interpreted in the Middle Ages as a prefiguration of the Incarnation—the marital union of God (Christ) and mankind in Mary, but also their spiritual union, and, by extension, that of every human soul with the Heavenly Bridegroom. In Late Medieval devotional texts, the themes of spiritual motherhood and of the marital relationship of the soul with Christ fused with the imagery of the *hortus conclusus*, or enclosed garden, of the soul. Many texts were devoted to explaining to readers how they should create a garden in their own souls by planting and cultivating a variety of flowers, fruits, herbs, and trees. These plants were not to represent abstract symbolic notions but the spiritual flourishing of the reader's soul, which should be cultivated by meditating on the Mysteries of Salvation, the life of Jesus and his suffering, and Mary's compassion, as well as on other physical and spiritual virtues of Christ and of his mother. Often, this imagery culminated in an evocative and sensuous description of the bond of love between the bride and her Heavenly Bridegroom, presented in terms of the soul of the devout spiritually tasting the fruit and picking and smelling the flowers in the presence of Christ, who—these texts assured the faithful—would enter the garden of his earthly bride attracted by the "sweet scent" of her meditations.

The red rose, rosebush, and rose garden numbered among the most commonly used images in these "garden" texts. Sometimes entire booklets were devoted to this flower, as, for example, *The Rose of Our Lord* (*Die rose onse here*), which dates to the first quarter of the fifteenth century.[22] Here, the rose is compared to Christ, who sprouted from a rose (Mary) and who shed his blood on the cross and went on to draw the faithful to him through his noble scent. His wounds are roses that attract the devout, who, like bees, should "suck honey from these blooming roses" during meditation. In *This is a pleasant and sensual arbor of sweet-smelling flowers where the unique soul loves to walk with her Beloved and pluck the delightful flowers in the spiritual orchard* (*Hier begint een genuechlijc ende een wellustelijc prieel van welrukende bloemen daer die eenighe siel in mach gaan spacieren met haer geminde ende plucken die ghenuechlike bloemkens des gheestelicken boomgaert*),[23] Christ enters the garden of the soul, to whom he gives a red rose with the admonition, "And this you shall pluck if you love me as I have loved," adding, "Always bear in your heart the odor of the red rose for my sake as I have suffered for you." These texts contain a characteristic that is relevant to our understanding of contemporary visual imagery as well. This is the repeated use of the same metaphor for different holy persons—Jesus and Mary—which is then applied or transferred to the spiritual realm of the believer. The result is not a loose layering or scattering of meanings but, rather, a rhetorical strategy aimed at evoking a conjunction, or "consubstantiality,"[24] of these different persons and their respective spiritual qualities—all of whom carry in their hearts the same "name" ("rose")—the effect being that these persons and qualities seem mysteriously interconnected by a centripetal force. These shifts—sometimes in one sentence—from Christ (or Mary) to the soul, and then back again, emphasize the reciprocal nature of the relationship between the believer and Christ, between Mary and her son, between the soul and Bridegroom, and, finally, among them all. As is clear from the passage in which Christ gives the soul a red rose with the encouragement to "bear in [your] heart [during meditation] the odor of the red rose for my sake as I have suffered for you," it is always the soul that is in the passive role of receiver and imitator. Whatever gift the soul may offer to the heavenly lover is, in fact, merely a return of the gift received from him. He is the alpha and omega, the beginning and the end, and, therefore, the impetus behind the aspiration of the soul to consubstantiality, or *conformitas*, with Christ.

Although there is not space here to expound in any detail on the fundamental importance of the concept that "only like could know like," as Steven Ozment has

Plate 3. Rosebush against the wall and rosebud on the hat of the donor on the left wing of the *Merode Triptych* (detail of plate 1)

described the conformity between God and the human soul underlying the devotional equation "a rose is a rose" (the soul is "like" Christ),[25] this idea permeates many Late Medieval devotional texts as well as paintings, including the *Merode Triptych*.[26] I will not comment on individual motifs in the painting but, rather, on the structural relationships that relate to this concept of conformity and on those elements in the triptych that represent the visual expression of—and invite the beholder to join—a consubstantiality of souls.

I will elucidate this idea by focusing on the visual network of roses, which resembles the interconnected patterns of rose metaphors in contemporary devotional "garden" treatises. On the left panel of Campin's painting are three different rose motifs: a rosebush (one of the most frequently mentioned and depicted Marian plants in the iconography of the *hortus conclusus*) in the background against the wall (plate 3), a red rosebud on the hat of Peter Inghelbrechts, and a rosary held by Margarete Scrynmakers (plate 4). The garden setting as a whole, with the crenellated wall, rosebush, and flowery meadow as its main components, strongly resembles the type of courtly *hortus conclusus* seen in many devotional paintings with the Virgin and Child, of a slightly later date (fig. 2). The painting suggests that here, too, this courtly (or, rather, fifteenth-century urban version of courtly) *hortus* has connotations of a garden of love.[27] This suggestion is not only implicit in the iconography of the *hortus conclusus* as such but is made explicit as well by the motif of the rosebud on Peter Inghelbrechts's hat. In circles where the art of courtly love was practiced during the Late Middle Ages, it was the custom to sport a lover's insignia, including flowers, on hats and other garments; contemporary images of religiously inspired love also bear witness to this practice.[28] The composition on the left wing of the *Merode Triptych* suggests that the rosebud on Inghelbrechts's hat came from the rosebush at the back of the garden. After entering the garden through the gate and leaving behind his servant (who, as he is clothed like a messenger,

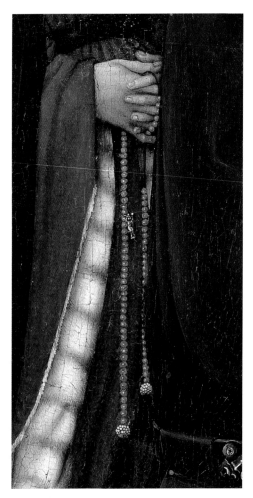

Plate 4. Rosary, held by the female donor, on the left wing of the *Merode Triptych* (detail of plate 1)

or herald, seems to call attention to the nature of his master's visit:[29] an audience with the Beloved), Inghelbrechts kneels before Mary's cubiculum, her insignia on his hat, while his wife carries her own insignia in her hand. That the rosebud is, indeed, to be understood as an emblem of love, originating from the rosebush of the Beloved, is underscored by a formal device that Campin employed in other paintings as well. The proximity of the rosebush to Inghelbrechts's head supports this association; although, in actuality, several yards

away, the rosebush frames his face just as the fire screen in Campin's *Virgin and Child* in London encircles the head of Mary, forming a kind of halo (see fig. 1). In both cases we are not dealing with disguised symbols—nor, as has been said of the *Merode* picture, with an "oversized" rosebush and a compositional solution "unworthy of Robert Campin"—but with a careful formal arrangement of different motifs in a pattern of conformity that suggests identification and interconnectedness. This visual strategy of implying a metaphysically and spiritually charged "conformity" through formal and compositional means seems to have been employed not only by Campin but also by other contemporary painters: Jan van Eyck's *Virgin in the Church* in Berlin (fig. 3), in which a monumental Mary is shown in—and as— the Church, is a well-known example.[30] Still closer to Campin's painting is Rogier van der Weyden's *Descent from the Cross* (fig. 4) in Madrid. (Rogier, it is now said, possibly was responsible for parts of the left wing of the *Merode Triptych*.) Here, the parallelism between the dead Christ and the swooning Virgin is a direct visualization of what fifteenth-century devotional texts called the "mede-vormigheit" (*conformitas*) of Christ and Mary in their Passion and compassion; this conformity represents a consubstantiality of souls, expressed in the configuration of their bodies.[31]

Similarly, the rose motifs in the *Merode Triptych* are arranged in a carefully constructed pattern of conformity denoting the love and *Seelenverwandtschaft* (congeniality) of the patrons and the Virgin. Given the central importance of the rose as the Marian flower *par excellence* in contemporary devotional images and texts, I am inclined to extend this visual pattern of conformity to the figure of Christ's first bride, in the central panel. The drapery of Mary's red robe, as it folds around her left knee, resembles a large rose that qualifies her as the "Mystical Rose," from whose womb, according to contemporary devotional literature, Christ sprouted ("budded"). This conformity and interconnectedness are expressed visually, evoking the joint love for

Early Netherlandish Painting at the Crossroads

the Heavenly Bridegroom of the Virgin
Mary, the Mystical Rose, the rosebush, the
hortus conclusus, and the Inghelbrechts couple,
with their love insignia of rosebud and rosary
(*rosarium*).[32] The viewer is implicated, as well,
in this pattern of conformity, not only
through his identification with the donors
(who, presumably, were the first intended
beholders of the triptych) but also through
the acts of interpretation and meditation—in
weaving the rose motifs into a meaningful
pattern of shared congeniality.

Other motifs contribute to this evoca-
tion of conformity, too. One example is the
Inghelbrechts coat of arms painted over
the original gold ground of the window.
As the devotional manual cited above states,
it is the coat of arms that identifies the mas-
ter of the house. This would seem to indicate
that it is the Inghelbrechtses' house that Mary
inhabits, yet, at the same time, they appear
to be visitors to the Virgin's chamber. This
anomaly can be explained if we interpret the
Inghelbrechtses' supposed ownership of the
house as an aspired state of their souls that
has yet to be realized. The most conspicuous
sign that the identification of their house with
that of Mary refers to a future state of bliss
is the stairs that lead from the garden to the
house, in front of which the Inghelbrechts
couple kneels. We can assess the meaning of
this configuration by comparing it to a con-
temporary drawing of the "Heart as a
House," made for a female monastic audience
at the Abbey of Saint Walburg, in Eichstätt,
Germany.[33] In this image, the soul joins
Christ (as part of the Trinity) in a love union
in the "House of the Heart," which is situated
in a garden. Also included is a staircase with
four steps leading to a closed door—a motif
that represents the ascent to virtuousness that
the nuns had to practice as part of the inner
preparation of the "House of the Heart" (the
cleansing of vices and the cultivation of virtu-
ous thoughts), so that the soul could unite
with the Heavenly Bridegroom. This combi-
nation of a house and a garden of the soul
and a "path and stairs of meditation" that the

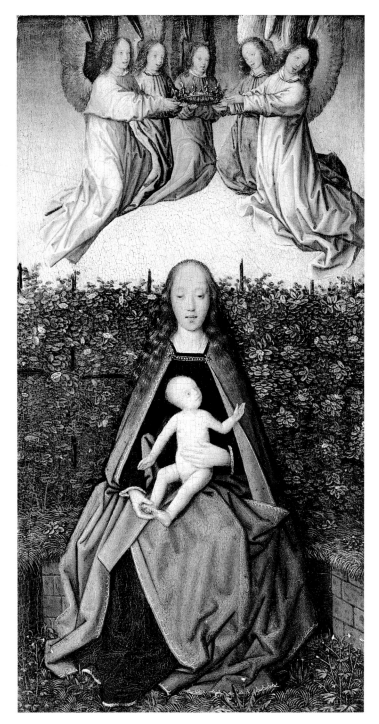

Figure 2. Jan Provost. *Virgin and Child*. The Metropolitan
Museum of Art, New York, Bequest of Joan Whitney
Payson, 1975 (1976.201.17)

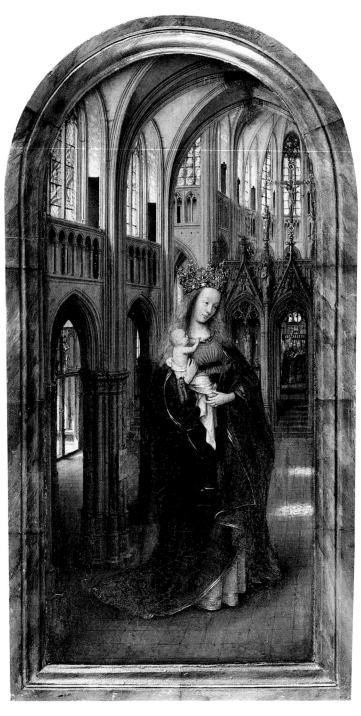

Figure 3. Jan van Eyck. *Virgin in the Church.*
Gemäldegalerie, Staatliche Museen
Preussischer Kulturbesitz, Berlin (no. 525C)

believer must ascend in order to achieve virtuousness occurs also in contemporary meditation manuals that deal with the garden of the soul.[34] Similarly, the donors of the *Merode Triptych* make clear that they expect prayer and meditation to be the "path and stairs of virtuous ascent" that will bring them to the Annunciate's cubiculum and open its door to their inner eye, so that they may spiritually enter this house and call it their own.

Another aspect of the interconnectedness of the Inghelbrechts couple and the Holy Family involves the coat of arms, which may be seen as an insignia of their kinship of souls. It is in this context that the figure of Saint Joseph on the right wing comes into play, shifting the balance from Mary's house to that of the Holy Family. According to Late Medieval belief, through his role as the foster father of Jesus and the protector of the Holy Family, Joseph came to be known as the patron saint of family life in general.[35] In the triptych, he occupies a room separate (of course) from Mary's, yet he serves the Holy Family by performing his humble work as a cabinetmaker. The objects that he is fabricating in his workshop—mousetraps and what appears to be a stove[36]—carry associations of humbleness, warmth, and protection, and underscore his function as the caretaker of this household. As Meyer Schapiro noted,[37] the mousetraps may recall Saint Augustine's metaphor of the cross as the devil's mousetrap (as well as the Passion that awaits the Christ Child), but as apotropaic symbols they more directly reinforce the identity of their maker as the protector of the Holy Family. The stove (if, indeed, it is one)[38]—an object usually associated with women—refers to Joseph's role as the provider of warmth and loving care to the Virgin, again stressing how, humbly, he serves the Holy Family.[39] The qualities that exemplify Joseph's role as "a family man"—humility, caring, and protectiveness—are homely and introversive in nature, and, in conjunction with the images on the other panels, may be interpreted in a spiritual sense as reflecting the virtuousness

Early Netherlandish Painting at the Crossroads

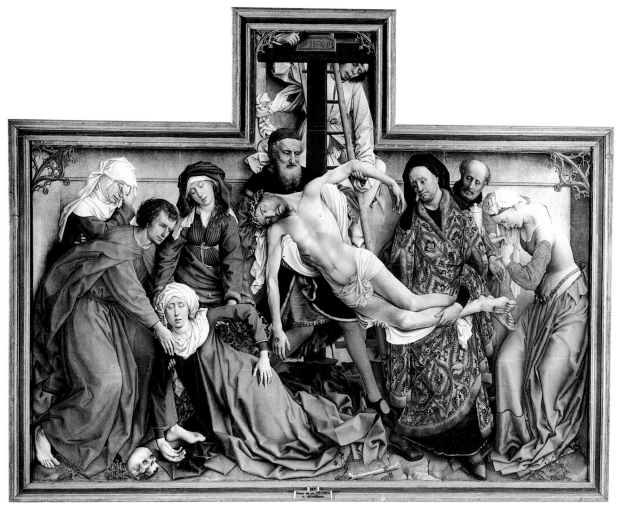

Figure 4. Rogier van der Weyden. *The Descent from the Cross*. Museo Nacional del Prado, Madrid (no. 2825)

of his inner self. By extension, they are meant to visually inspire viewers to perfect the "households" of their own souls by internalizing these qualities during meditation. However, this emphasis on the Holy Family as a spiritual unity may have had another dimension as well. Bossy has shown that the devout, in the Late Middle Ages, saw their relationship to Christ, Mary, and other saints in terms of family ties, or as one of kith and kin.[40] Accordingly, the coat of arms of the Inghelbrechts family on the central panel may have had a specific function, in this context, of emphasizing visually the "kinship of souls" between them and the Holy Family. In my opinion, it is in this detail that the significance of the resonance of their names with those of the *Annunciata* and the "cabinetmaker" lies, making the web of interconnectedness even tighter.

In conclusion, I would like to comment on the different levels of conformity seen

in the *Merode Triptych*. On the earthly, "horizontal" level, a conflation of architectural settings and activities unites the different social realms: the courtly garden in which the Inghelbrechts couple kneels in reverence during an audience with their Beloved; the bourgeois-patrician interior of an urban Flemish town house, in which Mary receives her Lord and Bridegroom with humility; and the humble workshop of her husband, who performs his artisanal duties while she reads and meditates. Work and prayer coexist. Even the labor of the Virgin has a worldly counterpart: Suspended from the rosary that Margarete Scrynmakers carries is a small statuette of Saint Christopher, the "Christ bearer," which symbolizes her desire to bear a child, as Mary once gave birth to Christ.[41] Praying for progeny, however, does not contradict but conforms to her aspiration to receive *the* child in the womb of her heart, as Mary did. Margarete's wish for progeny, therefore, is an integral part of the couple's aspiration to attain a spiritual "medevormigheit" (literally, a conformity) with the Holy Family. Campin's painting shares with contemporary devotional texts the phenomenon of a dense pattern of overlapping and conflating images that reflects this aspiration, and that is offered to the viewer (or reader) as a template for his own spiritual self constitution. The Inghelbrechts already have a vision of their spiritual cohabitation with the Virgin and the reception of the Heavenly Bridegroom in the house of their souls, but they still must strive for inner perfection through prayer and meditation. This ascent toward perfection is reflected in the general composition of the triptych—specifically, in the way in which the garden, the stairs, the open door, and the central room are connected. Devout viewers can join their soul mates in the painting by spiritually entering the garden, ascending the stairs to the house, cleansing their hearts (with the pitcher of water and the towel in the niche behind the angel), furnishing their souls with virtues, and receiving Christ—the child and the Heavenly Bridegroom—in their hearts. It is as if Robert Campin followed the maxim of the twelfth-century theologian Hugh of Saint Victor: "This, then, is what the arts are concerned with, this is what they intend, namely, to restore within us the divine likeness, a likeness which to us is a form but to God is his nature. The more we are conformed to the divine nature, the more do we possess Wisdom, for then there begins to shine forth again in us what has forever existed in the divine Idea or Pattern, coming and going in us but standing changeless in God."[42] It is this sense of an all-pervading divine program underlying the pictorial composition that gives Campin's triptych intellectual depth, semantic richness, and formal coherence, despite its fabrication in successive phases and that also serves as the basis for establishing a visionary counter image in the inner self of the viewer.

1. This text is a revised version of a talk given at The Metropolitan Museum of Art in New York on November 7, 1998. It is also an elaboration of my earlier article, "Het huishouden van de ziel: burgerlijk decor in het Mérode-altaarstuk," in H. Pleij et al., *Op belofte van profijt. Stadsliteratuur en burgermoraal in de Nederlandse letterkunde van de middeleeuwen* (Amsterdam: 1991), pp. 244–61.

2. See E. Panofsky, *Early Netherlandish Painting: Its Origins and Character*, 2 vols. (Cambridge, Massachusetts: 1953), esp. vol. 1, pp. 131–48.

3. See C. Harbison, "De iconologische benadering," in B. Ridderbos and H. van Veen, eds., *"Om iets te weten van de oude meesters." De Vlaamse Primitieven—herontdekking, waardering en onderzoek* (Nijmegen: 1995), pp. 394–432, esp. pp. 402–11.

4. For this kind of reasoning see, for example, J. B. Bedaux, "The Reality of Symbols. The Question of Disguised Symbolism in Jan van Eyck's *Arnolfini Portrait*," in J. B. Bedaux, *The Reality of Symbols. Studies in the Iconology of Netherlandish Art 1400–1800* (The Hague and Maarssen: 1990), pp. 21–65. For the iconography and the diffusion of the theme of the Madonna of Humility see M. Meiss, *Painting in Florence and Siena after the Black Death. The Arts, Religion and Society in the Mid-Fourteenth Century* (New York: 1951), pp. 132–56; H. W. van Os, *Marias Demut und Verherrlichung in der sienesischen Malerei, 1300–1450* (The Hague: 1969), pp. 79–142.

Early Netherlandish Painting at the Crossroads

5. See C. Reynolds, "Reality and Image: Interpreting Three Paintings of the 'Virgin and Child in an Interior' Associated with Campin," in S. Foister and S. Nash, eds., *Robert Campin. New Directions in Scholarship* (Turnhout, Belgium: 1996), pp. 183–95. For a refusal to see any allusions to religious concepts in the objects depicted in the *Merode Triptych* see J. De Coo, "A Medieval Look at the Mérode Annunciation," in *Zeitschrift für Kunstgeschichte* 44 (1981), pp. 114–32. For a well-argued example of the opposite view see C. J. Purtle, "The Iconography of Campin's Madonnas in Interiors: A Search for Common Ground," in S. Foister and S. Nash, eds., *Robert Campin. New Directions in Scholarship* (Turnhout, Belgium: 1996), pp. 171–82.

6. See, however, J. F. Hamburger, *The Visual and the Visionary. Art and Female Spirituality in Late Medieval Germany* (New York: 1998), who recently has stressed the "preexistent, organic unity among images, texts, and their contexts," in Late Medieval religious culture.

7. See, for example, C. Harbison, *Jan van Eyck. The Play of Realism* (London: 1991).

8. For two examples, one from the field of art history and the other from literary history, that bear testimony to the fluid boundaries between lay devotion and monastic piety see J. F. Hamburger, *The Visual and the Visionary. Art and Female Spirituality in Late Medieval Germany* (New York: 1998); G. Warnar, *Het Ridderboec. Over Middelnederlandse literatuur en lekevroomheid* (Amsterdam: 1995).

9. This is the case with the "garden" texts to which I refer below—and that I also consulted when preparing *The Fruit of Devotion. Mysticism and the Imagery of Love in Flemish Paintings of the Virgin and Child, 1450–1550* (Amsterdam and Philadelphia: 1994)—as well as with other devotional treatises and meditation manuals. Quite a few of these were incorporated in miscellaneous volumes that also contained secular texts, and that were produced increasingly for lay audiences, from the early fifteenth century in the southern Netherlands, as literary historians recently have pointed out. See, for example, K. Lassche, "Een boomgaard in zeven handschriften. Beschouwingen naar aanleiding van tekst 66 in het Geraardsbergse handschrift," in G. Sonnemans, ed., *Middeleeuwse Verzamelhandschriften uit de Nederlanden* (Hilversum: 1996), pp. 145–58; H. Brinkman, "Het Comburgse handschrift en de Gentse boekproductie omstreeks 1400," in *Queeste* 5 (1998), pp. 98–113; J. Schenkel, "Tekstcollecties: willekeurig of weloverwogen? Een verkenning naar aanleiding van de 'Comburg-collectie'," in *Queeste* 5 (1998), pp. 114–59. See also note 11, below.

10. For a survey of recent scholarship on the *Merode Triptych* see M. W. Ainsworth in M. W. Ainsworth and K. Christiansen, eds., *From Van Eyck to Bruegel. Early Netherlandish Painting in The Metropolitan Museum of Art* (exhib. cat., The Metropolitan Museum of Art)

(New York: 1998), pp. 89–96; H. Mund and C. Stroo, *Early Netherlandish Painting (1400–1500). A Bibliography (1984–1998)* (Brussels: 1998), pp. 281–83.

11. See C. C. de Bruin, ed., *TLeven Ons Heren Jhesu Cristi. Het Pseudo-Bonaventura-Ludolfiaanse Leven van Jesus* (Leiden: 1980), p. 24; according to de Bruin, p. XVIII, several of these texts were owned by "rich burghers and patrician ladies."

12. See C. Gottlieb, "Respiciens per Fenestras: The Symbolism of the Mérode Altarpiece," in *Oud Holland* 85 (1970), pp. 65–84. C. J. Purtle, *The Marian Paintings of Jan van Eyck* (Princeton: 1982), pp. 31–39, also explains fifteenth-century depictions of the Annunciation showing Mary in her *thalamus virginis* (bedroom) as symbolic images of Mary's womb.

13. See F. Thürlemann, *Robert Campin. Das Mérode-Triptychon. Ein Hochzeitsbild für Peter Engelbrecht und Gretchen Schrinmechers aus Köln* (Frankfurt am Main: 1997), pp. 36–38; H. Installé, "Le Triptyque Mérode. Évocation mnémonique d'une famille de marchands colonais réfugiée à Malines," in *Handelingen van de Koninklijke Kring voor Oudheidkunde, Letteren en Kunst van Mechelen* 96 (1992), pp. 55–154; A. Châtelet, *Robert Campin. De Meester van Flémalle* (Antwerp: 1996), pp. 106–7, 294. Châtelet disputes Thürlemann's identification of the donors, although he, too, identifies the male figure as a member of the Inghelbrechts (or Ymbrecht) family, named Jan. While the arguments of both authors lack conclusive evidence, especially with regard to the identification of the coat of arms of the woman in the central panel, I tend to agree with Thürlemann (whose identification seems to be more in line with the findings of Installé); see also M. W. Ainsworth and K. Christiansen, eds., *From Van Eyck to Bruegel. Early Netherlandish Painting in The Metropolitan Museum of Art* (exhib. cat., The Metropolitan Museum of Art) (New York: 1998), p. 95.

14. See H. Rahner, "Die Gottesgeburt. Die Lehre der Kirchenväter von der Geburt Christi im Herzen der Gläubigen," in *Zeitschrift für katholische Theologie* 59 (1935), pp. 333–418; M. E. Gössmann, *Die Verkündigung an Maria im dogmatischen Verständnis des Mittelalters* (Munich: 1957), pp. 209 ff.; H. van Os, *Marias Demut und Verherrlichung in der sienesischen Malerei, 1300–1450* (The Hague: 1969), pp. 66 ff.; J. F. Hamburger, *Nuns as Artists. The Visual Culture of a Medieval Convent* (Berkeley, Los Angeles, and London: 1997), p. 171.

15. See M. Carruthers, *The Craft of Thought. Meditation, Rhetoric, and the Making of Images, 400–1200* (Cambridge, England: 1998).

16. Published by W. Moll, *Johannes Brugman en het godsdienstig leven onzer vaderen in de vijftiende eeuw*, 2 vols. (Amsterdam: 1854), vol. I, pp. 293–309. The image of the "heart of the soul" often was conflated with that of the "house of the soul" as the meeting place with the Heavenly Beloved; see J. F. Hamburger, *Nuns as Artists. The Visual Culture of a Medieval Convent* (Berkeley, Los Angeles, and London: 1997), pp. 137–58 (with

additional literature). See H. Rademacher, ed., *Lectulus Noster Floridus. Unser Blumenbettchen. Eine devotmystische Schrift des 15. Jahrhunderts. Niederdeutsch von Johannes Veghe* (Münster: 1938), pp. 101 ff., 171 ff.: Here, the "chamber of the heart" is furnished with a mirror, washbasin, towel, cabinet, jug, birdcage, chandelier, paintings (depicting Death, Hell, the Passion, and "Eternal Bliss"), a table (with bread and wine), a chair, and a bed, among other things. See also F. Ohly, "Cor amantis non angustum. Vom Wohnen im Herzen," in F. Ohly, *Schriften zur mittelalterlichen Bedeutungsforschung* (Darmstadt: 1977), pp. 128–55, esp. pp. 140 ff.; and also note 20, below.

17. Mande's text clearly represents a continuation, with adjustments for new audiences, of the earlier monastic tradition of meditation imagery described by M. Carruthers, *The Craft of Thought. Meditation, Rhetoric, and the Making of Images, 400–1200* (Cambridge, England: 1998).

18. See F. O. Büttner, *Imitatio Pietatis. Motive der christlichen Ikonographie als Modelle zur Verähnlichung* (Berlin: 1983); C. Harbison, "Visions and Meditations in Early Flemish Painting," in *Simiolus* 15 (1985), pp. 87–118; J. H. Marrow, "Symbol and Meaning in Northern European Art of the Late Middle Ages and the Early Renaissance," in *Simiolus* 16 (1986), pp. 150–69.

19. For a different view of the nature of the symbolism in this painting see, for example, W. S. Heckscher, "The Annunciation of the Mérode Altarpiece: An Iconographic Study," in *Miscellanea Jozef Duverger. Bijdragen tot de kunstgeschiedenis der Nederlanden* (Ghent: 1968), vol. 1, pp. 37–65; and see also note 5, above.

20. The motif of the *sedes sapientiae*, or "Seat of Wisdom" (3 Kings: 10, 18–20), is represented by the bench against which Mary leans; decorated with small carved sculptures of lions, it is apparently a metaphor for Mary as the "Throne of Solomon" (see E. Panofsky, *Early Netherlandish Painting: Its Origins and Character*, 2 vols. [Cambridge, Massachusetts: 1953], vol. 1, p. 143), but it might have been intended, at the same time, as yet another trope for the soul: See, for example, a sixteenth-century devotional manual on the "house of the soul," the *Tempel onser Sielen*, in which the "soul of the just" is called the "(Solomonic) Seat of Wisdom." See also A. Ampe, *Den Tempel onser Sielen* (Antwerp: 1968), p. 111, who refers to the patristic origin of this idea.

21. See F. W. Wodtke, "Die Allegorie des 'inneren Paradieses' bei Bernhard von Clairvaux, Honorius Augustodunensis, Gottfried von Strassburg und in der deutschen Mystik," in H. Moser et al., eds., *Festschrift Josef Quint* (Bonn: 1964), pp. 277–90; R. Falkenburg, *The Fruit of Devotion. Mysticism and the Imagery of Love in Flemish Paintings of the Virgin and Child, 1450–1550* (Amsterdam and Philadelphia: 1994), esp. chapter 2 (with additional literature).

22. See R. Falkenburg, *The Fruit of Devotion. Mysticism and the Imagery of Love in Flemish Paintings of the Virgin and Child, 1450–1550* (Amsterdam and Philadelphia: 1994),
pp. 41–42; see also J. F. Hamburger, *Nuns as Artists. The Visual Culture of a Medieval Convent* (Berkeley, Los Angeles, and London: 1997), pp. 63 ff.

23. This text is the first part of *The spiritual fruit garden where the devout soul is satiated with the fruit of Christ's passion (Den geesteliken boemgaert der vruchten daer die devote siele haer versadicht vanden vruchten des passien Christi)* (Antwerp: n.d.) (Koninklijke Bibliotheek, Brussels, cat. no. L.P. 165 A). See also R. Falkenburg, *The Fruit of Devotion. Mysticism and the Imagery of Love in Flemish Paintings of the Virgin and Child, 1450–1550* (Amsterdam and Philadelphia: 1994), pp. 42–44.

24. I find this term, borrowed from E. Panofsky, *Early Netherlandish Painting: Its Origins and Character*, 2 vols. (Cambridge, Massachusetts: 1953), vol. 1, p. 182, far more insightful than his "disguised symbolism."

25. See S. Ozment, *The Age of Reform, 1250–1550. An Intellectual and Religious History of Late Medieval and Reformation Europe* (New Haven and London: 1980), pp. 46, 117, 242; S. Ozment, "Mysticism, Nominalism and Dissent," in C. Trinkaus and H. Oberman, eds., *The Pursuit of Holiness in Late Medieval and Renaissance Religion* (Leiden: 1974), pp. 67–77. As far as I know, there is no encompassing study of this mystical (and originally Platonic) "principle of likeness" (Ozment) in the Late Middle Ages. For the concept of *conformitas* see also, among others, F. Ohly, "Du bist mein, Ich bin dein. Du in mir, Ich in dir. Ich du, Du Ich," in E.-J. Schmidt, ed., *Kritische Bewahrung: Beiträge zur deutschen Philologie. Festschrift für Werner Schröder* (Berlin: 1974), pp. 371–415; W. Augustyn, "'Passio Christi Est Meditanda Tibi.' Zwei Bildzeugnisse Spätmittelalterlicher Passionsbetrachtung," in W. Haug and B. Wachinger, eds., *Die Passion Christi in Literatur und Kunst des Spätmittelalters* (Tübingen: 1993), pp. 211–40; P. Kaiser, "Die Christo der *Philosophia Spiritualis* Heinrich Seuses," in R. Blumrich and P. Kaiser, eds., *Heinrich Seuses Philosophia Spiritualis. Quellen, Konzept, Formen und Rezeption* (Tagung Eichstätt 2.–4. Oktober 1991) (Wiesbaden: 1994), pp. 109–72.

26. To give just one example from the corpus of treatises on the spiritual garden: *Here begins a pleasant garden of the devout souls (Hier begint een ghenoechlick hoefken deer devoter zielen)* (Nijmegen, Gemeente-Archief), Ms. Weeshuizen, folios 123 r.–153 v., esp. folio 131 v., where the "conformity" (*medeformicheit*) of the "nature" ("essence") of the soul with Christ is mentioned. See R. Falkenburg, *The Fruit of Devotion. Mysticism and the Imagery of Love in Flemish Paintings of the Virgin and Child, 1450–1550* (Amsterdam and Philadelphia: 1994), pp. 29–31.

27. For the conflation of worldly and religious love with garden imagery in the Late Middle Ages see, for example, R. Falkenburg, *The Fruit of Devotion. Mysticism and the Imagery of Love in Flemish Paintings of the Virgin and Child, 1450–1550* (Amsterdam and Philadelphia: 1994), esp. pp. 7–15.

28. See O. Pächt and D. Thoss, *Die illuminierten Handschriften und Inkunabeln der österreichischen National-*

bibliothek. Französische Schule (Vienna: 1974), vol. I, pp. 32–37, for an illustration of the wedding of Emila and Palemon in Boccaccio's *Teseida* (Cod. 2617, fol. 182 r.), showing men attending the wedding wearing carnations and roses on their hats; and a panel painting attributed to the Master of the Legend of Saint Lucy (The Detroit Institute of Arts) depicting the Virgin of the Rose Garden, with female saints seated in a *hortus conclusus*, and Saint Cecilia wearing a hat adorned with a red rose.

29. See H. Nickel, "The Man beside the Gate," in *The Metropolitan Museum of Art Bulletin* 24, 8 (April 1966), pp. 237–44, who identifies this man as a messenger carrying the colors of the city of Mechlin. This detail makes sense in the context of the pictorial narrative of the left panel as a whole if the man is interpreted as heralding the arrival of the Inghelbrechts couple.

30. See E. Panofsky, *Early Netherlandish Painting. Its Origins and Character*, 2 vols. (Cambridge, Massachusetts: 1953), vol. I, pp. 144–48.

31. See O. von Simson, "*Compassio* and *Co-redemptio* in Roger [sic] van der Weyden's *Descent from the Cross*," in *The Art Bulletin* 35 (1953), pp. 9–16. In my opinion, Mary's pose, which echoes that of Christ, is not so much a symbolic expression of the (contested) theological concept of Mary's role as Co-Redemptrix but, rather, as an exemplary (re)presentation of *conformitas*; see also R. L. Falkenburg, "The Decorum of Grief: Notes on the Representation of Mary at the Cross in Late Medieval Netherlandish Literature and Painting," in M. Terttu Knapas and Å. Ringbom, eds., *Icon to Cartoon. A Tribute to Sixten Ringbom* (Studies in Art History by The Society for Art History in Finland 16) (Helsinki: 1995), pp. 65–89. I will address this issue further in a more detailed study on pictorial tropes for the soul in Early Netherlandish painting.

32. For the resonance of all these interconnected themes—love, the garden of courtly love, the garden in the Song of Songs, the rose, and the rose garden—in rosaries (beads and prayers), see E. Wilkins, *The Rose-Garden Game: The Symbolic Background to the European Prayer-Beads* (London: 1969); A. Winston-Allen, *Stories of the Rose. The Making of the Rosary in the Middle Ages* (University Park, Pennsylvania: 1997).

33. See J. F. Hamburger, *Nuns as Artists. The Visual Culture of a Medieval Convent* (Berkeley, Los Angeles, and London: 1997), fig. 85, pl. 12 (Berlin, Staatsbibliothek, Preussischer Kulturbesitz, Handschriftenabteilung 417), and also pp. 137–75.

34. See R. Falkenburg, *The Fruit of Devotion. Mysticism and the Imagery of Love in Flemish Paintings of the Virgin and Child, 1450–1550* (Amsterdam and Philadelphia: 1994), chapter 2.

35. See, for example, J. Seitz, *Die Verehrung des hl. Joseph in ihrer geschichtlichen Entwicklung bis zum Konzil von Trient dargestellt* (Freiburg im Breisgau: 1908); H. Erlemann, *Die Heilige Familie. Ein Tugendvorbild der Gegenreformation im Wandel der Zeit. Kult und Ideologie* (Münster: 1993), esp. pp. 131 ff.; T. Brandenbarg, *Heilig Familieleven. Verspreiding en waardering van de Historie van Sint-Anna in de stedelijke cultuur in de Nederlanden en het Rijnland aan het begin van de moderne tijd* (15 de /16 de eeuw) (Nijmegen: 1990), esp. pp. 180–99.

36. See M. Roubo, *L'Art du Layetier* (Paris: 1782), plates 5, 7. A *layetier* (box maker) also made mousetraps and stoves. I am grateful to H. Installé of the Gemeente-Archief in Mechlin for pointing out this reference.

37. See M. Schapiro, " 'Muscipula Diaboli,' The Symbolism of the Mérode Altarpiece," in *The Art Bulletin* 27 (1945), pp. 182–87.

38. For other efforts to identify this object see M. W. Ainsworth and K. Christiansen, eds., *From Van Eyck to Bruegel. Early Netherlandish Painting in The Metropolitan Museum of Art* (exhib. cat., The Metropolitan Museum of Art) (New York: 1998), p. 90 (with additional references); M. A. Lavin, "The Mystic Winepress in the Mérode Altarpiece," in I. Lavin and J. Plummer, eds., *Studies in Late Medieval and Renaissance Painting in Honor of Millard Meiss* (New York: 1978), pp. 297–301.

39. Later, in seventeenth-century Dutch painting, the stove often occurs as a female attribute; see E. de Jongh, *Tot lering en Vermaak* (exhib. cat., Rijksmuseum) (Amsterdam: 1976), pp. 96–97. W. E. Franits, *Paragons of Virtue. Women and Domesticity in Seventeenth-Century Dutch Art* (Cambridge, England: 1993), fig. 152, illustrates a print by Cornelis Bloemaert, after a painting by Abraham Bloemaert, showing an old woman saying her prayers and holding a rosary in her hands, which are being warmed by a stove. The inclusion of a stove in a devotional context, as in the *Mérode Triptych*, therefore is not unique in Netherlandish painting.

40. See J. Bossy, *Christianity in the West, 1400–1700* (Oxford, England, and New York: 1985), esp. pp. 3–34; T. Brandenbarg, *Heilig Familieleven. Verspreiding en waardering van de Historie van Sint-Anna in de stedelijke cultuur in de Nederlanden en het Rijnland aan het begin van de moderne tijd* (15 de /16 de eeuw) (Nijmegen: 1990).

41. See M. W. Ainsworth and K. Christiansen, eds., *From Van Eyck to Bruegel. Early Netherlandish Painting in The Metropolitan Museum of Art* (exhib. cat., The Metropolitan Museum of Art) (New York: 1998), p. 91.

42. See *The Didascalicon of Hugh of St. Victor. A Medieval Guide to the Arts*, trans. from the Latin, with Introduction and Notes by J. Taylor (New York: 1991), pp. 29–30.

Peter Parshall

Commentary: Conformity or Contrast?

Contrary to the insistence of many post-structuralists that all consciousness is finally rooted in language, it is difficult to resist the perception that images are, indeed, images, and texts are texts. The sense that there is such a thing as "visual thinking" arises not only from our customary struggle as art historians to translate from one medium to the other. A distinctly visual mode of cognition is suggested in many other ways as well, including the experience of visions, of sleeping and waking dreams, and not least by the elusive operations of the memory. Whichever position we adopt on this question will ultimately rest on intuition, although in any case it is no trivial matter. Apart from more profound epistemological consequences, the relation between images and texts sits at the crux of Renaissance iconography. How should we weigh the usefulness of texts for understanding paintings? To what extent can texts function as complex or transparent statements capable of unveiling the meaning of an image?

Professor Falkenburg locates his own approach to this problem in opposition to Erwin Panofsky's groundbreaking and now overly criticized study of Early Netherlandish painting.[1] Falkenburg and others have tended to center their misgivings around the notion of "disguised symbolism," a concept of the relation between texts and images that Panofsky formulated in relatively unambiguous terms.[2]

For better or worse, disguised symbolism has come to be the burr under the saddle of much recent scholarly debate. How can a symbol be properly termed "disguised" if it is to function as a symbol at all? Moreover, how disguised can a symbol be if we are still able to recover its meaning many centuries later? To my mind this issue is largely semantic. As Panofsky well understood, a glass vessel in a niche or an apple on a window ledge is hardly more disguised than a pot of lilies accompanying the Virgin Annunciate. By employing the term "disguised," Panofsky was less concerned to define a specific strategy of encoding than to characterize the historical process by which a particular kind of symbolic allusion came about. Although his approach to iconographical analysis may at points seem unduly taxonomic, too bent on sorting out levels of meaning in overly stratified ways,[3] it is ironic in the present climate that his forthright approach to defining a methodology should provoke such a bother.

Nonetheless, the current debate over text and image raises pertinent questions about the discipline of art history. Should we suppose that images are best interpreted by mapping texts onto them in a one-to-one relationship? Is it possible by this means to recover an artist's conscious intention? If so, have we then succeeded in providing a reasonably sufficient explanation for a work of art? Put differently, do we think an account of what went into a painting, or, for that matter, what went into a text, is equivalent to what its initial respondents took away from it? Partly as a consequence of reconsidering this issue, a preoccupation with response has come to dominate the study of meaning in Early Netherlandish painting, resulting in a change of emphasis from input to output. It seems clear that Panofsky took largely for granted that what went into a painting was also what came out of it, whereas much

recent work on the cultural and economic circumstances surrounding the making of fifteenth-century religious art brings this mirror relationship into question. However, interpreting response is fraught with difficulties of its own. Texts, for example, are in many ways much less suited to dissecting the psychological states of respondents than to decoding an iconographic program. Yet, whatever the difficulties, the shift of attention from input to output has, at the very least, helped to complicate and give nuance to our readings of devotional art, leading to a greater emphasis on the complex empathetic relationship between a beholder and an object.

Although private viewing and solitary reading are necessarily different activities, the relevance of devotional literature written as instruction for meditation can hardly be discounted. As Falkenburg suggests, this seems particularly true when we are trying to understand devotional attitudes in a religious context that was deeply invested in reading and spoken instruction. Such texts do record specific intentions about the conduct and objectives of meditation, whether or not these texts are interpreted as characterizations of actual states of mind that were typically achieved. Here, Falkenburg's approach to the relation between texts and images is a subtle and flexible one. His analysis of the concept of *conformitas*, for example, implies something partly subjective and partly objective. It bears on subjective emotions like empathy and abjection, as well as on rationally guided understandings about doctrine and metaphorical or symbolic correspondence. If I read him right, *conformitas* seems also to include the encouragement to "imitate" holy figures and states of the soul in the manner so often urged by contemporary devotional texts. The term "*conformitas*" nicely suggests this appeal without quite reducing it to something as literal as an outright prescription for mimicry or immediate identification with the attitudes of figures seen in pictures. Thus, Falkenburg implies a complex condition of response that might readily achieve a kind of autonomy in which a beholder caught up in

the act of meditation appropriates a text or an image and elaborates on it in individual ways. This model of response veers away from any exclusive definition of meaning toward an understanding of symbolic reference as potentially polyvalent. An artifact or a text (for Falkenburg's proposition can apply just as well to a text as an image) becomes temporarily a part of us, and able to operate substantially on our terms. It must be said, however, that at this point we are talking about an experience the historian can no longer recover.

The texts Falkenburg discusses originated mainly in monastic subcultures, but they were intended for lay audiences as well. Although his concern is to explicate modes of devotional practice, we recognize that the paintings in question were commissioned by many sorts of patrons, who presumably had a spectrum of ambitions in mind. Some of these were surely other than strictly devotional, having to do, for example, with acquiring social prestige, acknowledging the material and procreative promise of a marriage alliance, providing a symbol of community for a guild or a confraternity, offering the pleasure of owning something manifestly beautiful or well crafted, and so on. Furthermore, a devotional object like the *Merode Triptych* (see plate 1) was almost certainly a conversation piece as well as an object of private contemplation, so, among other things, we are obliged to speculate on how such exchanges might have gone. Here, apart from the paintings themselves, we have precious little evidence and little vocabulary from the period to guide us.

Panofsky would have us suppose that a key element of such conversations was the intricacy of disguised symbols. However, it is often pointed out that the few Early Renaissance texts that respond directly to images almost never discuss what we now call iconography, apart from identifying the principal subject of a work. How then should we imagine the owners of the *Merode Triptych* reflecting on the meaning of the snuffed candle on the table? Whether we regard this detail as hidden or not, it must have presented itself as something in need of explanation. For

our purposes, "hidden" is not so much the issue as knowing whether some metaphorical reference was available at all, and whether that reference is integral to a symbolic program or merely idiosyncratic. No doubt paintings such as this did have programs of a sort, even if they were often unsystematic, or iconographically lax, as Falkenburg puts it. His principle of laxity is a useful one. Being permissive, it avoids a strict definition of meaning as necessarily singular and exclusive and grants the beholder leeway to improvise within certain thematic parameters.

However, it is crucial to decide how this "iconographical laxness" came about, whether it was accomplished by design or merely by default. In his explication of the *Merode Triptych,* Panofsky concludes that this work represents an unresolved stage in a coherent evolution of Early Netherlandish art that would soon reach its maturity with Jan van Eyck. From this perspective, Campin's painting is spatially immature and iconographically unsystematic, not because it was designed to be so but because the *Merode Triptych* exemplifies an exploratory stage in a development that was still short of its goal. The historical determinism underlying Panofsky's account bears squarely on the problem of artistic intention.[4] Panofsky assumes that Campin's intention can be measured (and its fulfillment critiqued) according to a standard fixed elsewhere in the tradition—namely, the mature stage of Eyckian realism with its more thoroughgoing, programmatic symbolism. For Panofsky, a lack of resolution—in effect, a kind of failed work—is further evidenced by a lack of sophistication in the spatial design of Campin's composition, an immaturity reciprocally confirmed by the lack of coherence in its iconography. Yet, it now appears likely that the *Merode Triptych* is the product of at least two (if not three) stages of design that included the later addition of the wings. Thus, gradual accretion came to modify the meaning of the triptych and, therefore, necessarily the iconographic implications of its central panel. An analysis of a work of art that presumes

a fully synthesized and singular integrity bestowed by the maker is surely anachronistic when applied to works that were typically collaborations between artists and patrons and that evolved in stages over time. In cases like this, the problem of interpreting artistic intention becomes especially vexed.

Falkenburg's concept of iconographic laxness could also be taken to imply a standard unmet, although I might be misunderstanding him. More likely, he is suggesting an appropriate degree of flexibility in the employment of conventions of representation and symbolic reference. Artists made

Figure 5. Jan van Eyck. *The Crucifixion* (detail). The Metropolitan Museum of Art, New York, Fletcher Fund, 1933 (33.92 a)

Early Netherlandish Painting at the Crossroads

things up as they went along, much as they often still do, and respondents did likewise. Formal invention and the elaboration of content went hand in hand, just as the experience of a devotional object must have been partly guided and partly improvised on the basis of different priorities of varying interest to the beholder. This assumption is just common sense. Furthermore, however much we may value it now, in its own time the *Merode Triptych* was a relatively modest and unassuming work. In seeking mutual satisfaction, we can suppose that at points painter and patron devised the subject of these panels according to their own preferences, and that the "inconsistencies" are the result of our criteria rather than theirs. In stimulating meditation, a devotional image offered certain signposts for reflection, but not a road map. Such paintings are not incantatory, like the reciting of the rosary, if for no other reason than, being paintings, they cannot be read in a linear fashion. Nor do paintings in any direct sense mimic a meditational vision.[5]

"Laxness" is a suitable term, in that it cautions against too precise a reconstruction of meaning. For this very reason, Falkenburg's final suggestion that in explicating devotional images we must press our interpretations to the point of precision, rendering them as much proscriptive as permissive, is nonetheless worrying. Whether we are trying to reconstitute actual mental states through the example of texts, or merely seeking to establish conventional guidelines for relating one thing to another in a manner that may have occurred to an artist or a beholder while a picture was contrived or adored, we can certainly go too far. This is especially so if we imply that our rhetorical accounts actually do approximate a primary experience of the image. Arthur Danto puts the problem succinctly: "Can we after all respond to works of art from earlier periods in their own terms? Yes and no: we can at least come to know what their own terms are, but then to respond to them in those terms is excluded by the intrusions of consciousness."[6]

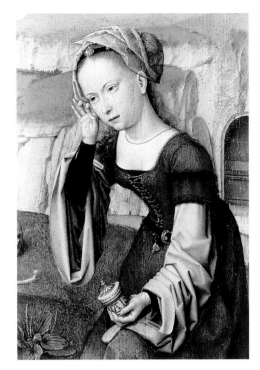

Figure 6. Gerard David. *The Lamentation* (detail). Philadelphia Museum of Art, The John G. Johnson Collection (no. 328)

It is troubling for historians that the sparse contemporary rhetoric we do have that immediately pertains to fifteenth-century northern European art gives no indication of such complex responses, either directed or improvisational. On the contrary. We find that Italian writers reacted foremost to convincing qualities of imitation: principally, the dazzle of realistic detail. Secondly, they responded to convincing representations of emotion or mien, admiring Northern works especially for their air of piety. I refer here to the texts of Bartolommeo Fazio and Cyriaco d'Ancona, although I doubt Northern populations would have written any differently about religious images at the time. We can add to these Italian accounts the evidence of paintings that quote one another—a pattern that above all else tends to confirm an interest in representing

emotional states. Pictorial responses are in a somewhat different domain, determined predominantly, but not exclusively, by their makers rather than by patrons. Nonetheless, pictorial quotation is more than just a record of workshop convenience. It also provides a trace of what people paid attention to, a record of successful communication with an immediate and extended audience of clients.

Take Rogier van der Weyden's famous *Descent from the Cross* in the Museo Nacional del Prado (see fig. 4). Remarking on what was definitely another painting, but of the same general subject and also presumed to be by Rogier, Cyriaco praises the emotional charge of its figures who "cry with great grief" and seem to "breathe as though alive." Cyriaco then notes the material details and their vividness, and finally the devoutness of

the image.[7] A survey of the pictorial influence of the *Descent from the Cross* suggests that it was not the theological conformity underscored by the parallel poses of the Virgin and Christ that most strongly imprinted itself on the tradition but rather the concentration of emotional power embodied in the figure of the Magdalene at the far right. This figure may ultimately derive from an invention by Jan van Eyck, perhaps something close to the wailing figure in green in the foreground of the Metropolitan Museum's *Crucifixion* (fig. 5). Regardless of its plausible forerunners, Rogier likely converted this remarkable formulation into a statement entirely of his own making. Mary Magdalene brackets the mourning group parenthetically, wrought in a complex pose that was doubtless meant to be understood as a cipher of poignant and

Early Netherlandish Painting at the Crossroads

Figure 7. Hugo van der Goes. *Portinari Altarpiece*. Galleria degli Uffizi, Florence (no. 1525)

inwardly conflicted grief. The figure is half bent in rotation, her head bowed and her arms raised at the elbows, her fingers interlocked and turned outward like the tormented unfolding of a gesture of prayer. These contradictory torsions of the body telegraph in a visceral way a wracked state of mind. It is the personification of a mental state as much as a descriptive account of lamentation. This highly artificial pose reads as a metaphor for the internal contradictions symptomatic of Mary Magdalene's life as a converted sinner in the flesh, whose passion was transmuted from the physical to the spiritual. Her traumatic body language carries the trace of both these conditions—an accomplishment that led to Rogier's invention being among the most often quoted figures in Early Netherlandish art.[8]

Cyriaco's appreciation of the empathetic aspect of Rogier van der Weyden's art may reflect Alberti's insistence that a narrative figure convey through pose and facial expression the condition of the soul. That Rogier's *Pathosformel* was so recognizably mimicked in so many variations indicates that Northern artists and patrons were equally susceptible to reading figures in this way. At least one other fifteenth-century Netherlandish invention seems to have had a similar longevity: the motif of a mourning figure wiping away a tear with the back of the hand. The first occurrence of this gesture may have been the angel in Campin's *Entombment* (Courtauld Institute Galleries). In any case, this, too, was adopted as a set piece that was repeated throughout the century and became a special favorite of Gerard David (fig. 6).

On the other hand, the Magdalene of the *Descent from the Cross* is a magnificent exception within the repertoire of Northern *Pathosformeln* because it addresses an often acknowledged absence in Northern art—namely, a reluctance (or inability, if one can say so) to portray fluid action in a compelling way. The figure of the Magdalene was very likely embraced because it stood out as a curiosity, a strikingly energetic deviation that registered accordingly. Both the fraught Magdalene and the crying figure quickly became conventions in Northern painting, and both have in common an overt appeal to sentiment. Exactly how that appeal was empathetically received is hard to say. Paintings, particularly those related to the Passion, commonly present an array of possible responses to Christ's suffering by depicting figures who adopt them. Nonetheless, it is difficult to be content with reconstructions of responses that interpret such exempla as particular recommendations to the viewer. Although these figures are memorable, they are also merely virtual experiences, lodged in a distant and vicariously passionate moment.

Indelible impact on the memory was a much claimed advantage of images over texts, an opinion confirmed by the very fact that artists so often repeated figures such as Rogier's Magdalene. Much like the instability of memory itself these reiterations are never exact but improvised around the axis of a strongly imprinted pictorial idea. They impress themselves on the memory, embodiments of states of mind intended to strike a particular chord. Moreover, as ancient and medieval rhetorical texts dealing with the effect of images on the memory persist in telling us, an image is most striking when it invokes contrast rather than conformity.[9] The Magdalene is evocative because in every respect she stands apart from her cohorts. Whether and how such images may have moved the respondent to empathy is impos-

sible to determine. Certainly they may have done so, but any painting has sundry distractions and possible points of engagement, as all direct testimony of response to actual works of art at the time tells us. Craftsmanship, illusion, innovation or venerability, familiar domestic details, and that proliferating "thingness" of which Falkenburg speaks were all elements there to be admired. Transport into a meditative state must have been only an occasional occurrence before an object that was, after all, also a part of the household or guild chapel furnishing. On the other hand, a remembered painting was by definition a successful one, if only because it would lead to the commissioning of another. Certain motifs recur so often because of their ability to register themselves in an eidetic way that was abiding and easily recalled. The effectiveness of a figure like Rogier's contorted Magdalene had more to do with establishing contrasts than demonstrating conformities. Empathetic models depended on a strategy of differentiation rather than assimilation.

One final comment on the *Merode Triptych*: In his discussion of *conformitas*—between figures in a painting, objects themselves, viewer and object, and objects and ideas—Falkenburg gives us a sense of the non-linear and complexly interrelational ways in which pictures can be viewed and understood. He reminds us of the fundamental reflex behind representational art to establish analogues or equivalences, which in devotional imagery often meant exploring the reciprocal or "consubstantial" relationship between the material and spiritual worlds. Radial or meandering or centripetal modes of viewing are encouraged by the formal construction of the *Merode Triptych* itself, for the composition bursts out from the center and then returns through the converging perspective of the room. Centeredness, of course, is a structural aspect of the triptych form, provoking a pattern of

visual and iconographic cross-referencing that nevertheless remains anchored to a dominant theme and a centralized composition. It is important to recognize that these formal characteristics are not narratival, although they may well approximate certain types of devotional writing.

Hugo van der Goes's *Portinari Altarpiece* (fig. 7), painted a half century later, reads as an index of how the earlier Netherlandish tradition was venerated retrospectively. The monumental size of this triptych was manifestly an Italian preference, whereas its peculiar archaisms are probably the result of a well-versed Florentine's desire for something essentially and polemically Flemish. The persistent difficulty in locating the *Portinari Altarpiece* within Hugo's chronology may well be due to the fact that he was required by his patron, Tommaso Portinari, to make a work that looked somewhat more like a Campin than the style of the 1470s. Such a motive is betrayed not only by the exceptionally complex and assertive symbolic program and the famously rustic shepherds but also in the strangely delirious, dish-like space of the center panel, with its irregular constellation of figures and consequent discrepancies in scale. Are these oddities perhaps also a result of valuing a formal construction better suited to pious reflection—in short, exactly the properties it shares with the *Merode Triptych*? The *Portinari Altarpiece,* too, is a painting intended to be "read around" in much the manner that Falkenburg describes.

I have tried here not to discount Reindert Falkenburg's applications of texts to images but to qualify them, and to suggest an alternative approach that may help to confirm or modify his conclusions by different means. However, I remain firm in the view that we shall never be able to map the inner workings of a fifteenth-century mind, and in this respect we shall never be more than merely adequate supplicants before these curious altars.

1. See E. Panofsky, *Early Netherlandish Painting: Its Origins and Character,* 2 vols. (Cambridge, Massachusetts: 1953).
2. Ibid., vol. 1, pp. 140–44.
3. See E. Panofsky, *Studies in Iconology* (New York: 1962), chapter 1.
4. This issue was raised almost immediately after the publication of *Early Netherlandish Painting*: See O. Pächt, "Panofsky's *Early Netherlandish Painting*," in *The Burlington Magazine* 98 (1956), pp. 257–58. For later responses to Panofsky's method see also M. Podro, *The Critical Historians of Art* (New Haven and London: 1982), chapter 9, esp. pp. 195–99; K. Moxey, "Panofsky's Concept of 'Iconology' and the Problem of Interpretation in the History of Art," and A. Danto, "Commentary," in *New Literary History* 17 (1986), pp. 265–79. On the problem of iconology and post-Hegelian views of history in general see E. Gombrich, *In Search of Cultural History* (Oxford, England: 1969).
5. On the other side see C. Harbison, "Visions and Meditations in Early Flemish Painting," in *Simiolus* 15 (1985), pp. 87–118.
6. See A. Danto, "Commentary," in *New Literary History* 17 (1986), p. 278. See also M. Baxandall, *Patterns of Intention: On the Historical Exploration of Pictures* (New Haven: 1985), chapter 4, on the criteria of legitimacy, order, and necessity in interpretation.
7. See K. Christiansen, "The View from Italy," in M. W. Ainsworth and K. Christiansen, eds., *From Van Eyck to Bruegel. Early Netherlandish Painting in The Metropolitan Museum of Art* (exhib. cat., The Metropolitan Museum of Art) (New York: 1998), pp. 39, 48.
8. For example, see the drawing after the *Descent from the Cross,* perhaps by Vrancke van der Stock (Paris, Musée du Louvre, Cabinet des Dessins), in which Mary is bent lower toward the body of Christ; Dieric Bouts's more sedate version in a *Lamentation* of about 1455 (Paris, Musée du Louvre); Hans Memling's similar reformulation in a *Lamentation* of about 1480 (Bruges, Sint-Janshospitaal); Geertgen tot Sint Jans's *Lamentation* from the *Saint John Altarpiece* of about 1485–90 (Vienna, Kunsthistorisches Museum); the Master of the Virgin among Virgins' *Lamentation* of the 1480s (Enghien, Belgium, Sint-Nicolas Hospitaal); Quentin Massys's *Crucifixion* of about 1510 (London, National Gallery); and Gerard David's *Crucifixion* of about 1515 (Berlin, Staatliche Museen, Preussischer Kulturbesitz, Gemäldegalerie).
9. See P. Parshall, "The Art of Memory and the Passion," in *The Art Bulletin* 81 (1999), pp. 456–72.

Maximiliaan P. J. Martens

Approaches to the Heuristics of Early Netherlandish Art

A recently published survey of art-historical methodology deals in great length with historiography, connoisseurship, iconology, historical anthropology, Marxist interpretations, gender art history, semiotics, and system theories.[1] In this reference book, archival research is mentioned only in the chapter on Dutch historiography before 1933. Apparently, many art historians today consider archival research as an obsolete and rather esoteric branch of art-historical investigation. In the study of Early Netherlandish art, however, no one denies the importance of using basic historical data. Therefore, most scholars readily consult archival sources, which were published mainly in the second half of the nineteenth century.[2] Yet, seldom are these published sources verified or the original texts examined. Confidence in the comprehensiveness and accuracy of nineteenth-century archival investigations is widespread. Omissions or mistakes in transcriptions that were made by our predecessors have permeated our textbooks like heuristic viruses. The prominent illuminator Jan Baudolf, for instance, continues to be called "Jean Bondol" in most reference works,[3] and the date of Jan van Eyck's death is still often mentioned as July 9 instead of shortly before June 23, 1441.[4]

The results of historical research from an epoch with completely different theoretical and methodological standards than ours frequently are copied without any form of basic criticism of these sources. The nineteenth-century publications I am referring to originated in a positivistic age, and to a large extent they were motivated by nationalistic considerations.[5] It goes without saying that the selection of the material that was published then was determined by contemporary knowledge of, and insights into, art-historical issues.

Alexandre Pinchart, for instance, published his *Archives des Arts, Sciences et Lettres, Documents Inédits*, in three volumes beginning in 1860.[6] This work is a considerably varied collection of notes on the arts, sciences, and literature, based on archival sources mainly housed in the Archives générales du Royaume/ Algemeen Rijksarchief in Brussels, which were published fragmentarily and often only as summaries. With Comte de Laborde, known particularly for *Les Ducs de Bourgogne . . . Preuves,* of 1851,[7] Pinchart shared an interest in the Burgundian court as well as an astonishing sloppiness. Their transcriptions bristle with misreadings, especially in abbreviations, names, dates, figures, and currencies.

The Bruges archivist Louis Gilliodts-van Severen published his monumental eight-volume *Inventaire des Archives de la ville de Bruges* between 1871 and 1885.[8] Both the title of this work and the general layout of the material amaze the modern-day user. The publication is not a comprehensive inventory of the Bruges archives but of all the municipal charters arranged by inventory number, which is basically chronological. After an elaborate summary of each document, the author discussed the content and supplied additional facts derived from his notes on other areas of the archives, such as

the municipal accounts. The work touches upon nearly every imaginable aspect of institutional, political, social, economic, religious, and cultural life in the medieval city, yet in a kaleidoscopic rather than a systematic fashion. That the information is extremely rich and is still a nearly inexhaustible source today for scholars interested in the history of Bruges are indisputable. However, the material supplied by the author is usually incomplete and his transcriptions, especially of the additional information, are fragmentary and seldom entirely correct.

Gilliodts-van Severen's rival, the famous British historian James Weale, who resided in Bruges between 1855 and 1878, worked very differently.[9] His interests were more focused and closer to those of the traditional art historian. His publications and also his notebooks amply demonstrate his systematic methodology. He uncovered numerous documents on Jan van Eyck, and reconstructed the biographies of Petrus Christus, Hans Memling, Gerard David, and many other fifteenth- and sixteenth-century Bruges artists,[10] but he never compiled a complete list of all the members of the Bruges corporation to which these painters belonged.[11] That was done in a rather disorderly fashion by Van de Casteele in 1866 and again, with greater reliability, by Vanden Haute in 1913.[12] Weale's transcriptions are usually much more accurate than those of many of his colleagues but, like them, he rarely mentioned the rubric or heading under which he discovered a particular entry, thus presenting it out of context. Moreover, although he was able to identify many important paintings and objects with documents, such as the *Moreel Triptych* by Hans Memling, the Rouen *Virgin among Virgins* by Gerard David, or the *Hierarchy of Angels* by Albert Cornelis,[13] as a connoisseur he was much less important than Waagen or, later, Hulin de Loo and Friedländer.[14]

Édmond de Busscher was the first archivist to collect documents on the arts in Ghent. His *Recherches sur les peintres gantois du XIVe et XVe siècles,* of 1859, is strange in many respects, as it concentrates on a wall painting of 1448 in the guild hall of the Ghent butchers, discovered a few years prior to the publication of his book. In a haphazard fashion, the author jumped from one topic to the other, such as the usage of oil paint before van Eyck or the training of artists, and proved his arguments in footnotes with excerpts from the Ghent archival sources. Nowhere else have so many fifteenth-century contracts between artists and patrons been preserved. It is this type of information especially that continues to make de Busscher worthwhile to consult; however, he also made extensive use of a membership list of the Ghent painters that would be revealed as an early-nineteenth-century forgery by his successor, Victor Van der Haeghen, in 1899. De Busscher is still quoted now and then by authors who seem to be unaware of the forged documents. This is due in part to the fact that Van der Haeghen's *Mémoire sur les documents faux relatifs aux peintres, sculpteurs et graveurs flamands*, published in Brussels in 1899, received much less attention by scholars outside Flanders. The considerable importance of his methodology—a landmark in the criticism of historical sources—has thus been overlooked. Van der Haeghen determined that the membership list was forged by applying intricate techniques of paleography and codicology to the suspicious document, even having the ink chemically analyzed. Considering the date of publication, 1899, his methods, arguments, and conclusions are surprisingly cogent, illustrating the enormous progress achieved in archival research during the last fifty years of the nineteenth century.

The inaccuracy and incompleteness of many nineteenth-century anthologies of sources are understandable. Numerous archives had not been organized systematically or made accessible when scholars like James Weale first consulted them. They had no idea how extensive the different collections of sources were, yet, with positivistic optimism, they strongly believed in the

comprehensiveness of their own endeavors. Most of all, these pioneers lacked the means of archival research we have at our disposal now. The frequency of spelling and transcription mistakes in their publications is not surprising. At the time of their investigations into the sources of Early Netherlandish art, the methods of paleography, codicology, chronology, historical topography, and linguistics were just being developed.[15] For instance, the first volume of the dictionary of Middle Netherlandish by Verwijs and Verdam first appeared in 1885 and the last volume (IX) not until 1929.[16] In other words, most archival sources pertaining to the study of Early Netherlandish art were published long before a basic reference work on the language used in these documents was available.

The examples of published nineteenth-century sources mentioned here can be used only as starting points, for it is absolutely essential to check the original documents in their entirety. When they are published, it must be according to the standard conventions laid out by organizations such as the Koninklijke Academie voor Wetenschappen, Letteren en Schone Kunsten van België.[17] This would include the date and summary contents of the excerpt followed by the accurate, full transcription of the heading and the entry, annotated where necessary using a double reference system of editorial remarks in the text and regular notes, and completed by the precise whereabouts of the document and references to older publications. It is of the greatest importance to be accurate in numerical data, units of measurements, and currencies, for these are the basis for comparison and quantification.

As our present historical knowledge is infinitely larger than when these archives were first explored, written sources need to be confronted continuously with the results of newer research. When it was discovered that Petrus Christus was a member of the confraternity of Onze Lieve Vrouw van de Droge Boom in Bruges, this was mentioned

as merely a *fait divers*.[18] In light of the current interest in the historical phenomenon of social relationships, this document enjoys more than just anecdotal status: Now it can be interpreted as an indication of upward mobility on the part of the artist and as a strategic attempt to contact a new social group of potential clients.[19]

Traditionally, when an artist is mentioned in such a list, the publication of the source is often restricted to his name and a folio reference. Nevertheless, it is usually rewarding to compare the entry with others. In the case of the confraternity of Onze Lieve Vrouw van de Droge Boom, it can be shown that Petrus Christus's example was followed by painters as well as goldsmiths and composers. By putting this information together with Richard Strohm's discovery that the confraternity played a prominent role in the introduction of polyphonic music to Bruges,[20] its cultural significance may be established more firmly.

Not only can the interpretation be refined but often it is also possible to extract more accurate factual information from documents that were published a long time ago. When republishing the membership list of the Bruges confraternity of Onze Lieve Vrouw van de Droge Boom, I distinguished different hands in the script.[21] Based on the biographical data of people included in the groups of entries written by each of the consecutive hands, I was able to determine a terminus post quem of September 5, 1458, and a terminus ante quem of May 1463 for Petrus Christus's entry into the confraternity. Thus, by applying chronological and paleographical techniques that transcend the mere deciphering of the texts, new information can be obtained.

Obviously, the same holds true for codicological expertise. In 1864, Rombouts and Van Lerius published the now-famous *Liggeren*, the registers of the Antwerp painters' corporation.[22] About one hundred years later, Carl Van de Velde demonstrated that the entries from the first eighty years cannot possibly be authentic[23] by showing

that the watermark in the paper used throughout the entire volume dates from about 1520 to 1530, that the introduction to the register (beginning on folio 1) was written by a clerk whose activity was still being recorded as late as 1561, and that folios 8*v.* to 88*v.* (the entries from 1453 to 1531) were written by the same hand in the same ink. In other words, all of these entries were copied from an older, now-lost list, and, consequently, as copies they have to be treated cautiously.

An especially close reading and the application of linguistics allow one to refine traditional interpretations. A few examples can be mentioned that argue the case. The 1465 contract between Dieric Bouts and the Leuven Broederschaf van het Heilig Sacrament for the *Last Supper Triptych* (Leuven, Sint-Pieterskerk) is probably one of the most famous documents pertaining to Early Netherlandish painting. A phrase often quoted from this contract is that Bouts was not allowed to take on any other commissions after having started to work on this triptych, however this is not what the document says. The sentence in question reads: "Ende is vorwerde dat de voirscreven meester dieric als hy dese tafele voirscreven begonst sal hebben gheen ander tafelwerc aennemen en sal voir dat dese voirscreven tafele volmaect zijn sal" (And upon the condition that the said master Dieric, when he will have started the said panel, will not take on any other work on panel, as long as the said panel is [not] finished).[24] "Gheen ander tafelwerc" means "no other work on panel."[25] This implies that Bouts was allowed to accept projects involving design but no other major commissions on panel.

In 1532, Guyot de Beaugrant, who shortly before had settled in Bilbao as an art dealer, commissioned no fewer than forty-one paintings on canvas from Adriaen Provost, Jan's son, to be supplied in four deliveries over a period of two years.[26] The details of the contract indicate that the works were intended for sale on the open market. Each

consignment consisted of five small diptychs with Saint Jerome, and five single works described as *Palerme*. The archivist Parmentier, who published the document in 1941, felt insecure about the reading of this last term, and speculated that the works may have been either portraits of Jean Carondelet, dean of the Bruges church of Saint-Donatien and Archbishop of Palermo, or scenes featuring the god Palaimon from the myth of Ino. Neither hypothesis is convincing. It is unlikely that there would have been a demand on the Bilbao art market for a large number of such paintings. To my mind, it is more likely that the enigmatic *Palerme* scenes were copies after Jan Gossaert's famous *Malvagna Altarpiece*, which most probably was commissioned by Carondelet and shipped to Palermo.[27] A number of copies by Adriaen Isenbrant of the central panel of this painting are still preserved today, which suggests that the composition must have had a certain popularity in Bruges. Again, a close reading of the contract in light of our current knowledge of copying practices in Bruges in the early sixteenth century offers a plausible explanation for a document that remained completely obscure only fifty years ago.

Gerard David's *Justice of Cambyses* (figs. 8, 9; Bruges, Groeningemuseum) is dated 1498 in an inscription. The artist had received the commission for this diptych by the end of 1487 or early in 1488, with the stipulation that he had to paint "den iugemente ende vonnesse ons liefs heeren." Most art historians interpreted the phrase in the document as specifying a Last Judgment, a traditional subject for a painting in a courtroom, although some even thought that this entry was unrelated to the preserved painting. A very fine example of a close reading was given recently by Geirnaert and Vandamme,[28] who translated the phrase in question as "the Judgment and verdict of our dear Lord." The two terms *iugemente* and *vonnesse* are not synonyms, as was generally thought, but refer to two different scenes: a Christ before Pilate (judgment) and an *Ecce Homo* (verdict) or a

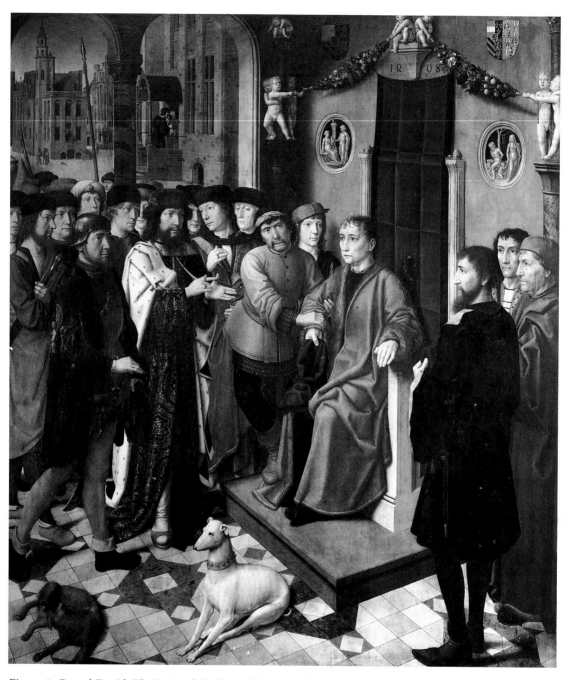

Figure 8. Gerard David. *The Justice of Cambyses: The Arrest of Sisamnes*. Groeningemuseum, Bruges (no. 0.40)

Early Netherlandish Painting at the Crossroads

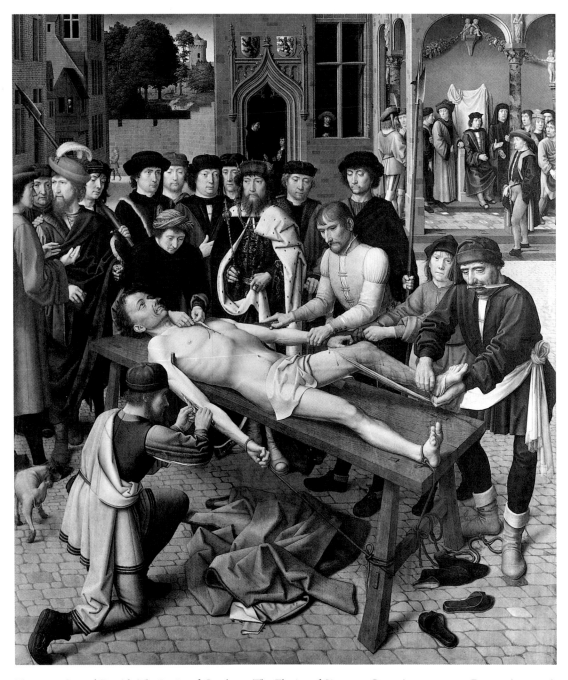

Figure 9. Gerard David. *The Justice of Cambyses: The Flaying of Sisamnes*. Groeningemuseum, Bruges (no. 0.40)

Crucifixion (execution of the verdict). In other words, the initial commission specified a diptych, meaning that the content and not the format was adjusted later due to political circumstances. Such pairs of terms, which at first seem to be redundant synonyms, are often found in Middle Netherlandish texts. Thorough scrutiny of a document usually results in a better understanding; this is certainly true of legal texts in which each word, as one might expect, was carefully chosen.

In addition to the application of paleographical, codicological, chronological, and linguistic techniques to the study of art-historical sources, historical statistics are gaining ground.[29] Methods of quantification have been applied to explorations of social and economic history since the end of the eighteenth century.[30] Initially employed in a positivistic attempt to approach historical material more objectively, these methods have proved useful mainly in unveiling certain phenomena and isolating specific tendencies in what Braudel called "l'histoire de longue durée," which had remained largely unnoticed by contemporaries.

As far as I know, the Louvain historian Jean-Pierre Sosson was the first to apply statistics on a source relevant to the history of Early Netherlandish art in his 1970 article "Une Approche des structures économiques d'un métier d'art: La corporation des Peintres et Selliers de Bruges."[31] Other social and economic historians with an interest in cultural history, such as Wim Blockmans and W. Brulez, have indicated the potential of their standard methods when adapted to our field.[32] However, it is mainly the writings of John Michael Montias, and their econometric methodology—applied recently, for example, to seventeenth-century Amsterdam inventories[33]—that have been most inspiring to a few art historians like myself, who have moved gradually toward interpreting art production in socio-economic terms.

Nevertheless, quantification of art-historical sources, and even more so of art objects, is received with much skepticism.

Although these methods are widely accepted in other fields in the humanities, such as linguistics, art objects are still regarded with too much of a romantic aura to reduce their study to mere numbers. Of course, we are dealing mostly with small numbers—that is, with the problematic issue of survival rate[34]—and calculations of statistics do expunge qualitative factors, but this does not exclude the possibility of attaining results that are numerically relevant. It is only by formulating new questions, and experimenting with statistical methods in attempting to answer them, that a methodological discussion can take place. If we ignore this approach, we miss the opportunity of studying important issues like the migration and movement of artists; fluctuations in artists' wages and prices of works of art; the social stratification and mobility of artists, dealers, and buyers; the nature of artistic centers; and much more.

A traditional critique of historical statistics is that ancien régime sources are used, which were not drawn up initially for statistical purposes.[35] By extension, this criticism holds true for all archival sources, which were never compiled to serve as witnesses to history but resulted from administrative and/or juridical procedures (accountancy, tax collection, legalization of contracts, household inventories drawn up for the purpose of wills, and court verdicts). An entry from the 1491 Bruges municipal accounts, yet another document related to Gerard David's *Justice of Cambyses* (figs. 8, 9) ought to clarify this point. It states: "Item betaelt Willem Hanic een vande tresoriers vande stede van Brugghe de somme van 2 lb. grooten omme daer mede te betaelne Gheraerdt David, schildre, ter cause van zekere schilderye by hem ghemaect in scepencamere" (Also paid [to] Willem Hanic, one of the treasurers of the city of Bruges, the sum of 2 pounds of groats to pay Gheraerdt David, painter, for [a] certain painting made by him in the aldermen's room).[36] The clerk has registered an expense of two pounds of groats (the standard currency of account in Flanders at that time) in

the municipal accounts. The sum was paid out to one of the city's treasurers who, as a representative of the financial administration of the Bruges city government, had to pay the painter Gerard David. It is not clear to which work the phrase "a certain painting" refers, yet the opinions are almost unanimous: it must be the *Cambyses* diptych.[37] However, this cannot be concluded from the entry, from which we learn only that the painting was made by Gerard David, and that it was located in the aldermen's room in the city hall. From the phrasing of the document—and relying on the past tense of the verb—one would think that the painting was completed and in place at that time ("made by him in the aldermen's room"), but this is contradictory to the date *1498* inscribed on the diptych. While many authors interpret the document as if it says "being made by him *for* the aldermen's room," this is not a literal translation. The phrasing allows for a looser interpretation: Perhaps the clerk meant to say that David made the painting *in situ* (thus, it was "made by him *in* the aldermen's room")—but, again, this seems unlikely, as we know now from technical research that the *Cambyses* paintings underwent serious modifications and cannot have been finished at that time. The reading of the phrase as "meant for the aldermen's room," which most art historians seem to favor, is rather far removed from the literal meaning. Whether the payment was final and total or partial is not clear from this document either. The fact is that the first interpretation is closest to the actual phrasing of the document, although we do know that David did not receive final payment for the *Cambyses* pictures until seven years later.

In other words, to relate this document to David's *Cambyses*, as nearly every scholar does, is a matter of speculation, deviating entirely from the literal sense of the phrasing. However, when other contextual evidence is taken into account, this interpretation is sound and obvious—which proves the point that the entry was not drawn up as a historical

witness. Like most archival sources, it remains terribly vague and ambiguous and it does not offer us the kind of information we really need. Nevertheless, it is the only information that we have, and, in comparison to other commissions of Early Netherlandish art, this is one of the best-documented cases.[38] Moreover, the archival entry is meaningful only when interpreted correctly, but this depends on a thorough knowledge of how institutions organize their archives.

Here, the critical methods used to interpret historical sources offer assistance. In the case of all historical sources—not only archival texts—external and internal criticism must be applied.[39] The external approach questions the authenticity of the source (criticism of the text) as well as its authorship, date, and localization, and whether or not the author was an original witness (criticism of the origin); the internal approach seeks the meaning (criticism of the interpretation), the authority, validity, and qualifications of the author as a witness (criticism of authority and qualifications), as well as his or her willingness or permissibility to have acted as witness (criticism of the orthodoxy). As the following examples will demonstrate, a combination of these critical approaches—all of which are based upon the rules of formal logic and probability—nearly always is applied when analyzing a source.

Criticism of the text is concerned with the original format and phrasing. If an original is unavailable, an archetype is established by examining existing copies—that is, determining the affiliation of these copies to the lost original by comparing their degree of concordance, and subsequently constructing a stemma, or tree, incorporating the variations.[40] Of course, the main purpose of this exercise is to eliminate mistakes, which are inherent in making copies, although the copies themselves may reveal information. Therefore, it might be useful to check the different copies and versions, even if an original text is available. Contemporary copies of the Bruges municipal accounts were made for verification

by the central Chambre des Comptes,[41] and are preserved in the Archives générales du Royaume/Algemeen Rijksarchief in Brussels. Only Hugo van der Velden bothered to check the Brussels copies against the original Bruges entries relating to Gerard David, and, in his 1995 article, demonstrated that, indeed, even the slightest variance in wording may affect our interpretation.[42] In the original 1487 document of payment, Gerard David's name was added by a contemporary hand, but in the Brussels copy his name does not appear, which means that the addition of his name to the Bruges version was made only after the copy had been inspected by the central Chambre des Comptes. Why this was the case remains a matter of speculation.

Certainly, when interpreting texts known only from copies, the greatest caution is required. Here, I will reopen one of the oldest discussions in art history: the mysterious wine offered to Rogier van der Weyden. On November 17, 1426, "maistre Rogier de le Pasture" received wine from the city of Tournai.[43] Less than four months later, on March 5, 1427, *Rogelet de le Pasture* ("little Roger") began his apprenticeship in the studio of Robert Campin.[44] On August 1, 1432, "Maistre Rogier de le Pasture" received the title of "free master" in the Tournai painters' corporation.[45] Many possible arguments have been offered to explain how a master honored by his native city only four months later becomes a little boy again and begins his apprenticeship. I am not about to recount the entire historiography of the dilemma; this was done most recently by Elisabeth Dhanens in her 1995 discussion of the van der Weyden documents.[46] There are two opposing factions in the interpretation of these data:[47] The first claims that the names cited in the documents are homonyms, and belong to unrelated persons; a second hypothesis—Panofsky's—argues that Rogier van der Weyden's apprenticeship was not a regular one, but, having returned to his native city, he would have had to be enrolled for a number of years as a pupil *de jure*, to fulfill the requirements of the painters' corporation.[48] The problem with the second interpretation is that the issue of corporate requirements originated with Panofsky, and is not based on any documented practice of such institutions. The presumption of homonyms provides an even less satisfying answer, for it does not explain why a man of twenty-seven or twenty-eight years of age— we know that van der Weyden was born in 1399[49]—was called "little Roger," and served as an apprentice so late in his career. Equally implausible is the possibility that the famous painter was the one who received the wine, and that his namesake was the one who learned his art from Robert Campin, only to vanish into oblivion afterward. In the latter case, Rogier would not have been related to Campin, which would then imply that the identification of the "Master of Flémalle" with Campin is equally untenable.[50]

As early as 1867, when Pinchart published the so-called 1427 and 1432 documents, he stated explicitly that they were not originals but copies dating to about 1482.[51] While many later authors pointed this out also, only Dhanens addressed that fact in her 1995 publication.[52] That the phrasing in the so-called 1427 document does not reflect the original is all too obvious; it reads: "Rogelet de le Pasture, natif de Tournay, commencha son apresure le cinquiesme jour de mars l'an mil CCCC vingt six et fut son maistre, maistre Robert Campin, paintre. Lequel Rogelet a parfait son apresure deuement avec son dit maistre"[53] (Little Roger de le Pasture, born in Tournai, commenced his apprenticeship on the 5th day of March in the year 1426 [1427 n.s.][54] and his master was, master Robert Campin, painter. This little Roger has duly fulfilled his apprenticeship with his said master). That the clerk knew that the apprenticeship was "duly fulfilled" proves that the notation was not written down at the earliest date cited. Dhanens concluded that documents compiled about 1482 were not faithful copies of the original, lost entries, but consisted of selected facts, assembled in the context of

the new, stricter statutes established in 1480 by the Tournai painters. Unfortunately, after these astute remarks, Dhanens constructed a "house of cards," situating Rogier in the studio of no less a master than Hubert van Eyck in Ghent. I will return to that hypothesis at another time, and restrict myself here to the observation that even Dhanens, fully aware that the documents were copies, did not draw the most obvious conclusion from them: that errors might very well have been introduced in the copying process, with the date of apprenticeship the likeliest place for such an error to have been made.

Mil CCCC vingt six may have been written in the original as *.m.cccc.xxuj.* (or *.m.iiij^c.xxuj*), or perhaps *.m.cccc.xxiij* (or *.m.iiij^c.xxiij*) — 1423 — and *.iij.* could have been misread as *.uj.* It is also possible that an *.x.* was added by mistake, and that the original read *.m.cccc.xuj.* (1416) or even *.m.cccc.xiij.* (1413). Each of these dates could have been written out by an inattentive clerk as *vingt six*, the difference in the roman numerals involving the sloppy transcription of only one or two ligatures in a split second of distraction.

I am not proposing this as the solution to the problem; on the contrary, it offers only a partial explanation. I am just stating that, in interpreting copied documents, the probability of recognizing discrepancies as ordinary minute copying mistakes is much higher than regarding them as exceptions to institutional practice.

The hypothesis that Rogier would have been registered at an older age as an apprentice *de jure* represents an *argumentum ex silentio*,[55] postulating that an event occurred although no facts are available. The *argumentum ex silentio* is an especially useful method of interpreting sources where the very lack of information might be significant — when, for example, the silence might have been motivated by force or by moral considerations. The greater the likelihood there is of a document being lost, the less certain that a deduction may result from the *argumentum ex silentio*. Thus, it should not be applied. As mentioned,

Dhanens has shown that the Tournai corporative regulations were made stricter in 1480 and that the older rules were, indeed, lost; therefore, the *argumentum ex silentio* has no value in this case. Some authors have tried to interpret the document in light of the later regulations.[56] This type of argumentation is anachronistic, and a positive result is unlikely. As the regulations were made stricter, some practices or abuses were no longer acceptable.

In certain cities, one who learned his trade elsewhere could buy the title of master, just as if he had been apprenticed to a local master.[57] Concerning the hypothesis of Rogier's apprenticeship *de jure*, an exceptional regulation was introduced into the argument for which there are neither analogies nor precedents. Therefore, this type of reasoning, too, has no historical foundation.

The hypothesis based on homonyms is also improbable because of the unique nature of the postulated phenomenon itself. The acknowledgment of transcription errors in a copied document remains the best interpretation, as it is standard methodology for a document of this type. Perhaps in the future an acceptable solution may be found, but it is also possible that a combination of conscious text manipulation (as suggested by Dhanens), the occurrence of unconscious copying mistakes, as well as the lack of sources to confirm one or the other of these explanations make the question too obscure to solve. I believe it is better to recognize that there are certain limitations to historical knowledge than to support unfounded hypotheses that are given the status of fact by the authority of their authors.

I have tried to demonstrate that it is necessary to check original documents, to publish them according to accepted conventions, and to interpret them by strictly applying the methods of historical criticism. These methods also offer enormous possibilities for the interpretation of types of heuristic material other than archival sources. Although, for more than a century, text criticism has been carried out by literary historians who deal

with copies of these texts, and their methodology has been refined continuously, to my knowledge this approach has never been applied rigorously by art historians in interpreting copies or reproductions of objects.

Furthermore, the interpretation of technical documents is analogous to the deciphering of texts. When the authenticity of an object is determined, or the different phases in its creation are reconstructed with the aid of infrared reflectography, X-rays, and paint samples, the lines of reasoning are almost identical to those employed by historians when citing documents to establish a historical argument. This is logical, because archives, objects, and technical documentation are all primary heuristic sources.

When archival and technical research balance each other out, the result is an unrivaled degree of historical certainty. However, when they seem to conflict, there is a deadlock. The study of the famous quatrain on the Ghent Altarpiece together with the related documents proves almost certainly that Hubert van Eyck must have had a part in the achievement.[58] Up to now, his presumed role has remained indiscernible, even when the results of technical investigations are taken into account.[59] Such an impasse can be bridged only by employing the methods used to interpret both archival and technical material.

1. See M. Halbertsma and K. Zijlmans, eds., *Gezichtspunten: een inleiding in de methoden van de kunstgeschiedenis* (Nijmegen: 1993).

2. I do not intend here to offer a comprehensive survey of archival studies and art-historical research into Early Netherlandish art or to be normative, but simply to present some of my personal views on the issues involved. Therefore, I find it inappropriate to list references to the work of colleagues. Criticizing their reliance upon nineteenth-century published sources would not reflect the esteem I have for other aspects of their work.

3. Corrected by J. Duverger, "Brugse schilders ten tijde van Jan van Eyck," in *Musées royaux des Beaux-Arts Bulletin/Koninklijke Musea voor Schone Kunsten (Miscellanea Erwin Panofsky)* 4 (1955), p. 95.

4. Corrected by E. Dhanens, "De kwartierstaat en het graf van Jan van Eyck," in *Mededelingen van de*

Koninklijke Academie voor Wetenschappen, Letteren en Schone Kunsten van België, Klasse der Schone Kunsten 39, 4 (1977), pp. 39–43.

5. For the ideological background of nineteenth-century Belgian historians see, among others, J. Tollebeek, *De ijkmeesters. Opstellen over de geschiedschrijving in Nederland en België* (Amsterdam: 1994), as well as more specific contributions by the same author, as, for example, on the situation in Ghent: J. Tollebeek, "De *Messager* en de Maatschappij: Over geschiedbeschouwing te Gent, 1870–1914," in *Handelingen der Maatschappij voor Geschiedenis en Oudheidkunde te Gent* 52 (1998), pp. 107–32.

6. See A. Pinchart, *Archives des Arts, Sciences et Lettres, Documents Inédits,* 3 vols. (Ghent: 1860–81).

7. See L. de Laborde, *Les Ducs de Bourgogne. Études sur les lettres, les arts et l'industrie pendant le XVe siècle, Preuves,* 3 vols. (Paris: 1851). In 1861, Weale already had pointed this out in his *Notes sur Jean van Eyck. Réfutation des erreurs de M. l'abbé Carton et des théories de M. le comte de Laborde, suivies de nouveaux documents découverts dans les archives de Bruges, Londres, Bruxelles et Leipzig* (n.p. 1861), cited by L. Van Biervliet, *Leven en Werk van W. H. James Weale, een Engels kunsthistoricus in Vlaanderen in de 19de eeuw* (Verhandelingen van de Koninklijke Academie voor Wetenschappen, Letteren en Schone Kunsten van België, Klasse der Schone Kunsten 55) (Brussels: 1991), pp. 139, 189.

8. See L. Gilliodts-van Severen, *Inventaire des Archives de la ville de Bruges,* 8 vols. (Bruges: 1871–85). See also the remarks by N. Geirnaert in the present volume.

9. On James Weale see L. Van Biervliet, *Leven en Werk van W. H. James Weale, een Engels kunsthistoricus in Vlaanderen in de 19de eeuw* (Verhandelingen van de Koninklijke Academie voor Wetenschappen, Letteren en Schone Kunsten van België, Klasse der Schone Kunsten 55) (Brussels: 1991).

10. He published his archival research on van Eyck in W. H. J. Weale, *Hubert and John van Eyck, Their Life and Work* (London: 1908). For his work on Petrus Christus see W. H. J. Weale, "Pierre et Sébastien Christus," in *Le Beffroi* 1 (1863), pp. 235–42, and W. H. J. Weale, "Peintres brugeois: les Christus," in *Annales de la Société d'Émulation de Bruges* 59 (1909), pp. 97–120; on Hans Memling see W. H. J. Weale, "Documents authentiques concernant la vie, la famille et la position sociale de Jean Memlinc découverts à Bruges," in *Journal des Beaux-Arts* 3 (1861), pp. 21–28, 34–36, 45–49, 53–55, 196; on Gerard David see W. H. J. Weale, "Gérard David," in *Le Beffroi* 1 (1863), pp. 223–34, W. H. J. Weale, "Gérard David," in *Le Beffroi* 2 (1864–65), pp. 293–94, and W. H. J. Weale, "Gérard David: sa vie et ses œuvres authentiques," in *Gazette des Beaux-Arts* 20 (1866), pp. 542–53, and *Gazette des Beaux-Arts* 21 (1866), pp. 489–501.

11. Noted by L. Van Biervliet, *Leven en Werk van W. H. James Weale, een Engels kunsthistoricus in Vlaanderen in*

de 19^{de} eeuw (Verhandelingen van de Koninklijke
Academie voor Wetenschappen, Letteren en Schone
Kunsten van België, Klasse der Schone Kunste 55)
(Brussels: 1991), p. 168.

12. See D. Van de Casteele, "Documents divers de la
société S. Luc à Bruges," in *Annales de la Société
d'Émulation de Bruges*, 2nd series, 18 (1866), pp. 1–438;
C. Vanden Haute, *La Corporation des peintres de Bruges*
(Kortrijk: n.d. [1913]).

13. See W. H. J. Weale, "Généalogie de la Famille Moreel,"
in *Le Beffroi* 2 (1864–65), pp. 179–96; W. H. J. Weale,
"Gérard David," in *Le Beffroi* 1 (1863), pp. 223–34;
W. H. J. Weale, "Albert Cornelisz. Hiérarchie des
Anges," in *Le Beffroi* 1 (1863), pp. 1–22.

14. On their respective historiographical importance
see B. Ridderbos, "Van Waagen tot Friedländer: het
kunsthistorisch onderzoek naar de Oudnederlandsche
schilderkunst gedurende de negentiende en het begin
van de twintigste eeuw," in B. Ridderbos and H. van
Veen, eds., *"Om iets te weten van de oude meesters": De
Vlaamse primitieven—herontdekking, waardering, en
onderzoek* (Nijmegen: 1995), pp. 189–235.

15. For a survey of recent developments in these disci-
plines see the bibliography in W. Prevenier, *Uit goede
bron: introductie tot de historische kritiek*, 4th rev. ed.
(Leuven: 1995) and in L. F. Genicot, *Introduction aux
sciences auxiliaires traditionnelles de l'histoire de l'art:
diplomatique, héraldique, épigraphie, sigillographie,
chronologie, paléographie* (Louvain-la-Neuve: 1984).

16. See E. Verwijs and J. Verdam, *Middelnederlandsch woord-
enboek*, 9 vols. (The Hague: 1895–1929); a reference
work in one volume appeared in 1911. See J. Verdam,
Middelnederlandsch Handwoordenboek, 2nd ed. (The
Hague: 1932; anastatic reprint, 1981).

17. For texts in Middle Netherlandish and Dutch see
Nederlands Historisch Genootschap, *Richtlijnen voor het
uitgeven van historische bescheiden samengesteld in opdracht
van het Nederlands Historisch Genootschap en van de
Rijkscommissie voor Vaderlandse Geschiedenis*, 6th rev. ed.
(The Hague: 1988), or Koninklijke Commissie voor
Geschiedenis, *Voorschriften voor het uitgeven van his-
torische teksten en van de Akten der Belgische vorsten*
(Brussels: Koninklijke Belgische Academie, 1940).

18. See W. H. J. Weale, "Pierre et Sébastien Christus," in
Le Beffroi 1 (1863), p. 237.

19. See M. W. Ainsworth and M. P. J. Martens, *Petrus
Christus: Renaissance Master of Bruges* (exhib. cat., New
York, The Metropolitan Museum of Art) (New York:
1994), p. 16. On social networks in the Burgundian
era see W. Prevenier, ed., *Prinsen en Poorters: beelden
van de laat-middeleeuwse samenleving in de Bourgondische
Nederlanden, 1384–1530* (Antwerp: 1998); on the role
of confraternities in Flemish social life see P. Trio,
Volksreligie als spiegel van een stedelijke samenleving
(Symbolae Facultatis Litterarum et Philosophiae
Lovaniensis, Series B), vol. 11 (Leuven: 1993).

20. See R. Strohm, *Music in Late Medieval Bruges* (Oxford,
England: 1983).

21. See M. W. Ainsworth and M. P. J. Martens, *Petrus
Christus: Renaissance Master of Bruges* (exhib. cat.,
New York, The Metropolitan Museum of Art) (New
York: 1994), pp. 20, 197–98 (doc. 8).

22. See Ph. Rombouts and Th. Van Lerius, *De Liggeren
en andere Historische Archieven der Antwerpsche Sint
Lucasgilde*, 2 vols. (Antwerp: 1864).

23. See C. Van de Velde, "De Schilderkunst," in *Antwerpen
in de XVI^e eeuw* (Antwerp: 1975), pp. 420–21.

24. The original document is lost; it is quoted here as
transcribed by E. Van Even, "Le Contrat pour
l'exécution du triptyque de Thierry Bouts à la
collégiale Saint-Pierre à Louvain (1464)," in *Bulletin
de l'Académie royale des Sciences, des Lettres et des
Beaux-Arts de Belgique* 68 (1898), pp. 469–78; and
W. Schöne, *Dieric Bouts und seine Schule* (Berlin
and Leipzig: 1938), p. 240 (doc. 55).

25. See M. P. J. Martens, "Het onderzoek naar de
opdrachtgevers," in B. Ridderbos and H. van Veen,
eds., *"Om iets te weten van de oude meesters": De
Vlaamse primitieven—herontdekking, waardering, en
onderzoek* (Nijmegen: 1995), p. 368. See J. Verdam,
Middelnederlandsch Handwoordenboek, 2nd ed. (The
Hague: 1932; anastatic reprint, 1981), p. 594, i.v. *tafel*.

26. This document was first published by R. A. Parmen-
tier, "Bronnen voor de geschiedenis van het Brugse
schildersmilieu in de XVIe eeuw. XX. Adriaan
Provoost," in *Belgisch tijdschrift voor Oudheidkunde en
Kunstgeschiedenis* 11 (1941), p. 114; for a full discussion
see M. P. J. Martens, "The Dialogue between Artistic
Tradition and Renewal," in M. P. J. Martens, ed., *Bruges
and the Renaissance: Memling to Pourbus* (exhib. cat.,
Bruges, Memlingmuseum) (Ghent: 1998), pp. 53–54.

27. See H. Pauwels, H. R. Hoetink, and S. Herzog, *Jan
Gossaert genaamd Mabuse* (exhib. cat., Rotterdam,
Museum Boymans-van Beuningen, and Bruges,
Groeningemuseum) (Rotterdam: 1965), p. 104. The
recorded provenance of this painting only goes as far
back as the Prince of Malvagna's collection, from
which it was acquired in 1600; M. J. Friedländer, *Early
Netherlandish Painting, 8: Jan Gossart and Bernart van
Orley*, with comments and notes by H. Pauwels and
S. Herzog, trans. from the German by H. Norden
(Leiden: 1972), no. 2, pp. 17–18, 90.

28. See N. Geirnaert and L. Vandamme, "Culture and
Mentality," in M. P. J. Martens, ed., *Bruges and the
Renaissance: Memling to Pourbus* (exhib. cat., Bruges,
Memlingmuseum) (Ghent: 1998), pp. 33–34. See
also M. W. Ainsworth, "The Mocking of Christ:
A Hitherto Unknown Painting by Gerard David,"
Staedel Jahrbuch 16 (1997), pp. 159–70.

29. See, for example, J. C. Wilson, "The Participation
of Painters in the Bruges 'Pandt' Market," in *The
Burlington Magazine* 125, 964 (1983), pp. 476–79;
D. Ewing, "Marketing Art in Antwerp, 1460–1560:
Our Lady's *Pand*," in *The Art Bulletin* 72, 4 (1990),
pp. 558–84; M. P. J. Martens, "Hans Memling
and his Patrons: A Cliometrical Approach," in

H. Verougstraete, R. van Schoute, and M. Smeyers, eds., *Memling Studies. Proceedings of the International Colloquium, Bruges, 10–12 November 1994* (Leuven: 1997), pp. 35–42; M. P. J. Martens, "Some Aspects of the Origins of the Art Market in 15th-century Bruges," in M. North and D. Ormrod, eds., *Art Markets in Europe, 1400–1800* (Aldershot, England; Brookfield, Vermont; and Singapore: 1998), pp. 19–27; M. P. J. Martens, "The Position of the Artist in the 15th century: Salaries and Social Mobility," in W. P. Blockmans and A. Janse, eds., *Showing Status* (Turnhout, Belgium: 1999), pp. 387–414.

30. See W. Prevenier, *Uit goede bron: introductie tot de historische kritiek*, 4th rev. ed. (Leuven: 1995), p. 67.

31. See J.-P. Sosson, "Une Approche des structures économiques d'un métier d'art: La corporation des Peintres et Selliers de Bruges (XVe–XVIe siècles)," in *Revue des archéologues et historiens d'art de Louvain* 3 (1970), pp. 91–100.

32. See, for example, W. P. Blockmans, "The Creative Environment: Incentives to and Functions of Bruges Art Production," in M. W. Ainsworth, ed., *Petrus Christus in Renaissance Bruges: An Interdisciplinary Approach* (New York: 1995), pp. 11–20; W. P. Blockmans, "The Social and Economic Context of Investment in Art in Flanders around 1400," in M. Smeyers and B. Cardon, eds., *Flanders in a European Perspective: Manuscript Illumination around 1400 in Flanders and Abroad: Proceedings of the International Colloquium, Leuven, 7–10 September 1993* (Leuven: 1995), pp. 711–20; W. Brulez, *Cultuur en Getal. Aspecten van de relatie economie-maatschappij-cultuur in Europa tussen 1400 en 1800* (Amsterdam: 1986). For more general information on historical statistics see, among others, J. Th. Lindblad, *Statistiek voor historici* (Muiderberg, The Netherlands: 1984); and K. Jarausch and K. Hardy, *Quantitative Methods for Historians* (Chapel Hill: 1991); and the Web site http://www.leidenuniv.nl/history/res/stat/html/statistiek.html.

33. See J. M. Montias, "Quantitative Methods in the Analysis of 17th Century Dutch Inventories," in V. A. Ginsburgh and P.-M. Menger, eds., *Economics of Art. Selected Essays* (Contributions to Economic Analysis 237) (Amsterdam: 1996), pp. 1–26.

34. For the survival rate in the later period see A. van der Woude, "The Volume and Value of Paintings in Holland at the Time of the Dutch Republic," in D. Freedberg and J. de Vries, eds., *Art in History, History in Art: Studies in Seventeenth-Century Dutch Culture* (Santa Monica: 1991), pp. 285–329.

35. See W. Prevenier, *Uit goede bron: introductie tot de historische kritiek*, 4th rev. ed. (Leuven: 1995), pp. 65–66.

36. This text recently was discussed by H. J. Van Miegroet, *Gerard David* (Antwerp: 1989), pp. 145, 335 (doc. 5); H. van der Velden, "Cambyses Reconsidered: Gerard David's *exemplum iustitiae* for Bruges Town Hall," in *Simiolus* 23, 1 (1995), pp. 40–62; M. W. Ainsworth,

Gerard David, Purity of Vision in an Age of Transition (New York: 1998), pp. 60–61.

37. Among the exceptions are H. van der Velden, "Cambyses Reconsidered: Gerard David's *exemplum iustitiae* for Bruges Town Hall," in *Simiolus* 23, 1 (1995), pp. 40–62.

38. Compare J. Folie, "Les Oeuvres authentifiés des primitifs flamands," in *Bulletin Koninklijk Instituut voor het Kunstpatrimonium* 6 (1963), pp. 183–256.

39. On these methods, I am paraphrasing here the textbook by W. Prevenier, *Uit goede bron: introductie tot de historische kritiek*, 4th rev. ed. (Leuven: 1995), pp. 80–102. In comparison to E. I. Strubbe, *Inleiding tot de Historische Critiek* (Antwerp: 1954), pp. 54–70, the critical survey by Prevenier reflects extremely well how intensively methodological thought has developed among historians, philologists, and epistemological philosophers during the last decades.

40. See W. Prevenier, *Uit goede bron: introductie tot de historische kritiek*, 4th rev. ed. (Leuven: 1995), pp. 80–89.

41. See A. Vandewalle, *Beknopte inventaris van het stadsarchief van Brugge, I: Oud Archief* (Bruges: 1979), p. 100.

42. See H. van der Velden, "Cambyses Reconsidered: Gerard David's *exemplum iustitiae* for Bruges Town Hall," in *Simiolus* 23, 1 (1995), p. 46.

43. See E. Dhanens, *Rogier van der Weyden: Revisie van de documenten* (Verhandelingen van de Koninklijke Academie voor Wetenschappen, Letteren en Schone Kunsten van België, Klasse der Schone Kunsten 57/59) (Brussels: 1995), pp. 46, 97.

44. Ibid., pp. 40–43, 123–24.

45. Ibid.

46. Ibid.

47. Two divergent hypotheses also were distinguished by J.-P. Sosson, "Les Années de formation de Rogier van der Weyden (1399/1400–1435: relecture des documents)," in D. Hollanders-Favart and R. van Schoute, eds., *Le Dessin sous-jacent dans la peinture. Colloque III, 1979* (Louvain-la-Neuve: 1981), pp. 37–42.

48. E. Panofsky, *Early Netherlandish Painting: Its Origins and Character*, 2 vols. (Cambridge, Massachusetts: 1953), pp. 155–57.

49. See E. Dhanens, *Rogier van der Weyden: Revisie van de documenten* (Verhandelingen van de Koninklijke Academie voor Wetenschappen, Letteren en Schone Kunsten van België, Klasse der Schone Kunsten 57/59) (Brussels: 1995), p. 33.

50. This identification was first proposed by G. Hulin de Loo, "An Authentic Work by Jacques Daret, Painted in 1434," in *The Burlington Magazine* 15 (1909), p. 208, and has been accepted by many but not all scholars. The titles of the most recent publications dealing with the Flémalle/Campin group aptly highlight the current confusion.

51. See A. Pinchart, "Roger de le Pasture, dit van der Weyden," in *Bulletin des Commissions d'art et d'archéologie* 6 (1867), p. 423.

52. See E. Dhanens, *Rogier van der Weyden: Revisie van de documenten* (Verhandelingen van de Koninklijke Academie voor Wetenschappen, Letteren en Schone Kunsten van België, Klasse der Schone Kunsten 57/59) (Brussels: 1995), pp. 40–43.

53. The original document is lost; quoted from E. Dhanens, *Rogier van der Weyden: Revisie van de documenten* (Verhandelingen van de Koninklijke Academie voor Wetenschappen, Letteren en Schone Kunsten van België, Klasse der Schone Kunsten 57/59) (Brussels: 1995), pp. 123–24.

54. As the Easter style is used here for the date, it has to be converted; see E. I. Strubbe and L. Voet, *De Chronologie van de Middeleeuwen en de Moderne Tijden in de Nederlanden* (Antwerp and Amsterdam: 1960), pp. 55–58.

55. See W. Prevenier, *Uit goede bron: introductie tot de historische kritiek*, 4th rev. ed. (Leuven: 1995), pp. 111–12.

56. See, especially, Th. H. Feder, "A Reexamination through Documents of the First Fifty Years of Roger van der Weyden's Life," in *The Art Bulletin* 48, 1 (1966), pp. 416–31.

57. See, for example, A. Schouteet, *De Vlaamse Primitieven te Brugge. Bronnen voor de schilderkunst te Brugge tot de dood van Gerard David* (Fontes Historiae Artis Neerlandicae, Koninklijke Academie voor Wetenschappen, Letteren en Schone Kunsten van België 2/1) (Brussels: 1989), p. 10.

58. See J. Duverger, *Het Grafschrift van Hubert van Eyck en het Quatrain van het Gentsche Lam Gods Retabel* (Koninklijke Vlaamse Academie voor Wetenschappen, Letteren en Schone Kunsten, Klasse der Schone Kunsten 7/4) (Antwerp and Utrecht: 1945).

59. See J. R. J. Van Asperen de Boer, "A Scientific Re-examination of the Ghent Altarpiece," in *Oud Holland* 93, 3 (1979), pp. 141–214.

Noël Geirnaert

Commentary: Some Experiences of an Archivist in Bruges

My response, which is intended as a reaction and supplement to Max Martens's contribution to this volume, is based on my knowledge of the situation in Bruges. Each art historian concerned with the study of the city's medieval history is confronted with the work of the nineteenth-century Bruges archivist Louis Gilliodts-van Severen (1827–1915), who remained active in his field up to his death.[1] Max Martens already has mentioned Gilliodts-van Severen's *Inventaire des Archives de la ville de Bruges,* which, together with the indicia of Édouard Gaillard, comprises nine monumental volumes, published from 1871 until 1885. I am in complete agreement with Martens's remarks about this work, and I believe that it is so important that a description bears repeating: The *Inventaire des Archives* presents in great detail and in chronological order the holdings of the Politieke oorkonden, eerste reeks (the municipal charter collection) for the years up to and including 1500. The collection is supplemented with much additional information from other archival sources, especially from the municipal accounts. Almost all aspects of town life in medieval Bruges are mentioned, and this information has been made easily accessible by Édouard Gaillard.

Yet, Gilliodts-van Severen's work is not exhaustive, and his data must be checked against the original documents. In addition to this *Inventaire*, he published several editions of his texts, such as the *Cartulaire de l'ancienne Estaple de Bruges* and the *Mémoriaux de Bruges*; these consist of multiple volumes and are considerably less accessible. The transcriptions are not as carefully prepared as those of the *Inventaire*, and the source materials cited in these publications definitely must be verified with the original documents.

By comparison, James Weale's work, as Martens has already noted, is more reliable and systematic. Scholars still refer regularly to his results. Two of Gilliodts-van Severen's successors in the twentieth century, Remi Parmentier (1895–1960) and Albert Schouteet (1909–1991), have made important contributions to the field by publishing complete documents concerning the Bruges painters of the fifteenth and sixteenth centuries. From 1938 until 1955, Parmentier published thirty-seven articles in his series "Bronnen voor de geschiedenis van het Brugse schildersmilieu in de XVIde eeuw," in *Belgisch Tijdschrift voor Kunstgeschiedenis.*[2] Schouteet continued the efforts of his predecessor, publishing another twenty-two articles in the same series,[3] as well as fifteen additional articles in the Bruges *Handelingen van het Genootschap voor Geschiedenis.* The culmination of this work was Schouteet's *De Vlaamse Primitieven te Brugge. Bronnen voor de schilderkunst te Brugge tot de dood van Gerard David*, only one volume of which was published—in 1989—but as early as 1913, Charles Vanden Haute, archivist of the Rijksarchief in Bruges, had published the principal documents in the archives of the painters' corporation.[4]

The main function of the archivist is to make the archives in his care accessible for scholarly research; therefore, a publication

similar to that by Vanden Haute still remains the archivist's responsibility, despite its more up-to-date form. In 1993, the present chief archivist of Bruges, André Vandewalle, produced such a publication concerning the Bruges corporation of silversmiths.[5] Yet, works like those by Schouteet and Parmentier cannot be expected from the present generation of archivists. One reason is that nowadays when most art historians publish a monograph about a specific painter or group of works, they also publish an edition of the documents pertinent to that painter or to the works, making redundant a duplicate effort on the part of archivists. The main reason, however, is that an archivist is no longer expected merely to find and publish isolated documents; his primary task is to aid the scholar in locating available source materials and to help in the interpretation of these sources within the proper historical and social context.

Archival research into Early Netherlandish painting in the Low Countries, especially in Bruges, may provide answers to rather straightforward questions about one painter or a group of painters, as well as information concerning the genesis of a work of art, the patrons or the original function of one or several works of art, or its later history and ownership. It is the particular role of the archivist, with his specialized knowledge of the sources, to make the art historian aware of new and unexpected areas of inquiry. Public archives both in Belgium and the Netherlands provide general surveys of their holdings,[6] and it is important to draw the attention of art historians to those that may contain quantifiable materials for new research.

Some time ago, I mentioned to Max Martens the possibility that the sixteenth-century auctioneers' registers might offer information about which Bruges citizens were early owners of paintings.[7] I was pleased to hear that he intends to investigate these registers. On the other hand—and maybe not everyone will agree with me—the archivist should also warn against the unnecessary duplication of efforts. Since Strohm's *Music in Late Medieval Bruges* was published in 1985,[8] several musicologists have visited the reading room at the Rijksarchief to consult the register of the confraternity of Onze Lieve Vrouw van de Droge Boom.[9] I once remarked to a musicologist that this very rare manuscript was in frequent demand and suggested instead consulting Strohm's book, where the documents had been well transcribed for the purpose of investigating the same issue. As I mentioned at the outset, I am well aware of the fact that every document must be studied anew and submitted to further questioning. However, as an archivist I must also be concerned with the preservation of these very rare and fragile documents for future as well as present-day scholars. Clearly, we must look at ways of producing a more permanent record of our holdings, creating electronic data that would be easy to consult, in order to preserve the originals.

In general, the accessibility of archival sources should be improved—also an important task of the archivist. A poignant example is the obituary register of Bruges painters.[10] This important fifteenth-century document was severely damaged during World War II and its delicate condition makes handling it for microfilm or scanning almost impossible. Therefore, a complete restoration is necessary. During the preparation of the exhibition "From Memling to Pourbus," such a restoration was proposed, but it was turned down at an early stage. Yet, scanning or producing a film of this document is an absolute necessity, and I am determined to work toward achieving this goal.

Finally, I wish to make a few remarks about the procedure for consulting well-known texts. Here, an archivist may assist the scholar by drawing the latter's attention to existing and still unsolved problems, many of which are not obvious at first sight. Examples exist in already published archival documents: Since 1938, it has been known that Hans Memling registered as a Bruges citizen on January 30, 1465. However, in the

"Poortersboek," the entry clearly was not made in the appropriate place, but at the bottom of the page, after one dated February 25, 1465. There is, perhaps, an explanation, even if only a hypothetical one. The matter was thoroughly discussed by André Vandewalle in a talk delivered at the Memling colloquium in 1994,[11] yet, even his explanation leaves out one important element: All entries in the "Poortersboek" had to be copied into the municipal accounts of 1464–65, but the entry concerning Hans Memling does not appear there; from this we may assume that he avoided paying the required twenty-four shillings, although how he was able to do so still remains a mystery. Another example concerns Gerard David's *Justice of Cambyses* panels (see figs. 8, 9), which figure in seven or eight different entries in the Bruges municipal accounts. However, some of these references have not yet been adequately dated, leaving open the question of the accuracy of their interpretation up to this point.[12] Thirdly, for several years I have been trying to convince scholars who use the reading room that Jan van Eyck's widow did not participate in a lottery in Bruges in 1446, but that the town paid her an allowance from the profits of that lottery.[13] Such seemingly small details about painters' lives, wives, or commissions will doubtless lead to the disclosure of more significant information and thus to fresh interpretations.

A final example, which I will deal with in somewhat greater detail, concerns an item in the will of the Bruges burgher Anselm Adornes, which, since the nineteenth century, has been related to the Philadelphia and Turin paintings of *Saint Francis Receiving the Stigmata* by Jan van Eyck (figs. 10, 11): "Item zo gheve ic elcken van mijne lieve dochters die begheven zijn, te wetene Margriete, 't Saertruesinnen, ende Lowyse, sint Truden een tavereel daer inne dat sinte Fransoys in portrature van meester Jans handt van Heyck ghemaect staet, ende datmen inde duerkens die dezelve tavereelkins beluucken doe maken mijn personage ende mer vrauwe,

alzo wel alsmen mach, te dien hende dat wij van hemlieden ende andere devote persoonen moghen ghedocht zijn, ende daer toe elcken 1 lb. gr. om haerlieder wille mede te doene" (Item, I give my two daughters who are destined to enter into the convent and who are already staying there now [this is the correct meaning of *begheven zijn*], namely Margaret, in the Carthusian nunnery [near Bruges] and Louise in Sint-Trudo abbey [also near Bruges], each a painting [*tavereel*] by Jan van Eyck in which Saint Francis is portrayed. The portraits of me and my wife will be made on the small shutters [*duerkens*] which close off these small paintings [*tavereelkins*]. They should be very much alike so that they [Margaret and Louise] and other pious persons might remember us [in their prayers]. Therefore each of them gets 1 pound of groats which can be spent on whatever they want).

I was able to study the complete document in context.[14] In brief, from this comprehensive reevaluation, I concluded that on February 11, 1470, Anselm Adornes possessed two small panels with portraits of Saint Francis, painted by Jan van Eyck (or by his workshop), which probably had belonged to Adornes's father or his uncle. The hypothesis that the paintings cited in the will should be identified with those in Philadelphia and in Turin remains very plausible. However, most of the stipulations of the will regarding the panels probably were never executed. There is little evidence to assume that they were ever equipped with shutters on which Anselm Adornes and his wife were portrayed. Moreover, the panels may never have come into the possession of Anselm Adornes's two daughters, who are mentioned in the will as beneficiaries. A thorough study of the complete text of the will in its historical context thus shows that the passage about the two van Eyck works should be read with critical scrutiny.

In such a case, collaboration between the archivist and the art historian yields the best results. First, the archivist must understand

Figure 10. (left) Jan van Eyck. *Saint Francis Receiving the Stigmata.* Philadelphia Museum of Art, The John G. Johnson Collection (no. 314)

Figure 11. (below) Jan van Eyck. *Saint Francis Receiving the Stigmata.* Galleria Saubauda, Turin (no. 187)

the art historian's questions, so that he can recommend appropriate sources and indicate their potential value as well as their limitations. In addition to archival sources, other written texts, such as chronicles, letters, and inscriptions, may contain important elements for research; these, too, should be consulted with a scrupulous and scholarly approach. On the basis of a previously ignored chronicle, in combination with two archival texts, I was able to prove that the *Crucifixion Triptych* by Hans Memling, painted about 1468–70, was commissioned by Abbot Johannes Crabbe of Ter Duinen Abbey for the chapel in his residence in Bruges.[15] Relying on the legend on Pieter Pourbus's map of the abbey, together with a chronicle, I determined that the fifteenth-century panels with representations of the abbots of Ter Duinen Abbey and of the counts of Flanders replaced a series of older wall paintings.[16] I mention these two examples of my own research to illustrate how a combination of several archival sources and written texts may lead to a better understanding of a work of art. Of course, these sources also should be combined with data from technical research. Any claim to historical certainty may be made only when all data agree: An interdisciplinary approach is absolutely necessary!

I would like to review, here, my main arguments: Nineteenth- and twentieth-century archivists have been able to provide much of the source material concerning Bruges painting by offering transcriptions of documents. These texts always should be checked against the original sources and examined in a larger context—for which cooperation between the archivist and art historian is essential. Unlike their predecessors, archivists today believe that even though current monographs and catalogues may include selected documentation, consulting such partial sources is insufficient for a thorough investigation.

New areas of research based on quantifiable data may still be uncovered if the scholar and the archivist together exercise their creativity in looking at old documents in new ways. For example, I am convinced that an answer to the question of why a painter is not mentioned in a specific source is imminent.[17] Known sources should be continually reexamined, in a broad historical context, with a fresh approach. Once again, it must be stressed that, as well as archival sources, other often ignored written texts must be scrutinized. While sometimes the poor condition of archival documents may render them difficult to decipher, it is the archivist's job to make these sources more easily accessible, even in a physical sense. In short, the final aim of our research is a better understanding of the artist and his work. A historian, especially an archivist, must not forget this.[18]

1. On Gilliodts-van Severen and his work see A. Vandewalle, ed., *100 jaar Gilliodts. Academische zitting en tentoonstelling ter herdenking van de voormalige stadsarchivaris Louis Gilliodts-van Severen (1827–1915)* (Bruges: 1980): An exhaustive bibliography of Gilliodts-van Severen's publications, compiled by Vandewalle, appears on pp. 23–30.

2. On Remi Parmentier see A. Schouteet, "In memoriam R. A. Parmentier," in *Handelingen van het Genootschap voor Geschiedenis "Société d'Émulation" te Brugge* 106 (1969), pp. 239–46.

3. On Albert Schoutet and his publications see J. De Groote, "Bibliografie," in *Album Albert Schoutet* (Bruges: 1973), pp. 13–22; A. Vandewalle, "In memoriam Albert Schoutet," in *Handelingen van het Genootschap voor Geschiedenis "Société d'Émulation" te Brugge* 128 (1991), pp. 129–34.

4. See C. Vanden Haute, *La Corporation des peintres de Bruges* (Bruges and Courtrai: 1913).

5. See A. Vandewalle, "De besturen van het ambacht van de goud- en zilversmeden, 1363–1794," in D. Marechal, *Meesterwerken van de Brugse Edelsmeedkunst. Catalogus* (Bruges: 1993), pp. 413–38.

6. For Bruges see A. Vandewalle, *Beknopte inventaris van het stadsarchief van Brugge, I: Oud Archief* (Bruges: 1979). Recently, the same author compiled a general survey of all Bruges archives: "Brugs Archiefpanorama," in *Archiefleven, Nieuwsbrief van het Stadsarchief van Brugge*, vol. 5, November 1998, pp. 3–23. See www.brugge.be/archief.

7. Bruges, Stadsarchief, Oud Archief, series 203: *Stokhouders (1537–1795)*.

8. See R. Strohm, *Music in Late Medieval Bruges* (Oxford, England: 1985; reprinted, 1992); see also the article by R. Strohm, "Muzikaal en artistiek beschermheerschap in het Brugse Ghilde vanden Droghen Boome," in *Biekorf* 83 (1983), pp. 5–18.

9. Bruges, Stadsarchief, Oud Archief, series 505: *Gilde Drogenboom.*

10. Bruges, Stadsarchief, Oud Archief, series 314: *Beeldenmakers.*

11. See A. Vandewalle, "À Propos du Lieu de naissance de Memling," in H. Verougstraete, R. van Schoute, and M. Smeyers, eds., *Memling Studies. Proceedings of the International Colloquium, Bruges, 10–12 November 1994* (Leuven: 1997), pp. 19–24.

12. See Bruges, Stadsarchief, Oud Archief, series 216: *Stadsrekeningen,* September 1, 1487–February 1488 n.s., fol. 126*v.* (entry from 1487–88, with two additional entries from 1492); January 1, 1491 n.s.–August 31, 1491, fol. 161*r.*; September 2, 1498–September 2, 1499, fol. 166 *v.* (two or three entries), fol. 166*v.*–167*r.* (one entry). These entries should be compared with similar entries in the copies of the city accounts, now in Brussels, Algemeen Rijksarchief; see H. van der Velden, "Cambyses Reconsidered: Gerard David's *exemplum iustitiae* for Bruges Town Hall," in *Simiolus* 23, 1 (1995), pp. 40–62, esp. pp. 44–45.

13. Bruges, Stadsarchief, Oud Archief, series 273: *Loterijen,* Register van Pieter van den Vagheviere,

1446, fol. 2*v.*–3*r.*: "Item betaelt diversche Rentiers bi quitancien," fol. 3*r.*: "de weduwe Jans van Eyck."

14. See N. Geirnaert, "Anselm Adornes and His Daughters. Owners of Two Paintings of Saint Francis by Jan van Eyck?," in *Proceedings of the Jan van Eyck Symposium, The National Gallery, London, 13–14 March 1998* (Turnhout, Belgium: 1999), pp. 165–70.

15. See N. Geirnaert, "Le Triptyque de la Crucifixion de Memling pour Jean Crabbe, abbé de l'abbaye des Dunes (1457–1488). Témoignage des documents contemporains," in H. Verougstraete, R. van Schoute, and M. Smeyers, eds., *Memling Studies. Proceedings of the International Colloquium, Bruges, 10–12 November 1994* (Leuven: 1997), pp. 25–30.

16. See N. Geirnaert, "De portrettenreeks van de graven van Vlaanderen uit de Duinenabdij: Vlaamse schilderkunst van vóór Van Eyck of van 1480?," in *Jaarboek 1991–1992. Stad Brugge. Stedelijke Musea* (Bruges: 1993), pp. 137–38.

17. A remarkable result has been obtained by A. Janssens, "De schilder Hans Memling. Als Brugs poorter financieel, sociaal en politiek doorgelicht," in *Handelingen van het Genootschap voor Geschiedenis "Société d'Émulation" te Brugge* 134 (1997), pp. 65–89.

18. I would like to thank Eva Tahon, Rita Vandamme, and Marijke Verschelde for their assistance.

Filip Vermeylen

The Commercialization of Art: Painting and Sculpture in Sixteenth-Century Antwerp

The last decade or so has witnessed a renewed interest in the relationship between art and economics in the Low Countries during early modern times.[1] In 1976, Lorne Campbell published his important survey of the Netherlandish art market in the fifteenth and sixteenth centuries. In the late 1980s, the series of books and articles by John Michael Montias, in which he examines the economic aspects of Dutch painting in the seventeenth century, first appeared. Only then did historians and art historians become intrigued by this kind of interdisciplinary research.[2] Montias invigorated and to some degree redefined the field. His research often was based on the study of a variety of primary sources, including the wealth of probate inventories preserved in the archives in Delft and in Amsterdam. A particularly fruitful contribution was what is now referred to as the "Montias innovation thesis": By introducing the concepts of "product innovation" and "process innovation" in painting, attention was focused on the impact of economic factors on art.[3] In a nutshell, process innovation denotes a lowering of production costs without changing the basic appearance and nature of the (artistic) object. In Netherlandish workshops that manufactured paintings and carved altarpieces, cost-cutting strategies might have entailed a division of labor, countless reproductions of a particular composition, and the use of cheaper or fewer raw materials such as paint. Product innovation means generating an entirely new commodity or profoundly changing the appearance of an existing one. In the context of art history, this might have resulted in a new genre of painting or in a completely different art form.

Economic historians since then have, indeed, devoted a great deal of attention to art history, and, overall, this approach has had an enriching effect on the study of Netherlandish art. The intensified interest in the art market accords with the general trend toward more interdisciplinary research. This interdisciplinary approach was realized, early on, with the publication, edited by Jan De Vries and David Freedberg, of a collection of essays that explored the interaction between history and art history.[4] Scores of books and articles have followed, scrutinizing various facets of the art market, and many scholars have made valuable contributions to the fields of Flemish and Dutch art. For instance, Ad van der Woude was the first to attempt to quantify the total volume of paintings produced in the Dutch Republic; Raymond van Uytven investigated the correlation between artistic output and the state of the economy in the Burgundian Netherlands; and Marten Jan Bok examined the structure of supply and demand as it applied to painting in the Dutch Republic.[5] Nowadays, every respectable exhibition catalogue will include at least one essay that deals with the social and economic background of the period, acknowledging the impact economics may have had on the style, form, and content of the featured works of art.

With regard to this rich harvest of scholarly publications, I would like to make three

remarks. First, it is striking that so few of the recent studies are based on actual archival research while, at least in the case of Antwerp, countless valuable and relevant documents that can shed light on the fascinating but complex relationship between art and economics await discovery.[6] Secondly, it is astonishing that the term "market" has permeated academic discourse to the extent that it has, in very much the same way that it has infiltrated most other aspects of Western society. These days, virtually every publication on Netherlandish art will include at least a pro forma reflection on the market,[7] and, as a result, it seems to me, the term has become increasingly elusive the more it is (over)used. Therefore, additional effort needs to be made to arrive at a clear and pragmatic description of the term, yet most definitions of the art market fail to do justice to its complexity. In early modern times, the term "art market"—or any other market—according to Richard Swendberg, could denote either the physical marketplace, the legal right to hold a meeting at such a place, the actual gathering at a marketplace, or buying and selling in general. Economists have focused on the price-setting function of the market as the key to the allocation of resources in any given economy.[8] Economic sociologists, on the other hand, have described the market as the arena in which various types of "exchange" take place, and, as such, they emphasize that the market is a societal phenomenon rather than a purely commercial one.

In my view, it is essential to consider the meaning of the term "market" carefully, especially when examining this phenomenon as it existed during the sixteenth century, which was precisely the time when works of art made their grand entry into the realm of market economics. For pragmatic purposes, I have defined the art market as the arena in which works of art are transferred from producer to consumer, either directly or through a dealer. In this environment, the buyer can commission the work of art or purchase it on the open market.[9]

In the context of this discussion, it is important to distinguish between the distinct markets for art that existed simultaneously during the sixteenth century: On the one hand, there was the so-called high art, which consisted of high-quality and thus expensive items, and, on the other hand, there was a market for cheaper, *inferior* works of art. The paintings and carved altarpieces in the first category almost exclusively were commissioned by local or foreign elites and institutions, while the low end of the Antwerp art market tended to be fueled by serial production, works offered for sale on the open market that attracted a more socially diverse clientele.[10]

My third remark has to do with primacy. It is noteworthy that—until very recently—most of the publications and conferences dealing with these issues have centered on the Dutch Republic and, as a result, many of the innovations and developments in the way that art was produced, traded, and acquired have been attributed to seventeenth-century Holland. For example, one may get the impression from the literature at hand that the commercialization of art was a purely Dutch phenomenon. Was Holland truly the cradle of serialized production and market sales of works of art? Did a class of professional art dealers emerge in Holland first? A prime reason for this trend quite simply has been the preponderance of scholarly attention focused on the Dutch Republic, with its attendant thorough research. The situation, however, is changing rapidly. Several recent publications have scrutinized the economic context of Flemish art. Max Martens has published a series of stimulating articles in which he discusses the art market in Bruges at the close of the Middle Ages, Lynn Jacobs reserved half of her monograph on Early Netherlandish carved altarpieces for a discussion of their mass marketing, and Maryan Ainsworth gave considerable emphasis in her book on Gerard David to this artist's production for the open market.[11]

While the innovative role of the Dutch Republic remains unchallenged, I would argue

that the roots of the commercialization of art can be found in the southern Netherlands during the sixteenth century, and, more specifically, in—to quote Larry Silver—*the capital of capitalism*, the city of Antwerp, at a time when it had become the undisputed art center of the southern Netherlands.[12] Focusing on painting and sculpture, I will contend that the Antwerp market was highly commercialized, arguably more so than markets in most other art centers. Commercialization in this context denotes art that primarily was produced on spec—in other words, for the open market rather than on commission—and that was sold *en masse* to an international clientele. After commenting on Antwerp's rise to the position of one of the leading art markets in Europe, I will examine both the nature and the volume of the speculative production of altarpieces as well as paintings. Subsequently, I will outline the necessary conditions that made the commercialization of art possible and discuss some of the ramifications of this development. Finally, the process of commercialization as it developed in Bruges and in Antwerp will be compared.

PAINTING AND SCULPTURE IN ANTWERP

The origins of the boom in art that the city witnessed during the first decades of the sixteenth century must be seen in the context of Antwerp's rise as the premier commercial center north of the Alps. The maturing of the art market, which took place from 1490 to 1520, corresponds with the first phase in its expansion.[13] Catalysts for this rapid growth were the *jaarmarkten,* or fairs, which were held twice a year for a period of about six weeks and provided an ideal opportunity for local tradesmen and artisans to offer their goods to a cross section of European customers. Indeed, the fairs proved to be essential outlets for artists, who were able to build up their stock in the intervening months. As a result of the temporary convergence of international demand in Antwerp, transportation costs were reduced to a minimum.

The importance of the fairs is underscored by the reports of eyewitnesses. Pero Tafur, an Andalusian nobleman, visited the Antwerp fairs in 1435 and was duly impressed: "The market that is held in this city is the most important one in the whole world," he wrote, continuing, "The most beautiful merchandise of this earth is on display here, the greatest wealth, and superb entertainment." Tafur also elaborated on the locations where the merchandise was marketed, and he added specifically that paintings were being sold at the Dominican convent.[14] Almost a century later, in 1517, the secretary to the Italian cardinal Luigi d'Aragon also was struck by the magnitude of the Antwerp fairs, and claimed that they represented the greatest market in Christendom.[15]

Between 1530 and 1540, the Antwerp market *de facto* operated year round, and over one thousand foreign merchants resided permanently in the city. A key factor for the art business was its reliance on the advanced commercial infrastructure—not just the fairs, but also the Bourse and the seaport—already in place to facilitate the trade of more traditional goods. For instance, the fact that the city was a port guaranteed a reliable and steady supply of raw materials, such as various exotic pigments, and kept artists in tune with the latest fashion and international demand.[16]

Many artists were drawn to Antwerp as a result of this economic boom. An examination of the new members listed in the registers of the Guild of Saint Luke suggests a precipitous rise in the number of incoming artists from 1460 to 1520.[17] Without a doubt, the influx of countless painters, printers, wood-carvers, and sculptors was a *conditio sine qua non* for the establishment and growth of the Antwerp art market.[18] Such an abundance of creativity concentrated in one city led Karel van Mander, the Vasari of the Low Countries, to portray Antwerp in 1604 as the "mother of all artists."[19]

Naturally, the presence of a large artists' community does not in itself cause or

explain the high level of commercialization of art in Antwerp. Four elements support the claim that paintings and altarpieces were, indeed, produced primarily for the open market: First of all, the number of artists present was very substantial; the Italian merchant Ludovico Guicciardini estimated that about three hundred (mostly painters) were active in Antwerp in the 1560s, roughly twice the number of bakers and three times the amount of butchers.[20] Obviously, a fraction of them would have sufficed to satisfy local demand. This preponderance suggests that a significant portion of them must have been producing art for foreign markets, exports being a clear indication of speculative production. In addition, few artists were employed and salaried, as was so often the case in Italy, and, as Antwerp lacked the presence of a court and its accompanying nobility, artists rarely received commissions.[21] Instead, not being tied to one patron meant that artists were more at liberty to follow their own creative initiative with the open market in mind. This freedom allowed them to better respond to the variable market conditions, such as changes in fashion and in demand for a specific product.[22]

Secondly, it is undeniable that a huge percentage of the paintings and altarpieces produced in Antwerp were, to a large degree, standardized; their form and content often revealed their ready-made nature. Jacobs points out that the subject matter of carved altarpieces was conceived to appeal to a myriad of buyers; a limited number of themes prevailed, but nothing too complicated that would discourage potential clients. For instance, workshops concentrated on including large numbers of popular Passion scenes in the corpus, or *caisse,* of the retable.[23] Frequently, the same was true for paintings, as many copies existed of a particular composition. Standardization of the subject matter was espoused especially by the so-called Antwerp Mannerists, a group of anonymous artists active during the first decades of the

sixteenth century. They produced literally thousands of paintings of the Adoration of the Magi, in an easily recognizable style, which were in great demand abroad.[24]

Thirdly, the presence of *panden* in the city underscores the level of sophistication and the high output of the art trade.[25] A *pand* is best described as a combination sales hall and gallery, where artists and dealers could rent stalls and retail their merchandise. These galleries are considered among the most advanced institutions devoted to the marketing of art in early modern Europe. Their very presence supports the assumption that great quantities of works of art were produced for the open market, and thus points to the high level of commercialization. During the first half of the sixteenth century, somewhere between fourteen and sixteen of these *panden* operated in Antwerp, and most of them sold a particular type of luxury commodity, such as tapestries or jewelry. Onser Liever Vrouwen Pand was undoubtedly the most prominent gallery for the sale of retables and paintings until the middle of the century. This gallery was already in existence by 1460, and it enabled painters, printers, and glovers to sell their goods during the biannual fairs. Archival records provide ample proof that finished and even semi-finished carved altarpieces and paintings were traded at the *pand.*[26] That foreign merchants would consider purchasing ready-made art makes perfect sense: Most merchants were in the city for a limited amount of time only (for the duration of the fairs), and often could not await the completion of a commissioned work of art. According to Jacobs, it took at least six months to a year to finish an altarpiece, and possibly even longer.[27] Another major factor that may have persuaded potential clients to purchase a ready-made work of art was the price. Commissioned works were more expensive as a rule, and tended to display a higher level of specificity with fewer standardized components.[28]

In 1540, the marketing of paintings was further commercialized and facilitated by the opening of the *schilderspand*, or painters' gallery. This gallery, run by the city, contained one hundred stalls or shops and, not coincidentally, was located in the new Bourse, the nerve center of trade and finance in Antwerp.[29] This *pand* was open for business year round, and its revenues—the barometer of its success—would grow exponentially until the eve of the Iconoclastic Revolt of 1566. When the printer and art dealer Jan van Kessel died on December 18, 1581, a probate inventory was drawn up containing a section on the goods that were still present in his shop in the *schilderspand*, thus providing us with a rare glimpse of what was actually on sale at the *pand*; van Kessel's merchandise included the following:

119 double canvases of various types, some not finished

13 double canvases depicting figures from Kortrijk

an old painting on canvas by Hieronymus Bosch

477 double canvases of different types

6 wooden boxes containing paintings

3 printed images by Raphael depicting martyrdom

19 printed sheets by Raphael, Parmigianino, and others.[30]

If nothing else, this document gives us an idea of the vast amount of works that were available in the art trade. According to the list, no fewer than 610 paintings were in stock at van Kessel's stall at the time of his death, as well as a number of prints. Obviously, not all of these works could be displayed simultaneously within the confines of one shop. The vast majority of the canvases probably were rolled up, which, besides saving space, enabled them to be easily transported. The reference to painted figures from Kortrijk becomes meaningful when we consult *Het Schilderboeck* on this genre. Van Mander commented in very

pejorative terms about the style of painting that was associated with the town of Kortrijk, defining it as "a simple manner of working which is often not worthy to be called painting, but merely a bit of canvas-coloring or staining to which one is accustomed in that town, and which are chased after by some peddlers who scour the markets."[31] Clearly, van Mander associated the style with cheap, low-quality pictures, painted in tempera on canvas. Pictures of this type also were produced in Mechlin, and appear to have been readily available on the Antwerp art market.[32]

That there were unfinished diptychs for sale at the *schilderspand* is very significant, as it underscores the advanced degree of commercialization of the art trade. The potential customer thus had another option besides having to choose between purchasing a ready-made painting or commissioning a new one. In Antwerp, he or she could acquire a semi-finished painting, to which personalized elements, such as a portrait or a coat of arms, could be added at a later stage. This phenomenon already existed much earlier in the century, with regard to Antwerp Mannerist painting. The wings of triptychs were occasionally left blank so that the ultimate buyer (often a foreigner) could customize the altarpiece by having his portrait or patron saint painted in. The same trend affected sculpture, where carved altarpieces often combined a standardized corpus and some personalized scenes and components.[33]

Lastly, the effectiveness of the *panden* is best explained by the vast amount of exported paintings and altarpieces, and many documents directly corroborate this fact.[34] Exports, of course, consisted almost exclusively of non-commissioned art. Paintings by Antwerp masters were, indeed, disseminated in enormous quantities, and the ever-perceptive Guicciardini reflected on the economic importance of this trade for Antwerp's art community: "The works of these painters are not only widespread in these [European] countries, but in the whole world, since paintings generate a great deal of commerce."[35]

	Number of Shipments	Value (in guilders)	% of Total Value
Iberian Peninsula	48	2,023	33.70
Italy	11	531	8.84
England	25	1,100	18.31
Germany	22	1,436	23.90
Other countries	24	916	15.25

Figure 12. The export of paintings from Antwerp, 1543–45

The previously mentioned Antwerp Mannerists produced innumerable paintings of the Adoration of the Magi during the first third of the century to be shipped to different destinations.[36] The success of the Mannerists set the tone for artists for the rest of the century, and Antwerp paintings continued to be exported even when the Mannerist style was no longer in vogue (fig. 12). During the 1540s, a one-percent tax was levied on the value of exported goods, and tax registers reveal 130 shipments of paintings in a two-year period, the bulk of which were sent to the Iberian Peninsula. In 1553, a similar tax was levied, but only on goods exported to the Iberian Peninsula. A comparison with the data from ten years earlier shows that the monetary value of exported paintings had risen from 1,012 guilders annually to an impressive 17,543 guilders.[37] Increasingly, more professional and wealthy art dealers were becoming involved in the art trade. For instance, in February 1553 alone, the dealer Lancelot Robian loaded four large cases and five coffers filled with canvases and other items, such as two organs, on ships headed for Andalusia. The estimated value of this cargo exceeded 2,000 guilders.[38]

Brabantine carved altarpieces, the most important examples of Flemish sculpture, were widely exported as well during the first half of the sixteenth century. Ready-made altarpieces in addition to commissioned ones from Antwerp, Brussels, and Mechlin were renowned throughout Europe, especially in the Baltic region. Countless Brabantine altarpieces were shipped to the northern regions of present-day Germany and Poland, but Flemish altarpieces were equally popular in Scandinavia, and many fine examples still exist today in Norway, Sweden, and Denmark. While intended primarily for churches in Portugal, altarpieces frequently adorned private family chapels in Spain. They were also found—albeit in more modest quantities—in Italy, France, England, and Scotland.[39]

In sum, these observations imply that very substantial quantities of paintings and carved altarpieces were produced on spec. Jacobs spared no effort in her book to claim that in Antwerp up to seventy-five percent of carved altarpieces were, indeed, produced for the open market rather than on commission.[40] Given the high export figures and the absolutely stunning numbers of ready-made paintings on sale at the *pand* (over six hundred paintings in van Kessel's shop alone), the conclusion is inescapable that the percentage of paintings made for export must have been even higher—probably about ninety percent

of the total output. In light of these figures, we need to examine the conditions that existed in Antwerp to explain not only the predominance of the art market but also its high degree of commercialization.

Firstly, workshops produced art in a semi-industrial fashion, applying process-innovation strategies to cut costs. Masters employed several kinds of assistants, which allowed for an in-depth division of labor and intensified collaboration between artists. In painting, this resulted in the serial production of a few well-chosen compositions. Various techniques were applied to facilitate these reproductions. The use of patterns and models was widespread in the southern Netherlands from the fifteenth century onward, and a rich collection of prints and drawings was essential to the success of any workshop. Furthermore, techniques such as pouncing and tracing enabled artists and their assistants to duplicate existing compositions countless times. Pouncing most often involved tracing the original composition on paper, and subsequently transferring the sketch—and, hence, the composition—through pricking, onto another canvas or panel.[41] The atelier of the Antwerp-based painter known as the Master of Frankfurt, for instance, serves as an early example of an advanced workshop that produced paintings featuring the distinct repetition of brocade patterns.[42]

Carved altarpieces also were subjected to a standardized mode of production along the same lines as paintings. Many of these altarpieces were characterized by a repetition of models and the prefabrication of parts: Jacobs has identified the same figures in several altarpieces.[43] Furthermore, division of labor was especially pronounced: Joiners would make the *caisse,* or corpus; sculptors would produce the main carved scene; and the wings would be the responsibility of the painters. For instance, on September 7, 1520, the painter Peter De Vleeminck promised to pay thirteen guilders to the sculptor Aerdt de Beeldsnijder for the sculpted part of an altarpiece. In this instance, the painter acted as the leading artist who subcontracted part of the work.[44] The division of the production process was often not that clear-cut, but there definitely was a high level of specialization among the artists involved. Additionally, there are indications that a system existed in Antwerp that ensured that certain painters produced pictures directly for art dealers. Van Mander reports that Hieronymus Cock commissioned engravings, etchings, oils, and watercolors, which he subsequently tried to sell, and the art dealer Anthony De Palermo also had painters working for him. Jacques De Backer, for instance, supplied De Palermo with a number of pictures that the latter exported to France, where they sold well.[45] The existence of this practice is further implied by an ordinance issued by the Guild of Saint Luke in 1575, which refers twice to the commissioning of paintings by art dealers with the intention to sell to a third party ("to have made for other persons").[46] The net result of these strategies—both for paintings and carved altarpieces—was that the artist-entrepreneur was able to offer his product at a competitive price.

Secondly, the Antwerp Guild of Saint Luke, to which most artists active in the city belonged, adopted a pragmatic approach toward market sales rather than restricting them—a policy that was not adhered to in other cities. On the contrary, through various regulations, the guild's aim was to control, structure, and channel the art trade to its own advantage. In 1484, Onser Liever Vrouwen Pand was given exclusive rights by the guild to sell works of art. Although the sale of art effectively was concentrated in one location for the duration of the fairs, the corporation was flexible and artists and dealers from other cities could also market their merchandise in Antwerp.[47] In fact, during the fifteenth century, artists from Brussels are believed to have outnumbered their Antwerp counterparts in the Dominican *pand*—a predecessor of Onser Liever Vrouwen Pand—which led Dan Ewing and others to conclude that Antwerp was a major center for the distribu-

tion of art long before it became the focus of artistic production in the Low Countries.[48] Furthermore, the guild instituted a strict system of quality control for carved altarpieces, requiring them to be stamped before they could be offered for sale. Jacobs and Montias have argued convincingly that the goal of this measure was to gain the confidence of the buyer. Such a label guaranteeing a certain quality must have benefited the workshops in the long run, as it fueled further demand for these devotional works.[49]

A similar, institutionalized system of quality control did not exist among painters, but the merchants who bought the work of Antwerp masters often had its authenticity and value verified. The Spanish merchant Samson del Barco, for instance, instructed Melchior Groenenborch in 1542 to estimate the value of three paintings by Jan Mandijn and Pieter Aertsen and to establish authorship.[50] The language of the document is a kind of *ad hoc* Esperanto, possibly to enable an undetermined foreign clientele to read and understand the certificate.

This brings us to the final and perhaps most crucial precondition necessary for the commercialization of art: Ultimately, the Antwerp art market thrived because the demand for luxury commodities had expanded dramatically, domestically and abroad. The demand side of the art market too often is overlooked in the recent literature, even though Richard Goldthwaite has demonstrated that for Italy the art trade was in essence a demand-led industry, and his conclusions apply also to the Low Countries.[51] Traditionally, the Church and the nobility had commissioned works of art, but new clients came from both the religious and secular spheres. Affluent merchants as well as civic authorities revealed themselves as major consumers of art in most urban centers, and the continuing proliferation of religious orders and institutions increased the call for a wide variety of liturgical objects and images. Moreover, as the sixteenth century progressed, the production of art was especially

stimulated by the various reforms that took place—within and outside the Roman Catholic Church.[52] Particularly important for art in Antwerp were the effects of the Counter Reformation, which would bring great fame to the city in the seventeenth century with works by the school of Rubens.[53]

Antwerp's pivotal position in the European trade network meant that the city became an international marketplace where supply and demand coalesced; once the traditional supplier of luxury goods, Italy, lost ground due to external factors, Antwerp not only supplied its immediate hinterland with works of art but, as the export registers indicate, the far corners of Europe and beyond, as well.

The trend toward the increased commercialization of art had some significant ramifications. As the production of works of art became more calculated, increasingly standardized, and geared toward export, art became a commodity on the regular international trade circuit: Thus, the manner in which art henceforth was made, distributed, and obtained was, in essence, no different from that of such traditional goods as textiles, a saddle, or a table. Price became an important issue, as did mass marketing through the *panden*. Clearly, the implications of these developments changed the way art was created and acquired, and the introduction of art into the realm of market economics had both profound and in many respects irreversible effects.[54]

Through the implementation of various process-innovation strategies, workshops were able to produce paintings and altarpieces at competitive prices, which secured their survival. However, the question arises as to whether the quality suffered at all from these cost-saving measures. It is undeniable that a simplification of the subject matter took place, but efforts were made to maintain the level of quality of the finished product, which prevented the price from dropping. Certainly, in the case of altarpieces, it is quite clear that the Guild of Saint Luke imposed standards that prevented inferior work from

reaching the marketplace. Records of various court cases prove that the guild vigorously attempted to enforce the stamping requirement. In 1520, Gillis de Bakmaker was visited twice by the deans of the guild, who wanted to verify that the sculptor had, indeed, made the necessary improvements to an altarpiece before it appeared on the art market.[55] As to painting, on the other hand, documents inform us that thousands of inexpensive paintings from Antwerp, of rather poor quality, flooded the international markets. The fact is that the Antwerp workshops were simply tapping into a demand that existed for these works, and they successfully claimed that segment of the market, much to the chagrin of competing centers. Nonetheless, we should also keep in mind that throughout the sixteenth century, parallel to the mass production of inexpensive paintings, a number of first-rate artists, such as Quentin Massys, Joachim Patinir, Pieter Bruegel, and Frans Floris, were active in Antwerp as well. These painters, who worked primarily on commission, catered to a very different market, although it is worth noting that Pieter Bruegel began his career as a "commercial artist" whose prints capitalized on popular compositions by Hieronymus Bosch.

Arnout Balis has pointed out that changing tastes and a growing interest in art led to a diversification of the genres of painting—a phenomenon that Montias would describe as product innovation.[56] The introduction of such different subjects as landscapes, market scenes, and peasant themes was, at least in part, a response to market incentives. This assumption is underscored by the fact that these new compositions almost instantly were commercialized, initially through prints, but later in painted copies and variations. This broadening of genres in turn generated new demand, which allowed the Antwerp artistic community to further capitalize on these innovations. However, the artists who made the renowned carved altarpieces failed to reinvent or restyle their products sufficiently when fashions changed: By the middle of the sixteenth century, Brabantine altarpieces were no longer in vogue, despite attempts to incorporate more Renaissance elements into their design.[57]

As the volume of exports increased and the art trade diversified, the need for professional art dealers became apparent. Merchants of this type first appeared in Antwerp in significant numbers during the second half of the sixteenth century, and were responsible for ensuring that supply met demand at a time when the art market was becoming more professional and commercial. Much research needs to be done regarding the social and economic backgrounds and activities of these dealers, but indications are that they frequently originated from within the artistic milieu. For instance, Bartholomeus de Momper began his career as a painter and publisher of prints before becoming the manager of the *schilderspand* in 1565.[58]

As works of art made their entry into the capitalist arena, the language of contemporary documents changed as well. Capitalist terminology infiltrated contracts and letters dealing with art, which bears eloquent testimony to the high degree of commercialization of the Antwerp art market. By the mid-sixteenth century, documents dealing with the transactions surrounding a work of art provided such additional details as the price, type of packaging, mode of transportation, means of payment, and—last but not least—the authorship. Numerous entries in the *certificatieboeken*, which documented shipments of works of art, also included in the margins the mark of the art dealer, and these were found as well on the boxes, bales, and barrels in which the goods were transported. These observations suggest that art was now well assimilated in the world of commerce and had, indeed, become a commodity. The question then arises as to what extent the content of the art object was influenced by these developments.

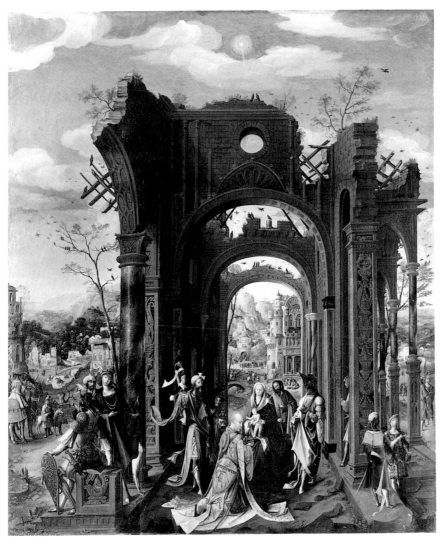

Figure 13. Unidentified Antwerp Master. *The Adoration of the Magi.* Alte Pinakothek, Munich (no. 708)

It is clear that the subject matter of paintings also did not remain unaffected. The diversification of genres meant that more universal topics with a broad appeal were being portrayed. Landscapes in the style of Patinir, for instance, lacked a high degree of specificity as well as a complicated iconography. Hence, these popular compositions were especially suited to the requirements of large-scale works produced on spec. Commercialization had an even more

concrete impact in certain cases: Some type of commercial activity is depicted in the background of many Antwerp Mannerist paintings. It has been suggested that the theme of the Adoration of the Magi owed its success to the evocation of travel, which would have appealed to the foreign merchants who purchased these paintings[59]—as, for example, the *Adoration of the Magi* in the Alte Pinakothek, Munich (fig. 13), in the background of which we can clearly observe

men handling baggage (fig. 14). In a number of paintings, the merchants' marks on the bags leave little doubt that they contain commercial goods. Finally, other compositions reflect directly on the relationship between art and capitalism, and quite a few either warn against the dangers of mixing the two or against the evils of commercialism in general. Pieter Bruegel may have attempted to convey such a message in his enigmatic painting *Two Monkeys* (Berlin, Gemäldegalerie), and rather blatantly in the engraving of *The Battle between the Moneybags and the Strongboxes*.

ANTWERP AND BRUGES

In view of the similar role both cities have played in the history of European trade, it is tempting to compare (admittedly, in a very superficial manner) the process of commercializing works of art—and painting in particular—in Antwerp as opposed to Bruges. The latter was the *emporium mercatorum* of the Burgundian Netherlands and home of such artistic giants as Jan van Eyck, Hans Memling, Petrus Christus, and Gerard David,[60] but, by the early sixteenth century, the economic focal point clearly had shifted to Antwerp, and soon after, the city on the River Scheldt became *the* art center as well. Even during its heyday, however, the Bruges art market was very different in structure from Antwerp's, and until about 1475 the commercialization of art was not a primary concern of painters in Bruges.

Painters did not need to make sales in the art market to earn a living. In terms of patronage, during most of the fifteenth century Bruges artists could rely on the Burgundian dukes and their entourage for commissions, a luxury that Antwerp never had.[61] In addition, a wealthy upper class of aristocrats, merchants (as, for instance, the Arnolfini brothers), and clergy generously supported the arts. As a result, it was not necessary for the guild to promote uncommissioned art. Quite the contrary; the authorities did their very best to restrict the sale of unsponsored work. Exhibition space was limited in shops and a ban against the import of foreign paintings that might compete with those locally produced was in effect.[62] Therefore, it comes as no surprise that Max Martens has expressed reservations about Campbell's contention that "only a small proportion of pictures were commissioned" in the southern Netherlands at this time. Furthermore, it is plausible that collaboration among artists was not as commonplace as was probably the case in Antwerp, where the workshops were larger, even though masters in Bruges generally employed more pupils and journeymen over the course of time.[63] Indeed, there is very little evidence that on-spec production was widespread in Bruges during its golden age: The degree of commercialization was deliberately kept in check by limiting the standardization and export of ready-made art.

Nevertheless, when the fortunes of the Venice of the North began to wane as the century drew to a close, a change of strategy took place: There was some serialized production of art—as Ainsworth has shown, in the case of Gerard David— and the guild exhibited greater leniency toward free-market sales, as attempts were made to unload more paintings on the open market.[64] Most importantly, workshops grew in size, which allowed for an increasingly streamlined and standardized production process. Interestingly, the enlargement of the workshops and the trend toward calculated production, which took place in Bruges during the latter third of the fifteenth century, was not caused by a heightened demand, as was true in Antwerp, but rather was a response

Figure 14. (right) Unidentified Antwerp Master. *The Adoration of the Magi* (detail of fig. 13)

Early Netherlandish Painting at the Crossroads

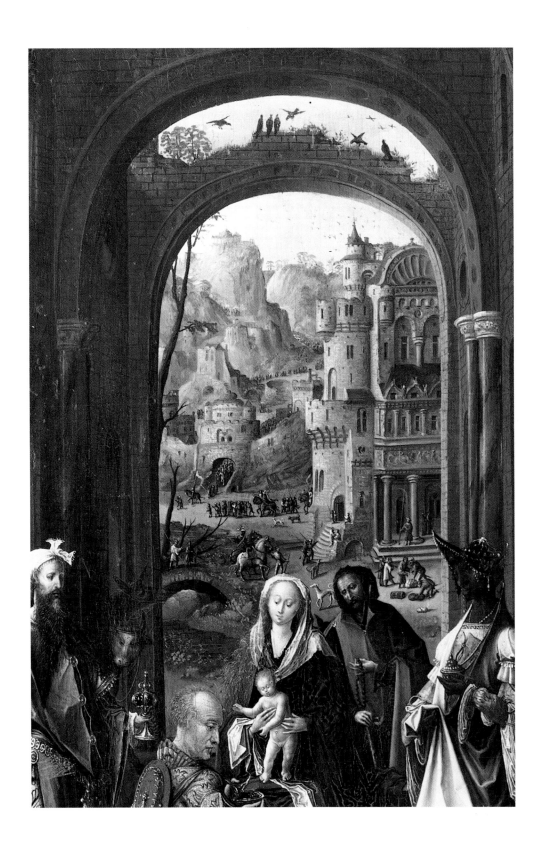

to a shrinking art market. Through innovations in the artistic process, the art community attempted to prevent a further drop in demand to protect the viability of its workshops.[65] In other words, these measures were aimed at reaching new markets, at a time when the old patrons had all but disappeared or become impoverished.

To stimulate exports, a *pand* for luxury commodities, modeled on predecessors in Antwerp, opened in 1482, and before long artists took advantage of it to market their merchandise. Nonetheless, the share of total rents paid by artists for exhibition space was never high—a mere eleven percent in 1512—and it decreased further over the years. By 1528–29, many of the stalls usually occupied by painters remained vacant. Furthermore, not only did the *pand* not open until 1482, but comparable galleries selling art had existed in Antwerp for several decades.[66] Clearly, there was less of a need for such a sales vehicle in Bruges so long as the patronage system engendered a sufficient amount of commissions.

By the late 1480s, the vast majority of foreign merchants had taken up residence in Antwerp. Together with the departure of the Burgundian dukes, a large part of the client base depended upon by Bruges artists appears to have been lost, and many were forced to move. Some masters, such as Gerard David and Jan Provost, remained in Bruges but purchased citizenship in Antwerp as well; others, such as Adriaen Isenbrant, allied themselves with art dealers from Antwerp. Both strategies allowed painters to sell their work directly on the Antwerp market. While these efforts confirm a more market-oriented approach by the Bruges artistic community, they also reveal that there was a lack of commercial outlets in Bruges. In the long run, attempts by Bruges artists to gear the production of paintings toward the open market were not particularly successful. Export registers drawn up in the 1540s and 1550s show very little or no evidence that paintings from Bruges were exported in great numbers.

CONCLUSION

To recapitulate, in a relatively short time the Antwerp art market had become among the most modern in Europe, and the highly commercialized production of art affected economic activity on three levels: Paintings and altarpieces were created in proto-industrial workshops; at the distribution level, the final product was dispersed via the *panden* and art dealers to an international audience; and on the level of the consumer, art was purchased primarily ready made rather than ordered on commission. In the southern Netherlands, the commercialization of paintings and altarpieces was ultimately a result of market forces; in Antwerp, it was due to increasing demand; while in Bruges, artists responded *de facto* to a shrinking market for art.

Paintings and carved altarpieces were not the only works of art that were produced on spec. Both the production and distribution of Flemish tapestries were highly commercialized: Cheaper versions of Brussels masterpieces were mass produced in such cities as Oudenaarde and offered for sale at the *tapissierspand* in Antwerp. The tapestry trade sustained a veritable industry, which represented an important segment of the economy of the southern Netherlands.[67]

The same process of the commercialization of art took place almost simultaneously in Nuremberg and certain Italian cities, but perhaps it was more pronounced and visible in Antwerp than elsewhere because of the *panden*—that is, by the very existence of these vast public art markets, rather than by the way in which these markets affected both the form and content of works of art. Thus, the sixteenth century marked the beginning of a long, complex, and often troublesome relationship between art and economics.[68]

1. Several important works have been published in the last couple of years: See, for instance, M. North and D. Ormrod, eds., *Art Markets in Europe, 1400–1800* (Aldershot, England; Brookfield, Vermont; Singapore; and Sydney: 1998); M. P. J. Martens, "De dialoog tussen artistieke traditie en vernieuwing," in *Brugge en de Renaissance, Van Memling tot Pourbus* (exhib.

cat., Bruges, Memlingmuseum) (Bruges: 1998);
M. W. Ainsworth, "The Business of Art: Patrons,
Clients, and Art Markets," in M. W. Ainsworth and
K. Christiansen, eds., *From Van Eyck to Bruegel. Early
Netherlandish Painting in The Metropolitan Museum of
Art* (exhib. cat., The Metropolitan Museum of Art)
(New York: 1998), pp. 23–38; N. De Marchi and
H. J. Van Miegroet, "Novelty and Fashion Circuits in
the Mid-Seventeenth Century Antwerp–Paris Art
Trade," in *Journal of Medieval and Early Modern Studies*
28 (1998), pp. 201–46; L. Jacobs, *Early Netherlandish
Carved Altarpieces, 1380–1550. Medieval Tastes and Mass
Marketing* (Cambridge, England; New York; and
Melbourne: 1998); J. M. Montias, *Le Marché de l'art
aux Pays-Bas, XVe–XVIIe siècles* (Paris: 1996); M. J.
Bok, *Vraag en aanbod op de Nederlandse kunstmarkt,
1580–1700* (Utrecht: 1994); A. Balis, "Mercado del arte
en Flandes en el siglo XVII," in *Rubens y su siglo*
(exhib. cat., Mexico City, Museo Nacional de San
Carlos) (Mexico City: 1998), pp. 39–45. The central
theme of the 1999 volume of the *Nederlands
Kunsthistorisch Jaarboek* was "Art for the Market."
2. See L. Campbell, "The Art Market in the Southern
Netherlands in the Fifteenth Century," in *The
Burlington Magazine* 118 (1976), pp. 188–98; J. M.
Montias, *Artists and Artisans in Delft: A Socio-Economic
Study of the Seventeenth Century* (Princeton: 1982);
J. M. Montias, "Cost and Value in Seventeenth-Century
Dutch Art," in *Art History* 10 (1987), pp. 455–66; J. M.
Montias, "Socio-Economic Aspects of Netherlandish
Art from the Fifteenth to the Seventeenth Century: A
Survey," in *The Art Bulletin* 72/73 (1990), pp. 358–73;
J. M. Montias, "Le Marché de l'art aux Pays-Bas, XVe et
XVIe siècles," in *Annales ESC* (1993), pp. 1541–63.
3. See J. M. Montias, "The Influence of Economic
Factors on Style," in *De zeventiende eeuw* 6 (1990),
pp. 49–57; J. M. Montias, "Cost and Value in
Seventeenth-Century Dutch Art," in *Art History* 10
(1987), p. 456.
4. See D. Freedberg and J. De Vries, eds., *Art in History.
History in Art. Studies in Seventeenth-Century Dutch
Culture* (Santa Monica: 1991).
5. See A. Van der Woude, "De schilderijproduktie in
Holland tijdens de Republiek. Een poging tot
kwantificatie," in *Kunst-zaken. Particulier initiatief en
overheidsbeleid in de wereld van de beeldende kunst*,
J. C. Dagevos and P. G. van Druenen et al., eds.
(Kampen, The Netherlands: 1991), pp. 18–50, 286–97;
R. van Uytven, "Splendour or Wealth: Art and
Economy in the Burgundian Netherlands," in
Transactions of the Cambridge Bibliographical Society 10
(1992), pp. 101–24; M. J. Bok, *Vraag en aanbod op de
Nederlandse kunstmarkt, 1580–1700* (Utrecht: 1994).
6. This point needs no further elaboration since Max
Martens and Noël Geirnaert have addressed this issue
elsewhere in this volume.
7. See, for instance, E. Honig, *Painting and the Market in
Early Modern Antwerp* (New Haven and London:
1998).

8. See R. Swendberg, "Markets as social structures," in
N. J. Smelser and R. Swendberg, eds., *The Handbook
of Economic Sociology* (Princeton and New York: 1994),
p. 255.
9. For an alternative but not dissimilar definition of
"art market" see B. Tattersall, *Dictionary of Art*, vol. 1,
s.v. "Art Market."
10. This division is somewhat arbitrary. Some works of
art produced for the open market were of a superior
quality, indeed, and fetched reasonably high prices,
but the two market segments adhered to different
modes of production and distribution, each aimed at
a diverse clientele. See N. De Marchi and H. Van
Miegroet, "Art, Value and Market Practices in the
Netherlands in the Seventeenth Century," in *The Art
Bulletin* 76 (1994), p. 453.
11. See M. P. J. Martens, "Some Aspects of the Origins
of the Art Market in Fifteenth-Century Bruges," in
M. North and D. Ormrod, eds., *Art Markets in Europe,
1400–1800* (Aldershot, England; Brookfield, Vermont;
Singapore; and Sydney: 1998), pp. 19–28; L. Jacobs,
*Early Netherlandish Carved Altarpieces 1380–1550.
Medieval Tastes and Mass Marketing* (Cambridge,
England; New York; and Melbourne: 1998); M. W.
Ainsworth, *Gerard David, Purity of Vision in an Age of
Transition* (New York: 1998). In addition, Jean C.
Wilson devoted a substantial chapter to the market in
Bruges in *Painting in Bruges at the Close of the Middle
Ages. Studies in Society and Visual Culture* (University
Park, Pennsylvania: 1998).
12. See L. Silver, "Pieter Bruegel in the Capital of
Capitalism," in *Nederlands Kunsthistorisch Jaarboek* 47
(1996), pp. 125–53.
13. Three factors supported this expansion: English mer-
chants utilized Antwerp as the gateway to eastern
Europe, to facilitate the export of cloth; the Portu-
guese descended on the city to supply Europe with
Indian spices; and the south Germans came laden
with silver, eager to purchase these two commodities;
see H. van der Wee, *The Growth of the Antwerp Market
and the European Economy (Fourteenth–Sixteenth
Centuries)*, 3 vols. (The Hague: 1963).
14. See J. A. Goris, *Lof van Antwerpen. Hoe reizigers
Antwerpen zagen van de XVe tot de XXe eeuw* (Brussels:
1940), pp. 24–27.
15. Ibid., p. 32.
16. See F. Vermeylen, "Exporting Art across the Globe:
The Antwerp Art Market in the Sixteenth Century,"
in *Nederlands Kunsthistorisch Jaarboek* 50 (1999), p. 14.
17. See P. Rombouts and T. Van Lerius, *De liggeren en
andere historische archieven der Antwerpsche Sint-Lucasgilde*,
2 vols. (Antwerp: 1872).
18. Some of the more famous immigrants were Quentin
Massys from Leuven, Joachim Patinir from Dinant,
and Pieter Bruegel from the Breda region.
19. See K. van Mander, *Het schilder-boeck waer in voor eerst
de leerlustighe ineght den grondt der edel vry schilderconst
in verscheyden deelen wort voorgedraghen* (Haarlem: 1604),
fol. 232.

20. Quoted by B. Dubbe and W. H. Vroom, "Mecenaat en kunstmarkt in de Nederlanden gedurende de zestiende eeuw," in *Kunst voor de beeldenstorm* (exhib. cat., Amsterdam, Rijksmuseum) (Amsterdam: 1986), p. 13.

21. See J. M. Montias, "Le Marché de l'art aux Pays-Bas, XVe et XVIe siècles," in *Annales ESC* (1993), p. 1544.

22. See F. Vermeylen, "Exporting Art across the Globe: The Antwerp Art Market in the Sixteenth Century," in *Nederlands Kunsthistorisch Jaarboek* 50 (1999), p. 15.

23. See L. Jacobs, *Early Netherlandish Carved Altarpieces, 1380–1550. Medieval Tastes and Mass Marketing* (Cambridge, England; New York; and Melbourne: 1998), p. 54.

24. See C. Van de Velde, "De Schilderkunst," in *Antwerpen in de zestiende eeuw* (Antwerp: 1975), p. 425; F. Vermeylen, "Exporting Art across the Globe: The Antwerp Art Market in the Sixteenth Century," in *Nederlands Kunsthistorisch Jaarboek* 50 (1999), p. 18.

25. On the *panden* see esp. D. Ewing, "Marketing Art in Antwerp, 1460–1560: Our Lady's *Pand*," in *The Art Bulletin* 72 (1990), pp. 558–84; F. Vermeylen, "Marketing Paintings in Sixteenth-Century Antwerp: Demand for Art and the Role of the *Panden*," in P. Stabel, B. Blondé, and A. Greve, eds., *International Trade in the Low Countries (14th–16th Centuries). Merchants, Organization and Infrastructure* (Leuven and Apeldoorn: 1999), pp. 193–213.

26. See D. Ewing, "Marketing Art in Antwerp, 1460–1560: Our Lady's *Pand*," in *The Art Bulletin* 72 (1990), pp. 558–84.

27. See L. Jacobs, *Early Netherlandish Carved Altarpieces, 1380–1550. Medieval Tastes and Mass Marketing* (Cambridge, England; New York; and Melbourne: 1998), pp. 168, 199–200.

28. Ibid., p. 200.

29. See F. Vermeylen, "Art and Economics: The Antwerp Art Market of the Sixteenth Century," Ph.D. diss. (New York: Columbia University, 2000), pp. 207–12.

30. The document SAA, N 1478, dated February 26, 1583, lists other miscellaneous items.

31. See K. van Mander, *The Lives of the Illustrious Netherlandish and German Painters, from the First Edition of the Schilderboeck (1603–1604)*, vol. 1, H. Miedema, ed. (Doornspijk: 1994), pp. 254–55, fol. 249 *r*.

32. Ibid., vol. 4, p. 110.

33. See L. Jacobs, *Early Netherlandish Carved Altarpieces, 1380–1550. Medieval Tastes and Mass Marketing* (Cambridge, England; New York; and Melbourne: 1998), pp. 228–35.

34. See F. Vermeylen, "Exporting Art across the Globe: The Antwerp Art Market in the Sixteenth Century," in *Nederlands Kunsthistorisch Jaarboek* 50 (1999).

35. "De wercken van alle dese schilders zijn niet alleenlijck in alle dese landen, maer oock meestendeels de gantsche wereldt door verbreytt: want daer wort groote coopmanschap met ghedaen": L. Guicciardini, *Beschryvinghe van alle de Nederlanden* (Amsterdam: 1612), p. 81.

36. ARAB, rk 23357–64. For a more in-depth analysis of these figures see F. Vermeylen, "Art and Economics: The Antwerp Art Market of the Sixteenth Century," Ph.D. diss. (New York: Columbia University, 2000), pp. 125–60.

37. ARAB, rk 23470-2. For a discussion on the discrepancy between the two export figures see my "Further Comments on Methodology" in this volume.

38. ARAB, rk 23471, fol. 81 *r.*, fol. 117 *r.*, fol. 142 *v.*, fol. 145 *v.*, and fol. 206 *r.-v.*

39. See F. Vermeylen, "Exporting Art across the Globe: The Antwerp Art Market in the Sixteenth Century," in *Nederlands Kunsthistorisch Jaarboek* 50 (1999), pp. 21–22; L. Jacobs, *Early Netherlandish Carved Altarpieces, 1380–1550. Medieval Tastes and Mass Marketing* (Cambridge, England; New York; and Melbourne: 1998).

40. See L. Jacobs, *Early Netherlandish Carved Altarpieces, 1380–1550. Medieval Tastes and Mass Marketing* (Cambridge, England; New York; and Melbourne: 1998), p. 9.

41. For a brief description and further bibliography see M. W. Ainsworth, *Gerard David, Purity of Vision in an Age of Transition* (New York: 1998), pp. 47–49, 55, n. 79.

42. See S. H. Goddard, *The Master of Frankfurt and His Shop* (Verhandelingen van de Koninklijke Academie voor Wetenschappen 38) (Brussels: 1984), pp. 82–101; J. M. Montias, *Le Marché de l'art aux Pays-Bas, XVe–XVIIe siècles* (Paris: 1996), p. 42.

43. See L. Jacobs, *Early Netherlandish Carved Altarpieces, 1380–1550. Medieval Tastes and Mass Marketing* (Cambridge, England; New York; and Melbourne: 1998), pp. 228–31.

44. See J. Van der Stock, "Beeld in veelvoud te Antwerpen (15de eeuw–1585). Produktie—controle—consumptie. Vijf perspectieven," Ph.D. diss. (University of Leuven: 1995), p. 327.

45. See K. van Mander, *The Lives of the Illustrious Netherlandish and German Painters, from the First Edition of the Schilderboeck (1603–1604)*, vol. 1, H. Miedema, ed. (Doornspijk: 1994), pp. 185–86; E. Leuschner, "Defining Backer. New Studies on the Last Phase of Antwerp Mannerism before Rubens," in *Gazette des Beaux-Arts* (April 2001), pp. 167–92.

46. The ordinance reads, in part, "te doen maecken voor andere persoonen"; see J. B. Van der Straelen, *Jaerboeck der vermaerde en kunstrycke Gilde van Sint Lucas binnen de stad Antwerpen* (Antwerp: 1855), pp. 63–65.

47. See F. Vermeylen, "Marketing Paintings in Sixteenth-Century Antwerp: Demand for Art and the Role of the *Panden*," in P. Stabel, B. Blondé, and A. Greve, eds., *International Trade in the Low Countries (14th–16th Centuries). Merchants, Organization and Infrastructure* (Leuven and Apeldoorn: 1999), pp. 193–213.

48. See D. Ewing, "Marketing Art in Antwerp, 1460–1560: Our Lady's *Pand*," in *The Art Bulletin* 72 (1990), p. 561.

49. See L. Jacobs, *Early Netherlandish Carved Altarpieces, 1380–1550. Medieval Tastes and Mass Marketing* (Cambridge, England; New York; and Melbourne: 1998), pp. 157–58; J. M. Montias, "Le Marché de l'art aux Pays-Bas, XVe et XVIe siècles," in *Annales ESC* (1993), p. 1558, n. 53.

50. See the document SAA, N 2071, dated August 22, 1542, fol. 126*v*.

51. See R. Goldthwaite, *Wealth and the Demand for Art, 1300–1600* (Baltimore: 1993); F. Vermeylen, "Marketing Paintings in Sixteenth-Century Antwerp: Demand for Art and the Role of the *Panden*," in P. Stabel, B. Blondé, and A. Greve, eds., *International Trade in the Low Countries (14th–16th Centuries). Merchants, Organization and Infrastructure* (Leuven and Apeldoorn: 1999), pp. 193–213.

52. See R. Goldthwaite, *Wealth and the Demand for Art, 1300–1600* (Baltimore: 1993), p. 99.

53. See A. Balis, "Mercado del arte en Flandes en el siglo XVII," in *Rubens y su siglo* (exhib. cat., Mexico City, Museo Nacional de San Carlos) (Mexico City: 1998).

54. See M. W. Ainsworth, *Gerard David, Purity of Vision in an Age of Transition* (New York: 1998), p. 37.

55. See the document SAA, V 647, dated July 13, 1520, fol. 312*v*.; this reference was kindly supplied by Jan Van der Stock.

56. See A. Balis, "De nieuwe genres en het burgerlijk mecenaat," in J. Van der Stock, ed., *Stad in Vlaanderen. Cultuur en Maatschappij 1477–1787* (Brussels: 1991), pp. 237–54, esp. p. 238.

57. See L. Jacobs, *Early Netherlandish Carved Altarpieces, 1380–1550. Medieval Tastes and Mass Marketing* (Cambridge, England; New York; and Melbourne: 1998), p. 31. As a result, exports of altarpieces came to a virtual standstill; see F. Vermeylen, "Exporting Art across the Globe: The Antwerp Art Market in the Sixteenth Century," in *Nederlands Kunsthistorisch Jaarboek* 50 (1999), p. 22.

58. De Momper would function as *pandmeester* off and on for the remainder of the sixteenth century; he was registered in the guild both as a painter and an art dealer. See F. Vermeylen, "Marketing Paintings in Sixteenth-Century Antwerp: Demand for Art and the Role of the *Panden*," in P. Stabel, B. Blondé, and A. Greve, eds., *International Trade in the Low Countries (14th–16th Centuries). Merchants, Organization and Infrastructure* (Leuven and Apeldoorn: 1999), pp. 193–213.

59. Dan Ewing also suggested this interpretation at "Art in Antwerp," a conference held at Smith College, Northampton, Massachusetts, November 12, 1994.

60. See W. Brulez, "Brugge en Antwerpen in de 15de en 16de eeuw: een tegenstelling?," in *Tijdschrift voor Geschiedenis* 83 (1970), pp. 15–37.

61. Granted, the Burgundian dukes did not always reside in Bruges, as the court was ambulant, but they did spend enough time there to generate a steady flow of commissions for works of art.

62. See M. P. J. Martens, "Some Aspects of the Origins of the Art Market in Fifteenth-Century Bruges," in M. North and D. Ormrod, eds., *Art Markets in Europe, 1400–1800* (Aldershot, England; Brookfield, Vermont; Singapore; and Sydney: 1998), pp. 19–20; M. P. J. Martens, "De dialoog tussen artistieke traditie en vernieuwing," in *Brugge en de Renaissance, Van Memling tot Pourbus* (exhib. cat., Bruges, Memlingmuseum) (Bruges: 1998), p. 55.

63. See M. P. J. Martens, *Artistic Patronage in Bruges Institutions, ca. 1440–1482* (Ann Arbor: 1992), pp. 38–41; M. P. J. Martens, "Some Aspects of the Origins of the Art Market in Fifteenth-Century Bruges," in M. North and D. Ormrod, eds., *Art Markets in Europe, 1400–1800* (Aldershot, England; Brookfield, Vermont; Singapore; and Sydney: 1998), pp. 22–26.

64. See M. P. J. Martens, "Some Aspects of the Origins of the Art Market in Fifteenth-Century Bruges," in M. North and D. Ormrod, eds., *Art Markets in Europe, 1400–1800* (Aldershot, England; Brookfield, Vermont; Singapore; and Sydney: 1998), p. 21; M. W. Ainsworth, *Gerard David, Purity of Vision in an Age of Transition* (New York: 1998), pp. 293–97.

65. See M. P. J. Martens, "Some Aspects of the Origins of the Art Market in Fifteenth-Century Bruges," in M. North and D. Ormrod, eds., *Art Markets in Europe, 1400–1800* (Aldershot, England; Brookfield, Vermont; Singapore; and Sydney: 1998), pp. 24–26.

66. The Dominican *pand* in Antwerp was selling artwork during the fairs as early as 1445, and Onser Liever Vrouwen Pand opened in 1460; see D. Ewing, "Marketing Art in Antwerp, 1460–1560: Our Lady's *Pand*," in *The Art Bulletin* 72 (1990), pp. 560, 561. M. P. J. Martens, *Artistic Patronage in Bruges, Institutions, ca. 1440–1482* (Ann Arbor: 1992), p. 41, also claims that there is no reason to assume that painters and other artists were displaying their precious wares at the *pand* in Bruges before 1511.

67. See W. Brulez, "De handelsbalans van de Nederlanden in het midden van de 16e eeuw," in *Bijdragen voor de Geschiedenis der Nederlanden* 21 (1966–67), p. 302. H. van der Wee, "Handel in de Zuidelijke Nederlanden," in *Nieuwe Algemene Geschiedenis der Nederlanden*, vol. 7, pp. 75–97, estimated that the tapestry industry provided employment for up to 20,000 workers in the mid-sixteenth century.

68. I would like to thank Arnout Balis for his suggestions and careful reading of this text. I am also grateful to John Michael Montias for his constructive criticism.

John Michael Montias

Commentary: Fine-tuning Interpretations

I have little to quarrel with regarding the main issues raised in Filip Vermeylen's essay. I find much of what he has to say on the adaptation of artists' supply to export demand—the simplification of design, the use of shortcuts to curtail costs, and so forth—relevant, and to some extent original. I do wish, however, that he were less sure of the solidity and accuracy of his quantitative propositions. We must always keep in mind that when we are dealing with the fifteenth and sixteenth centuries, statistics on the marketing and prices of works of art are very scarce. There are only a small number of paintings and carved altarpieces about which we know more or less with certainty whether they were commissioned or produced for the market on spec. While it is probable that, from the 1480s on, there was a trend toward sales on spec for works of both types—and yes, on average, those made on spec *were* less expensive than their commissioned counterparts—the evidence on all counts is still weak.

Quantitative estimates must be used with great care. It is tempting but dangerous to cite those by other scholars, making more of them than they originally were meant to convey. Take, for instance, Vermeylen's interpretation of Lynn Jacobs's estimate of the production of carved altarpieces for export in the late fifteenth and the sixteenth century. Vermeylen writes: "Jacobs spared no effort in her book to claim that in Antwerp up to seventy-five per-

cent of carved altarpieces were, indeed, produced for the open market rather than on commission" (see page 51). From there he goes on to speculate that, "Given the high export figures and the absolutely stunning numbers of ready-made paintings on sale at the *pand* . . . the conclusion is inescapable that the percentage of paintings made for export must have been even higher—probably about ninety percent of the total output." In the introduction to her book, to which Vermeylen refers, Lynn Jacobs does claim that "the vast majority of carved altarpieces—perhaps as much as 75 percent—were exported to buyers outside the area."[1] The basis of this estimate is developed in chapter 6 of Jacobs's book. She notes that, of 350 surviving Brabantine altarpieces, seventy-five percent were found outside Belgium.[2] She warns her readers that this percentage must be "taken with great caution" because the ravages of Iconoclasm were particularly strong in the southern Netherlands in the sixteenth century, so that "larger numbers of carved retables may have been destroyed here than abroad"—a very sensible observation. She concludes, nevertheless, that "exports could well have formed the majority of sales." She might have added that cheaper works of art (those that were produced mainly for an anonymous market) tended to be destroyed or otherwise to have disappeared over time more rapidly than expensive ones: The works (altarpieces or paintings) that have survived constitute a very biased sample of those that were initially produced. The selective ravages of time may well have had an impact on the ratio of exports to total production. Jacobs's estimate is a useful point of departure but hardly more than that. It certainly cannot be used to demonstrate that seventy-five percent of the carved altarpieces were produced for the open market, let alone, by analogy, to estimate that ninety percent of the total output of paintings was produced on spec.

In addition to the cavalier use of numbers, there is a problem in distinguishing between

commissioned works and those produced on spec. Exported works of art need not have been produced on spec; they might have been commissioned by churches or even by private collectors abroad.[3] Lynn Jacobs frequently refers to retables with a predella or other component that had been customized to represent a favorite saint or the portrait of a donor. Should altarpieces such as these be classified as commissions or as examples of on-spec production? In the case of paintings, does a customer visiting an artist's studio, who asks to buy a copy of an original on view, which must be ordered in advance, really qualify as a "commissioner" of the work? In my view, there is a fine line between commissioning a work of art and buying one on spec, which at the very least complicates the problem of estimating the relative importance of one type over the other.

The table in Vermeylen's article (see fig. 12) contains some interesting data on the export of paintings from Antwerp between 1543 and 1545, based on a one-percent tax levied on exports. According to this table, just over a third of the exported paintings were sent to the Iberian Peninsula (Spain and Portugal) and 23.9 percent to "Germany" (presumably, the constituents of the Holy Roman Empire). Total exports in those years amounted to 130 shipments valued at 6,006 guilders. On the assumption that these statistics conform to the normal period of the toll, from May 1, 1543, to April 30, 1545, exports over these two years average out to 3,003 guilders per year.

These statistics appear to have been derived from the *Brabantse Watertol*, a tax "payable by those who were not citizens of Brabant on all goods which were brought by river via the Scheldt or the Honte to or from Antwerp."[4] From May 1, 1543, to April 30, 1545, the taxes collected on this toll amounted to 863,226 Flemish groats or 21,580 guilders of 40 groats each. In addition, exports by land were subject to the Brabant land toll. The amount collected from November 1543 to October 1544 from this toll (levied at twenty-nine tollhouses) for all goods was 8,400 guilders. I take it that Vermeylen's export data do not include overland shipments, such as those to Paris. It may be noted in passing that

the one-percent tax on the export of paintings cited in the table would have yielded about sixty guilders, or a mere .3 percent of the tolls collected on the water route.

We have seen that exports of paintings in the early 1540s via the water route generated about three thousand guilders a year in tolls. What does that figure represent in terms of the total value of paintings produced in those years? Our only reliable statistical anchor is the daily wages of master carpenters and free journeymen in Antwerp in that period— 7.5 stivers a day.[5] For a 220-day year, this amounts to a little over 80 guilders annually. Exports of paintings thus represented 37.5 years of a master carpenter's work. To figure out how many years of a master painter's work these exports might represent requires very speculative assumptions. In Delft—which, to be sure, was not as advanced or developed a city as Antwerp during this period—an ordinary painter working for the Oude Kerk was paid one-and-a-half times as much as a laborer (who earned less than a master carpenter) in 1550–51,[6] and successful masters two to three times as much.[7] Exports would have amounted to between twelve and nineteen years of a master painter's work. To relate these figures to the total activity of master painters in the guild, we cannot make use of Guicciardini's estimate—cited by Vermeylen— of "300 artists" active in Antwerp in the 1560s because we do not know whether the number comprises apprentices or what the proportion of painters was to the entire guild membership. I prefer to assume that the percentage ratio of master painters to the total population of Antwerp in the mid-sixteenth century (90,000 inhabitants) was about the same as in the major cities of the Dutch Republic in the mid-seventeenth century (1 to 1.5 per 1,000).[8] This would imply that there were between 90 and 135 master painters (and as many man-years of a master painter's work). To this should be added the production of paintings by journeymen and advanced apprentices (I cannot even guess at the amount). This suggests that exports via the water route might have represented anywhere between twelve and twenty percent of the total output of master painters,

or even less if the production of assistants is included.[9] If exports via the land route added another fifty percent to the exports by water, together they may have comprised at most eighteen to thirty percent of the total. This seems like a reasonable result: The proportion is significant but falls somewhat short of the claims made by Vermeylen at several points in his discussion about the "globalization" of the painters' industry. (I suspect, incidentally, that the proportion of exported carved altarpieces came closer to between fifteen and thirty percent rather than to the fifty to seventy-five percent estimated by Jacobs and Vermeylen.)

Now, to turn to a fairly widespread problem, touched on by Vermeylen and by a number of other scholars in the field, there seems to be general agreement that the market for art expanded in the fifteenth and the early sixteenth century and that cost-cutting innovations were an appropriate response to "meet the increased demand." Neither part of this proposition is self-evident. The economic historian Henri Pirenne built a good part of his reputation after World War I by asserting that this period was one of restriction and retrenchment during which the stranglehold of the guilds held back economic development.[10] Very recently, the distinguished historian Jonathan Israel argued in the pages of *Art History* that cost cutting, at least in Holland in the first part of the seventeenth century, was not a response to an increase in demand but, on the contrary, an adaptation to a decline in demand, as artists sought to counter the market-shrinking effects of the recession, which he associates with the resumption of the war with Spain after the end of the twelve-year truce in 1621.[11] At first glance, the idea that artists may have cut costs to maintain a certain level of sales despite a recession is just as plausible as the traditional assertion that process innovations were adopted in response to increased demand. It should not be surprising to discover, therefore, that, in the course of history, cost-cutting innovations have occurred in periods of both high and low demand. How does this square with Vermeylen's proposition that paintings in Bruges chiefly were commissioned rather than

produced on spec? Did most of the independent master sculptors and painters who had an open shop obtain commissions from the Burgundian court? If they did receive such commissions toward the middle of the fifteenth century, did they do so at the end? Is Vermeylen's proposition consistent with the evidence of cost-cutting innovations in the work of such Bruges painters as Gerard David and Adriaen Isenbrant in the first and second decades of the sixteenth century?

The notion that cost-cutting innovations were a response to the increased demand for art slices through a complicated economic process. Students of Economics 101 are familiar with the response of a light industry (for example, pin making) to an increase in demand, which consumes a small proportion of the entire supply of raw materials and other factors that it employs. A higher demand will elicit a short-run increase in the price of pins, but prices will revert to their original level as more resources become available in the industry. (One should note that the industry, however, is too small to affect the prices of these resources.) Granted, an increase in the demand for art occurred in the fifteenth and the early sixteenth century, but why were cost-cutting measures introduced to avert an increase in prices, which would have cut back on demand? This was done precisely because the painting and sculpture "industries" relied on means of production that were in short supply and could *not be increased* readily in the middle to the long run. The principal such factor, of course, was a highly skilled labor force trained to produce art. This is where a careful study and comparison of art guilds in different cities may yield useful answers. How many years of apprenticeship were required in Bruges and in Antwerp before a fledgling painter or sculptor could become a master? Did the apprentice, as was the case in Haarlem (but not in Delft) in the seventeenth century, have to spend some time as a journeyman in the atelier of a master before he could establish a studio of his own? How rigidly were the guild restrictions applied that limited the simultaneous employment of apprentices in any one workshop to one or

two at a time? Filip Vermeylen has shown us that the number of new masters rose rapidly in Antwerp in response to the increased demand for works of art. Is there even partial evidence that this was also the case in Bruges?

However, it was not merely a question of sheer numbers of artists but of the limited pool of talented individuals among them who could be trained to the very high standards required for them to become established masters in their specialty. As I study the careers of apprentices and masters in seventeenth-century Delft, Haarlem, and Amsterdam, I am struck by how many apprentices it took to produce one master painter who distinguished himself sufficiently from the crowd for his work to be recognized by a notary or clerk drawing up an inventory—sufficiently enough, that is, for the notary or clerk to attribute a painting to that artist. The great majority of the names of apprentices that have come down to us are unrecorded in the inventories of the period—or in any subsequent sources for that matter. Of course, painting in Holland in the seventeenth century differed from painting in Bruges and in Antwerp in the fifteenth and sixteenth centuries in that there were very few large studios in Holland—and those that existed were mainly headed by the most successful practitioners of court portraiture and history painting.

In the seventeenth century, most artists made do with one or two apprentices, but it would seem that large studios prevailed in fifteenth- and early-sixteenth-century Bruges and Antwerp, economizing on scarce talent. They made it possible to combine the above-average ability of one master with the efforts of a number of not-so-talented assistants. Any mediocre independent master could make copies, using workshop drawings and transfer techniques to accelerate the production of new works, but the large atelier could also take advantage of economies of scale that were not available to the independent master. Specialization of tasks could only be effected in the larger studio. A set of stock figure drawings (for example, one for each apostle and for each major male or female saint) could almost as

easily be utilized by ten assistants as by one. Perhaps this also suggests why process innovations differed in the earlier period from those that were introduced a century later. In the large studio of the earlier period, innovation was oriented to gains from scale—specialization by tasks, copying, and the use of stock patterns. Later on, independent masters working more or less by themselves developed new techniques for accelerating the completion of their own works, such as painting "wet on wet," the elimination of intermediary stages requiring a lengthy drying process, and applying paint "alla prima." Some of these techniques, as Maryan Ainsworth points out, were already employed earlier, although they were not as fully developed. In the early sixteenth and the seventeenth century, it was the emphasis on workshop copies rather than on inexpensive "original" works of art that probably helps to explain the differences in the size and operation of painters' studios.

1. See L. Jacobs, *Early Netherlandish Carved Altarpieces, 1380–1550. Medieval Tastes and Mass Marketing* (Cambridge, England; New York; and Melbourne: 1998), pp. 9–10.
2. Ibid., p. 205.
3. Vermeylen recognizes this problem but argues that exports "consisted almost exclusively of non-commissioned art." This is plausible, but I would have liked to have seen some quantitative confirmation of this claim.
4. See H. van der Wee, *The Growth of the Antwerp Market and the European Economy (Fourteenth–Sixteenth Centuries)*, vol. 1 (The Hague: 1963), p. 510.
5. Ibid., p. 363.
6. J. M. Montias, *Artists and Artisans in Delft: A Socio-Economic Study of the Seventeenth Century* (Princeton: 1982), p. 20.
7. The ratio was probably closer to four to one in the seventeenth century (J. M. Montias, "Estimates of the Number of Dutch master painters, their earnings and their output," in *Leidschrift* 6, 3, pp. 59–74). Note that the higher the assumed ratio of a painter's wages to those of a master carpenter, the *lower* the ratio of exports to total annual production.
8. Ibid.
9. I assume that the value of their output was approximately equal to the total income of painters (in other words, that non-labor costs were negligible).
10. See H. Pirenne, *Economic and Social History of Medieval Europe* (London: 1956).
11. See J. I. Israel, "Adjusting to Hard Times: Dutch art during its period of crisis and restructuring," in *Art History* 20 (1997), pp. 449–76.

Filip Vermeylen

Further Comments on Methodology

While it is always dangerous to quote statistics from other scholars, it does not necessarily mean that you endorse them or take them for granted (see page 62). I have, indeed, referred to the estimate made by Lynn Jacobs that seventy-five percent of all carved altarpieces produced in the southern Netherlands were made on spec, but neither her argument nor the number she arrived at is essential to the point I wish to make. Whether it was seventy-five percent or forty to fifty percent (no doubt a more realistic figure) does not change in the least the fact that art in Antwerp was subject to a high degree of commercialization—which is my argument.

Montias raises an interesting problem when he discusses the definitions of and distinctions between the on-spec and on-commission modes of production (see page 62). Empirical evidence from Antwerp for both altarpieces and paintings reveals that what prevailed was a *mengvorm*—a type that defied the strict separation of the two forms. Carved altarpieces, especially, often mixed a standardized *caisse* and some personalized scenes and components. According to Ria De Boodt (Free University of Brussels), who has performed technical research on dozens of Brabantine retables, as many as twenty-five percent of the extant examples could fall

into this category. The same holds true for painting. The presence of the unfinished diptychs at van Kessel's shop in the Antwerp *schilderspand* in 1583 is very significant, as it underscores the high degree of commercialization of the art trade. The availability of "double canvases of various types, some not finished," gave the potential customer another option in addition to purchasing a ready-made painting or commissioning a new one (see page 50). In Antwerp, he or she could thus acquire a semi-finished painting to which personalized elements, such as a portrait or a coat of arms, could be added at a later stage. This was already the case much earlier in the century with Antwerp Mannerist paintings. The wings of these triptychs were occasionally left blank so that the ultimate buyer (often located in foreign lands) could have the work customized by requesting that his portrait or his patron saint be painted in.

It is true that I suggested that as many as ninety percent of the paintings produced could have been completed on spec. I was astounded to learn from an archival document that more than six hundred paintings were offered for sale in just one shop in the *schilderspand* (see page 50). Given the fact that there were one hundred shops in the gallery as well as additional venues in the city where ready-made paintings were marketed, it seemed to me that *in terms of absolute numbers* the total output of on-spec works must have been astronomical. Granted, we are talking of mostly cheap paintings *op doek* (on canvas), yet they numbered in the thousands. Again, in terms of countable works of art, the commissioned paintings could have represented only a fraction of the overall production.

There are, of course, some problems with my proposition, even though it is presented

merely as a point of departure. First of all, the relevance of working with absolute numbers can be questioned. Paintings that were commissioned tended to be significantly more expensive and required the input of many additional man-hours. Also, the fact that I do not know the exact number of paintings produced in Antwerp during the sixteenth century renders my figure of ninety percent even more speculative.

It is, thus, no surprise that Montias criticizes this hypothesis and arrives at an alternative figure of eighteen to thirty percent of paintings produced for the open market. However, as his percentages are based on the *value* of these paintings, the two figures should not be compared at all. Nevertheless, an attempt to come to an *ad valorem* estimate of what the speculative production of paintings might have represented is a worthwhile exercise. Montias's approach and method are not free of error, and fail to take into consideration the particularities of the Antwerp economy and art market in the sixteenth century.

As a starting point, Montias cites the table that I have provided (see fig. 12), its statistics taken from export registers for 1543 to 1545.[1] He assumes that the *Brabantse Watertol* was consulted to compile these figures (see page 63), but the amount of detailed information contained in the table is not available in these volumes. Unlike the *Watertol*, the export registers do include overland shipments, but such records are virtually non-existent for France, as the Habsburgs were at war with the French king, Francis I.[2] In fact, the toll was conceived to fund this war and was abolished shortly after the warring parties signed the Treaty of Crépy in 1544.

Montias proceeds by using export figures for the early 1540s essentially to make statements about art production in Antwerp during the 1550s and 1560s; fortunately, the other parameters he uses date from the appropriate time period.[3] In my view, comparing the two periods significantly distorts

the reality and increases the margin of error beyond acceptable levels. After all, the early 1540s were a time of transition for the economy. The southern Netherlands as a whole were recovering from a severe depression, which had crippled the region the previous decade. To make matters worse, Marten van Rossum pillaged the surrounding countryside during the summer of 1542, and Antwerp doubtlessly suffered further disruptions of trade due to the ongoing war with France. The fluctuations of the art market perhaps can be best tracked by examining the revenues of the city's most important venue for art sales, the newly opened *schilderspand* (see the graph, fig. 15). Clearly, the two years covered by the export registers do not indicate a period of booming art sales.[4]

In light of the wealth of information contained in the copious volumes of the *Brabantse Watertol*, I firmly believe that the export registers are a unique source, but I do acknowledge their shortcomings. The war with France certainly was an impediment for the export industries, and long-distance trade was still modest compared to what it would be in the future. The registers, therefore, supply us with a very conservative estimate of the art trade. My sense of Antwerp's commercial situation during the 1540s is reminiscent of what the economist W. W. Rostow has called the "take-off phase" of an economy. The ingredients for a rapid and exponential growth were present, but there were no results yet.[5] In terms of the art market, significant changes were taking place in the production process (as, for example, in the workshop of Pieter Coecke van Aelst) and in the distribution of art (year-round art sales at the *panden*) on which the city would capitalize during its true golden age, the 1550s and 1560s, so eloquently described by Guicciardini.

In order to reach his percentage of speculative production, Montias embarks on a very treacherous journey, indeed. For this he needed to know, first of all, how many masters were producing paintings in

Antwerp. He uses a figure of 90,000, which does approximate the size of the city's population during the 1550s, to calculate the number of masters, which he bases on the ratio that existed in the Dutch Republic (see page 63). This kind of extrapolation is certainly not without risk, however, even if we accept the hypothesis of 90 to 135 master painters, it is again an estimate, which at best *might* reflect the situation of the 1550s and 1560s, but surely does not apply to the years prior to 1545.[6]

There are strong indications that the art trade improved after 1545. Not only are increasing sales reflected in the revenues of the *schilderspand* but the expansion of the art market becomes evident when we examine the very similar revenues of an export tax, one that was levied in 1552–53. Again, another war with France prompted the toll, but only trade with the Iberian Peninsula was subjected to the tax.[7] The quasi-identical method of taxation allows for some interesting comparisons, and an

analysis of the toll books unequivocally shows that the export of all kinds of luxury items (for example, tapestries, books, musical instruments, and globes) had grown compared to ten years earlier.[8] In my text, I point out that Spain and Portugal imported about 1,011 guilders' worth of paintings annually from 1543 to 1545, but that this sum rose to 17,543 guilders from January 1 to December 31, 1553.[9] Incidentally, this spectacular increase is corroborated by the exponential growth of the revenues of the *schilderspand*. Of course, these amounts refer only to the Iberian Peninsula, but it is not inconceivable that exports to other locations enjoyed a similar increase, and, while perhaps not as pronounced, certainly were greater than they had been a decade earlier. As a result, the figure of 3,003 guilders (annual exports of paintings) Montias used in his calculations should be augmented substantially. If we adjust the numbers to reflect the historical reality more accurately, a very different percentage will emerge.

Figure 15. Revenues of the *schilderspand* (1540–1600) (in guilders)

　　Early Netherlandish Painting at the Crossroads

We need to modify the model in one other aspect. A more fundamental fallacy in the calculations presented by Montias lies in the *de facto* equation of export data with the total of on-spec production. Naturally, only a part of these non-commissioned paintings found their way abroad. It is very difficult to estimate the relative importance of exports, but I would suggest that this segment of the market was, indeed, substantial. On the other hand, scholars like Herman van der Wee repeatedly have stressed the significance of the home market for Antwerp's commerce and industry; in the mid-sixteenth century, it stretched from Groningen in the far north to Arras in the south, and included such prosperous art-purchasing cities as Bruges, Brussels, Mechlin, Amsterdam, and, not least, Antwerp itself. Surely, the domestic consumption of non-commissioned works of art must have been impressive in both volume and value, possibly equaling or even exceeding exports.

In conclusion, if we were to adopt Montias's model for calculating the portion of on-spec paintings produced in mid-sixteenth-century Antwerp, we would need to use an annual export figure of 20,000 guilders for paintings (still, no doubt, a conservative estimate) instead of the 3,000 guilders he suggested. In addition, we would have to add a significant sum of guilders for those paintings bought by Flemings, Walloons, and Dutchmen, which would raise the figure by several thousands of guilders per year. I am reluctant to present yet another percentage, but it should be clear from my comments and calculations that the ultimate figure—all other things being equal—will be much higher than the eighteen to thirty percent proposed by Montias. In my opinion, it seems plausible that, in terms of the man-hours expended by the master painter and his workshop, the production of paintings for the open market can be situated in the fifty to seventy-five percent range of the total output.

1. SAB, rk 23357-64. I compiled the export data for February 10, 1543, to February 9, 1545. For a discussion of the 100 Penny tax see F. Vermeylen, "Exporting Art across the Globe: The Antwerp Art Market in the Sixteenth Century," in *Nederlands Kunsthistorisch Jaarboek* 50 (1999), pp. 13–29.

2. At first glance, the inclusion of overland exports may strengthen Montias's argument, but I will show this made little difference.

3. For instance, the figure of 90,000 applies to the population in the 1550s, not the early 1540s, when an estimated 84,000 people resided in Antwerp. Population figures can be found in G. Marnef, *Antwerp in the Age of Reformation. Underground Protestantism in a Commercial Metropolis, 1550–1577* (Baltimore and London: 1996), p. 5. See also R. Boumans and J. Craeybeckx, "Het bevolkingscijfer van Antwerpen in de 16de eeuw," in *Tijdschrift voor Geschiedenis* 60 (1947), pp. 394–405; J. Van Roey, "De bevolking," in *Antwerpen in de XVIde eeuw*, pp. 95–108.

4. The other gallery involved in the selling of paintings in Antwerp at this time was Onser Liever Vrouwen Pand. The revenues for this market also (on average) increased during the 1550s, but only marginally so.

5. Rostow, of course, wrote primarily about industrialized nations, and this comparison should not be taken too literally; see W. W. Rostow, *The Stages of Economic Growth. A Non-Communist Manifesto*, 3rd ed. (Cambridge, England: 1990).

6. The membership lists of the Guild of Saint Luke suggest that the number of new masters registered was significantly lower during the 1540s compared to the 1550s, and even show a drop of nineteen percent compared to the 1530s (see the graph, fig. 15, in my text).

7. SAB, rk 23470-2. These registers are almost identical to those from the 1540s, and unless one looks at the dates, one cannot tell them apart. The toll did double from one to two percent of the value of all goods imported and exported.

8. For instance, the value of exported books rose from 1,374.5 to 56,670 guilders in ten years. See F. Vermeylen, "Art and Economics: The Antwerp Art Market of the Sixteenth Century," Ph.D. diss. (New York: Columbia University, 2000), pp. 152–54.

9. My first impression is that exports of other luxury items experienced an equally large increase.

Molly Faries

Reshaping the Field: The Contribution of Technical Studies

Early Netherlandish painting always has been closely identified with technical studies— more so, in fact, than almost any other area in the history of art. Most of the recent developments can be explained by what I consider an extraordinary commitment on the part of museums, in this country and abroad, to conservation research, systematic catalogues, and groundbreaking exhibitions, such as "From Van Eyck to Bruegel," held at The Metropolitan Museum of Art in 1998–99. This commitment is undoubtedly based on the long-standing recognition that Early Netherlandish paintings lend themselves to technical investigation. From the end of the nineteenth century, when Northern European panel paintings were first studied with X-rays, to the present, when a much wider range of investigative methods is available, Northern paintings have yielded a wealth of information about the ways in which they were made. These richly crafted works have provided us with a virtual explosion of new visual documents that form a unique record of artists' working procedures. More importantly, technology has developed so that artists' working methods no longer need to be elucidated strictly in terms of what traditionally has

been rather dryly labeled "materials and technique." The painting process now also can be imaged in pictorial and conceptual terms—something that was unimaginable in the days before infrared reflectography.

FINDING A PLACE FOR TECHNICAL STUDIES IN ACADEMIC TRADITIONS

Given the extent of technical investigations in the Early Netherlandish field, it should be easy to point to a long history of ongoing scholarship that would lead logically to all the current activity. Yet, it is difficult, in fact, to find the proper background against which technical studies can be profiled. There is really only one continuous literary tradition that helps to explain the close connection of Early Netherlandish painting and technical studies. This has to do, of course, with Jan van Eyck and his reputed "invention" of oil painting. The legend itself, as is well known, was the invention of Giorgio Vasari, who told the story of Jan van Eyck's discovery in both editions of his *Vite*. Vasari's claim sustained a steady stream of literature extending from the sixteenth century to such authors as Karel van Mander, who appears to have been an important proponent of the invention legend and was not countered until 1781, when Gotthold Ephraim Lessing published Theophilus's twelfth-century manuscript. According to Pim Brinkman, who has written the most complete study of this literature, the wide influence of Vasari's text assured Jan van Eyck a place in the canon of art history— if not as the first to discover oil paint, then as the artist who invented oil painting as we know it. The legend also stimulated those nineteenth-century investigations of additives to the oil medium and egg/oil emulsions that can be regarded as some of

the first technical studies in the field. As Brinkman notes, research in this area has not been steady: Almost nothing transpired from the nineteenth century until Paul Coremans's work on the Ghent Altarpiece in 1953, and the issue was only revisited again recently.[1] The twenty-five years of research into paint mediums at the National Gallery in London, together with the endeavors at other conservation laboratories that followed, including the development of new instrumentation within the context of the Molart research project in the Netherlands, will continue to provide us with a great deal of additional, and more definitive, information. As far as Eyckian technique is concerned, several important publications have appeared that contain valuable state-of-the field essays—specifically, those by Ashok Roy and by Raymond White (presented at the National Gallery, London, 1998 van Eyck symposium) and by Melanie Gifford (among the papers at the M. Victor Leventritt symposium in 1996 at Harvard University).[2] This Eyckian literature constitutes about the only specific historiography for technical studies of Netherlandish painting, and it makes medium analysis a central issue in the field, but further discussion of the topic clearly lies outside the scope of this article. The historiography, moreover, does not account for all of the methods of technical investigation that currently typify the field—and certainly does not address the dominance of infrared studies in the last few decades.

The more immediate background for technical studies is to be found in developments relating to the growing discipline of art conservation. It can be traced as far back as the nineteenth century, when there was a great interest in research into materials, and correlation with treatises, as well as far-reaching breakthroughs in photography and microscopy. It relates to the early application of many of these methods to archaeology, where technical investigation always has received a greater acceptance than in art

history. It is also closely tied to the steadily increasing professionalization of conservation in this country and elsewhere from the beginning of the twentieth century on. (One clear sign that this professionalization has occurred is the current proliferation of studies dealing with the history of conservation.) In one of the few general essays on the application of technical methods of examination to the study of paintings, Paul Philippot and Catheline Périer-d'Ieteren make several interesting observations. They divide the field into three periods: First they characterize nineteenth-century technical studies in relation to a positivist climate that valued the identification of materials and techniques for their own sake; then they define a subsequent period when technical methods were applied more systematically in conservation to construct the material history of a given work, from its original appearance to any later alterations; and, finally, they acknowledge that, especially after World War II, the same methods were used not only by restorers but also by art historians.[3] Reviewing this history is useful, since it helps elucidate why technical studies usually occupy a subordinate position within academic disciplines, and are designated as an auxiliary field, or sub-specialty, within another, more established, area of research. This history also makes it clear that, in the last decades, art historians using technical methods have had to chart their own independent course. The technical investigation of Early Netherlandish painting in an art-historical context must, as a result, be considered an emerging field.

In the 1930s or 1940s, someone made the connection that the preparatory layout drawing Cennini talked about in his famous *Libro dell'arte* could be made visible by means of infrared light. (I imagine this was insider information in conservation circles at the time.) As far as I have been able to ascertain, one of the first infrared photographs of a painting—in this case, an unidentified icon—was published by F. Arcadius Lyon in the

Figure 16. Infrared photograph of an unidentified Byzantine icon

Fogg Museum's *Technical Studies* in 1934 (fig. 16). The photograph had nothing to do with underdrawings; it was taken in order to see the painted forms more clearly through a heavy varnish.[4] Helmut Ruhemann, a prominent figure in paintings conservation during this period, was known to have looked for underdrawings with a microscope while conducting the examinations for his condition reports. However, Ruhemann also recognized the potential of infrared radiation to reveal what he called the painting's "preliminary drawing," and he stated as much in

a publication of 1941: "It would perhaps be interesting to try to find out by systematic comparison whether this kind of tentative sketchy drawing-in does not exist under the surface of most paintings of this school, and, in fact, of all schools. . . . Infra-red photography would, perhaps, play its part in answering this question."[5] By the next decade, infrared photography became institutionalized, one might say, as part of the standard documentation of the Centre National de Recherches "Primitifs Flamands" in Brussels. Several landmark publications resulted in the wake of this activity, such as Paul Coremans's 1953 study of the Ghent Altarpiece—well known to scholars of Early Netherlandish painting. Less well known was the appearance of Johannes Taubert's dissertation in 1956. Entitled "Zur kunstwissenschaftlichen Auswertung von naturwissenschaftlichen Gemäldeuntersuchungen," it examined infrared evidence and Early Netherlandish painting, and focused for the first time on many of the issues that still concern us today.[6] Taubert's study has not yet received the recognition it deserves, aside from the distribution of a few mimeographed copies; in fact, the only part of the dissertation that has been published is chapter 8, "Beobachtungen zum schöpferischen Arbeitsprozess bei einigen altniederländischen Malern," which appeared in volume 26 of the *Nederlands Kunsthistorisch Jaarboek* in 1975. However, that year Taubert's dissertation was given a symbolic place of honor: It was presented as the foundation document at the very first biennial colloquium on the study of underdrawings, organized by the Belgian scholars Roger van Schoute and Hélène Verougstraete. This historic meeting was followed soon after by J. R. J. van Asperen de Boer's 1979 reinvestigation of the Ghent Altarpiece based on the then-new technique of infrared reflectography. In many ways, these events in the 1970s can be seen as having ushered in the phase of study that occupies us today.

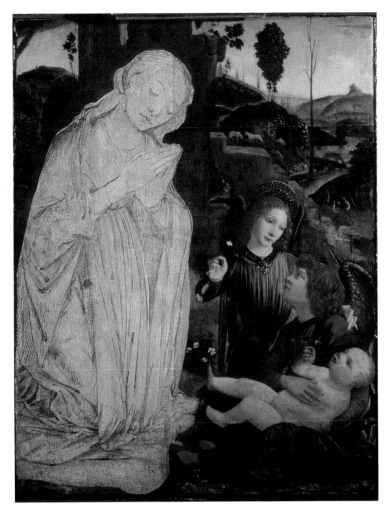

Plate 5. School of Leonardo. *Madonna and Two Angels Adoring the Christ Child.* The Detroit Institute of Arts (no. 57.37)

It is doubtful if any other area of art history could have benefited as much from infrared studies as Early Netherlandish painting; works from the Italian Renaissance, for instance, have not proven to be as receptive to infrared. (This perception is likely to change, however, as additional infrared studies of Italian collections are conducted.) To date, there have been many more reports of undetectable underdrawings in Italian works than in Northern paintings. A striking example of this phenomenon occurs in the *Madonna and Two Angels Adoring the Christ Child*, in The Detroit Institute of Arts, traditionally assigned to the school of Leonardo (plate 5).[7] The underdrawing of the figure of the Madonna is visible to the unaided eye; it picks out the details of the Madonna's face and hair, the contours of her hands, and the shading and fold lines of the drapery. Most likely executed in a pure brown pigment that becomes transparent to the eye of the infrared camera in the way that pure colors do, the underdrawing, when studied with infrared reflectography, simply

Plate 6. Head of the Madonna (detail of plate 5)

Figure 17. Infrared reflectogram assembly corresponding to plate 6

disappears (plate 6 and fig. 17). The use of darker, presumably carbon-containing, inks and chalks makes Northern underdrawings easier to detect. A Northern work roughly contemporary with the Detroit *Madonna and Two Angels Adoring the Christ Child* provides an interesting comparison (plate 7). Currently attributed to an anonymous master perhaps active in Ghent, this is also a painting in which sections of the underdrawing can be seen with the naked eye.[8] The underdrawing of the figures of the standing Saint John the Baptist and the Virgin and Child in the central part of the composition seems as elaborate as a finished study from the period, with accurate outlining and extensive shading in the form of oblique hatchings and cross-hatching. This underdrawing continues to register in infrared (as I have been informed, by Maryan Ainsworth), which means, of course, that an underdrawing can be revealed in its entirety beneath the paint film. The greater detectability of the underdrawings of Northern paintings has

influenced the Netherlandish field enormously and has even had what can be considered a quantifiable effect. Underdrawings have augmented the small number of surviving works from the period, and have helped compensate for the even smaller corpus of drawings on paper, as well as for the general lack of painting manuals or other documentation of painting technique. The underdrawing, moreover, exists in a known context, and thus can be interpreted in relation to its function, allowing researchers to interconnect the phases of an artist's working process in ways that were impossible before.

For these results, we are indebted to the Dutch physicist J. R. J. van Asperen de Boer, who, in the late 1960s, designed a prototype infrared reflectography camera that had immediate success in penetrating the blue and green pigments that had remained impervious to conventional infrared photography. The system he devised was remarkably stable and reliable; this stability allowed the whole field to

Plate 7. Unidentified Ghent (?) Master. *Virgin and Child with Saints*. Private collection

develop, as it made both consistent documentation and long-term systematic studies possible. Reflectography also proved to be an excellent lead-in technique: It encouraged close scrutiny of the paint surface through constant comparison with the underdrawing, as well as by focusing attention on basic issues related to condition, and it revitalized interest in other types of

technical examination. X-radiography, in particular, is a method of study that complements infrared, since it can reveal the first application of paint relative to the underdrawn layout. Dendrochronology, or tree-ring dating, also has been assimilated more and more into technical investigations of Early Netherlandish panels, from the 1980s on. Microscopic study of the paint

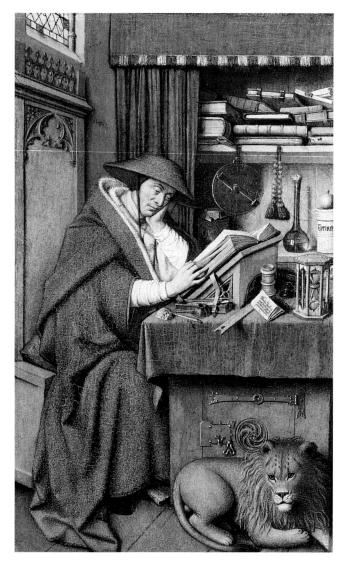

Figure 18. Workshop of Jan van Eyck. *Saint Jerome in His Study*. The Detroit Institute of Arts (no. 25.4)

declassified for astronomy and other types of night-vision applications, and they offer possibilities for developing new infrared focal plane arrays. Research with one of these new materials (platinum silicide) has been spearheaded by a team at the National Gallery of Art in Washington (Elizabeth Walmsley, Catherine Metzger, John K. Delaney, and Colin Fletcher), resulting in another prototype camera with a more stable signal, an extended range, and better maintenance of contrast in the infrared.[9] This camera, as well as others that recently have appeared on the scene, is digital, and, in our never-ending quest for the perfectly revealed, seamless reflectogram assembly, they will facilitate the computer matching of reflectograms, also opening up these documents to the burgeoning field of imaging technology. However, the new detectors will not end an era. I predict that, in the future, the new instruments will be calibrated to several ranges of infrared—one of which is now being called "classic" infrared reflectography—simply because reflectography has become an established standard in the field. Moreover, the impact of the new cameras on Netherlandish studies may be minimal compared with the effect on art from other geographic areas or periods, such as Italian or modern painting, where the "classic" method has proved less effective.

THE INCREASINGLY TECHNICAL CONNOISSEURSHIP OF EARLY NETHERLANDISH PAINTING

The fact that technical studies are object oriented makes the field problematic enough for many art historians, and the apparent focus on connoisseurship complicates matters even further. Critics of technical investigations should realize, however, that the research relating to basic aspects of art-historical identification is a necessary phase in this type of study. Technical evidence can be accumulated only gradually. Since this is most often done in relation to

surface, and paint sampling where possible, figured as well in the interdisciplinary approach that van Asperen de Boer championed. Now, after several decades of such integrated research, changes are on the horizon. Previously unavailable materials such as platinum silicide, indium gallium arsenide, and indium antimonide have been

single works, results are presented as case studies, extracts from ongoing fieldwork, or entries in museum catalogues. In this context, an immediate and natural concern is the way in which these new technical findings relate to an existing art-historical framework of attribution and dating. The exposition of the new material in this manner also sets up the conditions for a kind of mutual testing of the different approaches: Art-historical opinion can be reviewed and, at the same time, the validity of a particular method of technical investigation can be evaluated. Secondly, since connoisseurship is a skill, it can and has advanced with improvements in technology—all the more reason why connoisseurship should continue to be practiced on a new level at this point in time. Thirdly, such essentials as attribution, date, and function have formed the bedrock of art history, and will go on doing so, providing the basis for more wide-ranging investigations (as will be discussed later). Without constant attention to the endeavors of connoisseurship, it is hard to imagine how some of the profound shifts in our field would ever have taken place.

Among the most compelling examples of revised opinion are those that involve Early Netherlandish paintings in the United States. In each of these cases, new technical evidence has allowed us to see the painting in question as a larger whole.

One of the most dramatic reversals of opinion concerns the Eyckian painting known as the "Detroit *Saint Jerome*" (fig. 18). In 1994, at the symposium in connection with the Petrus Christus exhibition held at The Metropolitan Museum of Art, it became clear that the Detroit panel was not the forgery it long had been rumored to be. Technical information provided a new platform for discussion. Examination of the *Saint Jerome* by means of infrared reflectography, as it turned out, did not yield any conclusive information, since the amount of possible underdrawing that

could be revealed was minimal. More important was the realization that the painting's wood support, with its marbleized reverse, was original, and not the result of a transfer. Furthermore, dendrochronology established that the wood of the panel would have been available for use anytime after 1426, so that the *Saint Jerome in His Study* could have been painted during Jan van Eyck's lifetime. The fact that the painting was executed on paper and glued to the wood support was shown not to be a complete anomaly for the period, and the pigments also proved to be consistent with fifteenth-century practices.[10] Now we await the formation of a new art-historical consensus on the basis of these findings. Since 1994, the painting has been studied in relation to another panel that can be associated with Jan van Eyck's shop, the Philadelphia *Saint Francis Receiving the Stigmata,* which has an intermediate support as well—in this case, parchment glued to wood.[11] The *Saint Jerome* also has been exhibited several times recently: In 1994, the painting was included in the Petrus Christus exhibition as a work by an anonymous follower familiar with Jan van Eyck's workshop activities, and various comments in the Metropolitan Museum's 1998 *From Van Eyck to Bruegel* exhibition catalogue imply agreement with the assertion made earlier in the century that the Detroit panel may be the original described in the 1492 inventory of Lorenzo de' Medici's collection.[12] In 1998, The Detroit Institute of Arts published several articles related to the *Saint Jerome* in its bulletin: One, by Edwin Hall, dealt with historical information that would support an attribution to Jan van Eyck, and another, by Barbara Heller, summarized the results of technical investigations of the picture.[13] In her 1996 book on the *Turin-Milan Hours,* Anne van Buren took a slightly different tack: She attributed the work to the Master of the Berlin Crucifixion—one member of a team of artists active after 1437, when Jan van Eyck's workshop was expanded for the

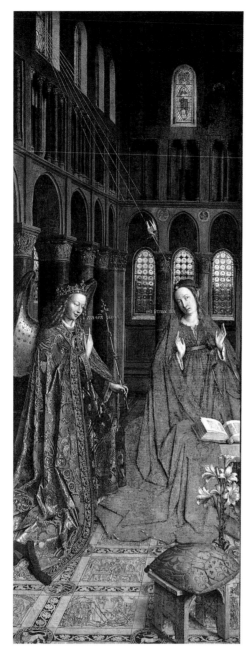

Figure 19. Jan van Eyck. *The Annunciation.*
National Gallery of Art, Washington, D.C.,
Andrew W. Mellon Collection (1937.1.39)

production of various panels and manu-
script illuminations.[14]

Another painting to take its more
rightful place in Jan van Eyck's oeuvre is
the *Annunciation* in the National Gallery
of Art in Washington (fig. 19). Again, the
factors that brought about the reconsidera-
tion of the painting are fairly recent.
About a decade ago, in 1991, a College Art
Association session devoted entirely to this
painting made it obvious that there were
still strong doubts about the attribution.
European scholars, in particular, expressed
their reservations. The subsequent cleaning
of this painting by David Bull, and the
accompanying technical studies by Melanie
Gifford and others, should have quelled
any lingering uncertainties by now and
made clear to us how much the nineteenth-
century transfer to a canvas support and the
darkening of varnish and retouches have
affected our opinions of this work.[15] Our
present, less encumbered viewing experience
takes in the stunning details of the paint sur-
face as well as the entire painting process
(plates 8, 9). Furthermore, the removal of
discolored varnish and old overpaints allows
infrared reflectography to reveal more fully
the fine precision of the underdrawing in
the painting (figs. 20, 21). One detail under-
scores the high quality evident everywhere in
the work: The underdrawing of the face of
Gabriel finds its closest counterpart in that of
the woman's head in Jan van Eyck's renowned
Portrait of Giovanni (?) Arnolfini and His Wife
in London. Reflectography also has shown
that many changes occurred in the execu-
tion of the *Annunciation*: some subtle visual
revisions, and others with more meaningful
implications for the painting in its final
manifestation. The complexity of the "evolv-
ing imagery" in the *Annunciation* can be
compared with the amount of compositional
change that has been discovered in other
major works by this artist, such as the *Virgin
and Child with Chancellor Nicolas Rolin* as well
as the *Portrait of Giovanni (?) Arnolfini and His
Wife.* Since the restoration, the *Annunciation*

Early Netherlandish Painting at the Crossroads

Plate 8. Head of the Angel Gabriel before restoration (detail of fig. 19)

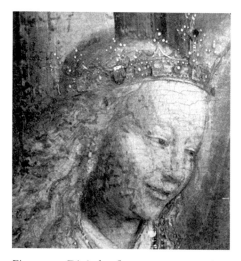

Figure 20. Digital reflectogram composite of the head of the Angel Gabriel before restoration

Plate 9. Head of the Angel Gabriel after restoration (detail of fig. 19)

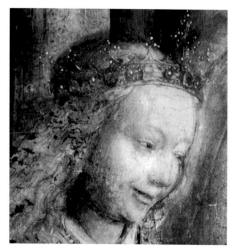

Figure 21. Digital reflectogram composite of the head of the Angel Gabriel after restoration

has been exhibited at least twice, in Chicago and in London, and several important publications by Melanie Gifford and Carol Purtle have appeared in which one can find a full discussion of this fascinating and now undisputed work by the preeminent fifteenth-century painter.[16]

The emerging view of the Friedsam *Annunciation* as a painting attributed to

Petrus Christus, not Jan van Eyck, reaffirms some earlier opinions and counters others (see plate 10). In this case, it is unnecessary for me to reiterate the discussions in the Metropolitan Museum's 1994 and 1998 catalogues, any more than to say that I agree with Maryan Ainsworth's realignment of this panel—which we now understand to be a fragment of a larger composition—

Figure 22. Rogier van der Weyden. *Saint Luke Drawing the Virgin*. Museum of Fine Arts, Boston, Gift of Mr. and Mrs. Henry Lee Higginson (no. 93.153)

Panofsky. Information from technical studies can have this effect. Attribution is no longer so much a matter of individual pronouncement, as technical evidence lends itself to discussion and consensus building.

A work of comparable stature to the paintings just mentioned in Detroit, Philadelphia, Washington, and New York, is the panel in Boston depicting Saint Luke drawing a portrait of the Virgin (fig. 22). This masterpiece by Rogier van der Weyden is one of the earliest Northern images of Saint Luke as an artist and, as such, the painting serves as a vital record of the status of the painter and his craft. Equally well known to scholars of Early Netherlandish painting is the fact that the Boston version is one of four virtually identical depictions of the subject. From 1961 on (the date of Colin Eisler's *Corpus les Primitifs Flamands* volume of paintings in New England collections), the panel has been the subject of a series of technical studies using X-radiography, infrared photography, infrared reflectography, dendrochronology, pigment and medium analysis, and, most recently, impressive digitized technical documents and overlays created by Ron Spronk and Rhona MacBeth. Every new phase of investigation has produced evidence in support of the opinion that the Boston panel is contemporary with the activity of Rogier van der Weyden and typifies his painting practices. The wide-ranging implications of this fact have been discussed in the newly published volume on the Boston panel, edited by Carol Purtle.[18] It is doubtful whether the publication would have appeared at all, however, if the

within the oeuvre of Petrus Christus. Of note is the fact that the underdrawing plays an important part in the argument regarding attribution, because even a basic knowledge of the underdrawing conventions of the van Eyck and Petrus Christus groups is enough to shift the painting from one to the other.[17] What technical studies have accomplished here, however, goes beyond a simple matter of reidentification. It may not be an overstatement to say that, in this instance, only the accumulation of data from a completely different perspective could have dislodged the enormous weight of previous opinion by such venerable scholars as Max J. Friedländer and Erwin

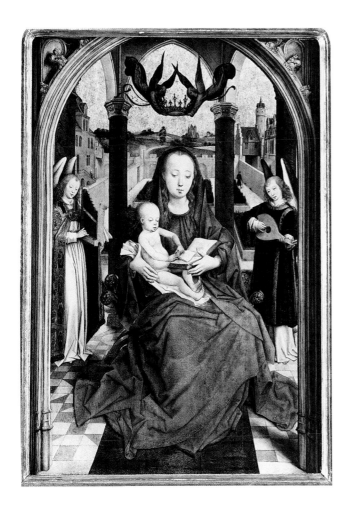

Figure 23 (left). Hans Memling. *Virgin and Child Enthroned with Two Musical Angels*. Nelson-Atkins Museum of Art, Kansas City, Missouri (no. 44.43)

Figure 24 (below). Infrared reflectogram assembly of the robe of the Virgin (detail of fig. 23)

painting had proved to be one of the copies in the series rather than the original.

We now have a very different perception of the early phase of Hans Memling's activity, and the *Virgin and Child Enthroned with Two Musical Angels* in the Nelson-Atkins Museum of Art in Kansas City has played a key role in the research leading to this new insight (fig. 23). Although several scholars in the past have had serious reservations about the attribution of this painting, the disclosure of the underdrawing has been critical in provoking a reassessment of this work and related paintings. The schematic manner of the underdrawn outlining and shading of the Virgin's drapery is

typical of that found in the works belonging to the early Memling "group." Several of the protruding or receding folds have a trowel or spatula shape, and the hatching consists of regularly spaced directional lines (fig. 24). Contours often end in T- or L-shaped hooks. The graphic characteristics of the underdrawing are so distinctive that links with other works, such as Memling's *Last Judgment* altarpiece in Gdansk, are immediately obvious. The blue and brown draperies of Saint John the Baptist on the center panel of the Gdansk altarpiece become equally transparent in infrared reflectography, disclosing a patterning of folds virtually identical to that in the Kansas

Figure 25. Hans Memling. *Last Judgment* altarpiece (detail of the draperies of Saint John the Baptist on the center panel). Gdansk, Poland (no. SD/413/M)

City painting (figs. 25, 26). Connections are also reinforced with Rogier van der Weyden's workshop, where Memling must have developed a functional understanding of underdrawings as well as a facility in copying them.[19] His ability to re-create this aspect of shop routine would seem to be apparent in the so-called Morgan *Annunciation* in The Metropolitan Museum of Art, for a similar method of underdrawing occurs in that work. Based on this new information, Maryan Ainsworth has, in fact, proposed that this painting may have been executed by Memling while he was still working in Rogier's shop.[20] In this instance, technical study has provided critical information about the training of an artist and the links between master and assistant.

The list could go on. Examples from other museums—and investigations—abound. The following random sampling illustrates a few of the typical findings. Scholars have been able to explore the relationship between underdrawings and drawings. On the basis of the stylistic characteristics of some newly revealed underdrawings, it has been possible to attribute the first known examples of drawings on paper to the Master of 1518, Joos van Cleve, and other artists.[21] The function of other drawings has been clarified by their place in the painting process. Those that were considered drawn copies after lost works by the sixteenth-century painter Jan van Scorel were found, when compared with underdrawings, to belong instead to the design stage of this

Early Netherlandish Painting at the Crossroads

Figure 26. Infrared reflectogram assembly corresponding to figure 25

artist's working process.[22] On the other hand, a drawing thought to be a preparatory study by Hieronymus Bosch was proven to be a copy, since it differed from the underdrawing of the painting in question but followed the forms of the finished work.[23] The study by Maryan Ainsworth of Gerard David's drawings as they relate to the artist's overall working method is an excellent recent example of this approach.[24]

Underdrawings often have rehabilitated paintings that have been neglected or downgraded because of the poor condition of their paint surfaces; the Brussels *Annunciation* associated with the Master of Flémalle group is certainly a well-known example of this phenomenon (as is Jan van Eyck's *Annunciation* discussed above), but Gerard David's *Head of*

Christ in Philadelphia is also a case in point.[25] Other works of exceptional quality and undoubted authorship were discovered to be the result of workshop collaboration. The underdrawing of Rogier van der Weyden's renowned Columba Altarpiece is not by the master but by a workshop assistant. As many as five hands have been identified in the execution of the *Last Judgment* in Beaune, another monumental altarpiece from Rogier's shop; and a team of artists, including Rogier himself, seems to have been responsible for the *Exhumation of Saint Hubert* (National Gallery, London).[26] Such revelations force the realization that attribution can be a complicated matter, as does the fact that the artist's name on a label sometimes can indicate a broader artistic group;

suffice it to mention two examples: Dieric Bouts's *Justice* panels or Rogier van der Weyden's *Crucifixion* in the Escorial.

More wide-ranging comparisons with other graphic traditions also have been made, since underdrawings have been discovered in manuscripts, on the ground preparation of polychrome sculptures, and even on textiles, such as vestments. In the *Turin-Milan Hours*, it was found that some miniatures by later artists overlapped the underdrawings of a previous decorative campaign.[27] Similarities in style were shown to exist between the underdrawings in paintings attributed to the Master of the Amsterdam Cabinet and dry-points made by that artist.[28] If the same type of underdrawing can be seen continuing from one panel to another, it may assist in the reconstruction of a work or confirm the existence of ensembles. That a similar underdrawing in pen can be detected in two panels attributed to a follower of Geertgen tot Sint Jans contradicts those who doubted that the two panels form a diptych.[29] Knowledge of the layout stage also has facilitated the determination of whether a cartoon was reused. This has now been proposed for a sequence of images of the Virgin by followers of Dieric Bouts and for several versions of an Italianate composition executed in Joos van Cleve's workshop.[30] The discovery of other shop routines, such as the use of color notations, has also led to remarkable results. The fact that one painting was shown to contain color notations in French supported Otto Pächt's shift in attributing the painting known as "Gonella," in Vienna (Kunsthistorisches Museum), from a Netherlandish master to Jean Fouquet.[31] Infrared studies even have disclosed hidden or illegible signatures. The revelation of a signature on a slightly later Netherlandish painting in Brussels allowed another scholar, Margreet Wolters, to identify the artist known as the Monogrammist HB as Huybrecht Bueckelaer, a master documented in Antwerp primarily in the 1570s.[32]

Such reidentification and reclassification continues unabated, establishing an impressive record. This activity is unquestionably one of the primary ways in which technical studies have concretely reshaped the Early Netherlandish field.

An episode from Bernard Berenson's career can serve as an amusing postscript here. During the trial dealing with the authenticity of several works attributed to Leonardo da Vinci, Berenson was asked about one of the paintings in question. "You've given a good deal of study to the picture in the Louvre?" "All my life; I've seen it a thousand times." "And is it on wood or canvas?" "I don't know." Berenson then quickly defended himself by implying that such lowly, physical details of a painting's construction were of no consequence: "It's as if you asked me on what kind of paper Shakespeare wrote his immortal sonnets."[33] Today, of course, connoisseurship has undergone a complete turnaround, and it would be unthinkable for even a fledgling connoisseur to make any sort of attribution without all relevant technical information at hand. Connoisseurship—as it has evolved—depends on even more specialized expertise than in the past. It is to be hoped that eventually many more individuals will acquire the necessary knowledge and skills to make additional contributions.

BEYOND CONNOISSEURSHIP: ENLARGING THE CONTEXT OF ARTISTS' PAINTING PRACTICES

As the discipline of art history has itself embraced approaches other than traditional connoisseurship, so the increasing use of, and familiarity with, technical evidence has led scholars down new avenues of analysis and interpretation. It should be noted, however, that many of the methods of discernment associated with connoisseurship continue to play a role as fresh directions in research are formulated and developed. From the wide range of discoveries in the last several decades, only a few areas where significant change has occurred in the discipline can be highlighted here. Those discussed also derive for the most

Figure 27. Jan van Eyck. *Virgin and Child with Chancellor Nicolas Rolin* (detail). Musée du Louvre, Paris. Infrared reflectogram assembly showing the arm of the Christ Child in its initial dangling position alongside the knee and in its finalized position in a gesture of blessing.

part from studies focusing on the artist's working methods and the function of the underdrawing in the painting process. Primary among these realizations are: 1) the extent to which an underdrawing was, and was meant to be, seen; 2) the importance of copies of Netherlandish paintings; 3) the use, dissemination, and significance of model drawings; and 4) the visualization of the artist's workshop and its practices.

As underdrawings became better known, many notions about them were revised. One assumption, often unstated, was that an underdrawing was for the artist's eyes only—an idea linked to several others. Whenever an underdrawing was revealed, it was assumed that it was by the hand of the master, as part of his introspective creative activity. Since—according to this reasoning—the underdrawing was by its very nature an ephemeral creation, with no audience or social context, it also could be inferred that underdrawings did not merit serious art-historical attention. However, we know

now that some underdrawings—perhaps even many—were, indeed, meant to be seen.

Some of the best evidence that underdrawings were visible derives from paintings by Jan van Eyck. The changes in Jan van Eyck's *Virgin and Child with Chancellor Nicolas Rolin* (Paris, Musée du Louvre) should be well known to scholars by now. They involve numerous small clarifications of form, slight shifts in glance, and the increase in dimensionality that typify the artist's style, and they also include the Christ Child's blessing gesture, which was not indicated in the underdrawing but was added by stages into the final image (fig. 27).[34] The Christ Child's right arm was originally depicted dangling in front of his stomach, but was changed in the finished painting into a recognizable gesture denoting Christ as judge and savior. When I first discussed the possibility that a change of this magnitude would have been made at the instigation of the donor, the idea offended the sensibilities of some scholars, who wanted to see van Eyck as the sole

Figure 28. Unidentified Antwerp Master. Wing of an altarpiece with *The Visitation* and other biblical scenes. Wallraf-Richartz-Museum, Cologne (no. 440)

creator of his so-called disguised symbolism. Such criticism was wholly in line with the belief in the artist as a lone genius, working almost in secret as a painting evolved. Yet, revisions in other key works, such as the *Portrait of Giovanni (?) Arnolfini and His Wife,* recently have been interpreted by the London researchers Rachel Billinge and Lorne Campbell as the result of mutual consultation between painter and patron(s).[35] It was suggested even earlier by J. R. J. van Asperen de Boer that some of the changes in the Ghent Altarpiece would have required the advice of someone who served as an outside consultant.[36] Nicolas Rolin must have felt that the blessing gesture, with its testament to his eternal salvation, was required for the painting of the Virgin and Child that was to serve an ongoing commemorative function in the Rolin family chapel, and he undoubtedly requested this adjustment after van Eyck's completion of the underdrawing. Rolin's intervention is all the less surprising in view of what has also been proposed about his later commission, the *Last Judgment* polyptych in Beaune: that he took a personal interest in the commission because of his awareness of the Ghent Altarpiece and his wish to rival Jodocus Vijd's monumental donation.[37] In the case of the *Virgin and Child with Chancellor Nicolas Rolin,* and perhaps in many other instances as well, the more we know about the donor the more it may enhance our understanding of the underdrawing and the subsequent painting process.

The idea that the underdrawing could function as a vidimus was first stated in the 1970s in some of the initial comprehensive infrared studies on the sixteenth-century northern Netherlandish masters Jan van Scorel and Lucas van Leyden.[38] At the time, this was no more than a supposition, but the evidence has continued to grow, especially in the field of technical studies. Maryan Ainsworth proposed such a function for a German underdrawing that was fully worked up with washes and very complete visually.[39]

Early Netherlandish Painting at the Crossroads

Figure 29. Infrared reflectogram assembly of *The Visitation* in figure 28, showing the words "de vysetatie" along the upper edge in the underdrawing

Scholars also began to emphasize the connections with contractual customs of the period. Jeltje Dijkstra has published the most extensive study of this phenomenon, in part by referring to an important Master's thesis on this subject by Willem Vroom, and noted that contracts usually were accompanied by a visual model, often called a *patroon* or *bewerp* in Dutch.[40] Some documented situations indicate that the underdrawing may have functioned on occasion as an extension of this practice. Recently, Max Martens and Jean Wilson called our attention to the documents associated with a legal dispute involving Bruges goldsmiths and the painter Adriaen Isenbrant. In answering the complaints of the goldsmiths that their guild banner had been damaged during the process of copying it, Isenbrant stated that he had invited his patrons to his workshop after the underdrawing had been finished to approve the work before he began painting. Isenbrant claimed that the patrons also had agreed to the use of pouncing to transfer the design. The court eventually ruled in Isenbrant's favor.[41] These documents clearly imply that patrons could have had access to a painter's shop when a work was in the underdrawing stage. Pieter Pourbus's preparatory drawing for the *Van Belle Triptych* provides another important documentary parallel for this aspect of painting practice: Not only is it an excellent example of a contract drawing, or vidimus, but it also documents a change that was to be made in the painting, as agreed to by both the patron and artist. In the inscriptions underneath the drawing, where the monograms of the painter and patron also appear, one finds the specification that in the final work the Virgin should not be shown weeping but with arms crossed.[42] The surviving painting shows that the painter adhered to this stipulation. Although it is probably not historically accurate to attach the same legal status to the underdrawing as to the contract sketch, the evidence still suggests that we should not overlook this potential function of the layout stage to bring us closer to the historical

circumstances in which a painting was made, for the underdrawing can document the first agreed-upon manifestation of a finished work and may serve as the starting point in a process of interim approval.

The discovery and identification of marks and written notations in underdrawings attest to another way in which they communicate. Color notations have been detected much more frequently in the underdrawings of German and northern Netherlandish paintings, although they also have been found in those of some sixteenth-century Flemish works. These notations can be difficult to find and to read, and a straightforward assessment of their function is not always possible. While it usually has been assumed that color notations were directives for assistants, they occur, as well, in paintings by artists who did not have large workshops. Notations generally appear in areas of pure color, with red the one most often indicated. This type of color scheme therefore may relate to Cennini's recommendation to use red as the key color, or it may designate the passages for which batches of pure pigment had to be prepared. As pure colors would have involved the most expensive pigments, such notations might have helped in estimating the cost of materials.[43] Again, such estimates may have been made in consultation with the commissioners of a painting.

Some notations that were first thought to be indications for color actually turn out to be titles in the underdrawing. Explicit examples have been found in a large, early-sixteenth-century retable from Antwerp with multiple wings and several scenes on each wing (fig. 28). In the smaller of the scenes on the wings, infrared reflectography revealed inscriptions at the top of each compartment, along with a preliminary layout of the composition. In one scene, two words—in Dutch—in the underdrawing can be read as *de vysetatie*, or "the visitation" (fig. 29). This is curious, for these titles would become superfluous once the underdrawing had been made. It is more reasonable to assume that the notations were

written on the ground when the surface was still blank, as a way of summarily indicating the positions of the scenes in the narrative sequence. Additional examples of underwritten inscriptions have been found in other works associated with the Antwerp Mannerists, so that the practice must be considered a part of the studio routine in that locale. Written labels on panels or on the partitions of wings were one way shops could streamline their work, somewhat like the contract sketches from the period, in which the painted scenes were left empty and the titles either were filled in or listed along the margin of the sheet.[44] These underdrawings not only were meant to be seen but also to be read, and constituted a form of communication within the studio and, very possibly, between studio and client.

Other aspects of the layout stage of a painting can expand our understanding of the function of the underdrawing in its own time. Twentieth-century painters such as Picasso or Beckmann at times seem to have used the ground of a painting as a sketch pad, with the underdrawing stage(s) representing a continuum of alternative, and sometimes overlapping, ideas for figures or whole compositions. In the fifteenth and sixteenth centuries, however, a prepared panel containing an underdrawing meant that the work had progressed to the point that it could be made public—to an individual purchaser, a commissioning body, or the wider market. The painting over of a composition implied no more than the reuse of the panel for practical reasons, rather than any form of personal rumination or rejection. A few other interesting panels from the sixteenth century make this abundantly clear. A painting of the *Parable of the Prodigal Son* (fig. 30) and an *Adoration of the Magi* in Aachen—a copy after Hieronymus Bosch—are closely related, but it would not have been possible to make this assertion without knowledge of the underdrawing. The underdrawing of the Aachen panel (fig. 31) is totally different from the final painted image (fig. 32): The composition is horizontal and

clearly was intended for another painting—one which, if completed, would have been identical to the *Prodigal Son* panel.[45] It is conceivable that these two works originated in the same shop and that the two panels were planned as compositional replicas of a popular theme, to be produced in a series. On the other hand, since the core of the composition of the *Prodigal Son* occurs in many drawings, and even on stained-glass roundels,[46] the two paintings may demonstrate the reuse of a workshop model that was in wide circulation at the time. In that context, both the extremely competent reproduction of Bosch's famous *Epiphany*, executed several decades after the original, as well as the repetitions of the Prodigal Son narrative can be seen as adaptations to changing aspects of consumer taste.

Recognition of the business-like procedures of painters' shops necessitates a further elucidation of the influence of technological concepts on developments in painting and workshop practices. The phenomenon of the copy, for instance, is an aspect of Netherlandish painting that can be approached best from this point of view.

Although art historians certainly have been aware of the copy as a feature of Early Netherlandish painting, the issue has been explicated much more fully in technical studies. To a degree, students of Early Netherlandish painting have taken the copy for granted, while those outside the field have commented on its obvious importance. Franz Günter Zehnder observed that early Cologne painting can be distinguished by its lack of copies, and Cranach scholars have pointed out that, although the painter used standard-sized panels and produced many versions of the same theme, there are no exact copies in his oeuvre (except for portraits), as there are in Netherlandish painting of the same period.[47] Credit for initiating serious research into the phenomenon of the copy should go to Johannes Taubert, one of the first scholars to use infrared documentation for art-historical purposes. Taubert devoted one chapter of his 1956 dissertation to this topic. Many other

Figure 30. Unidentified Brussels (?) Master. *Parable of the Prodigal Son.* Whereabouts unknown

studies have appeared since, culminating in Jeltje Dijkstra's important dissertation in 1990. Dijkstra distinguished copies from the circle of Rogier van der Weyden by their means of production, using a combination of investigative techniques including infrared, X-radiography, and—as a significant addition—dendrochronology. To Dijkstra, technical studies are the key to recognizing and elucidating this fundamental issue.[48]

As copies are studied more closely, we undoubtedly will come to understand nuances in the development of this painting tradition and to discern differences among the many types of replicas: copies of narrative compositions versus those of more iconic images; reduced and/or partial copies; copies that are composites of separate motifs, compositional replicas, or variants; and exact copies that reproduce the composition, style,

and even the quality of the original. It is to be hoped, too, that more will be learned about the motivations behind this phenomenon. Jeltje Dijkstra has found that copies exist in larger numbers than might be assumed. For instance, she estimates that there are over one hundred and sixty examples of the four-figure partial copy after Rogier van der Weyden's *Descent from the Cross.* Dendrochronology also helped Dijkstra establish the important fact that many of the copies she studied, including exact replicas, first appeared between 1470 and 1530, and she relates this spurt in activity to a number of factors. The logistics of producing identical or nearly identical images *en masse* may be explained by the organization of some workshops at the time; in Bruges in the last quarter of the fifteenth century, large numbers of assistants were concentrated in only a few shops. The

Early Netherlandish Painting at the Crossroads

Figure 31. Infrared reflectogram assembly of figure 32, with mylar overlay, showing the underdrawing of scenes from the *Parable of the Prodigal Son* (fig. 30)

availability of new models, such as prints, also may have facilitated the copying process. Dijkstra proposes that much of what was produced was consumer driven, and based on an intensification of private devotion. In about one-third of the fifteenth-century documents and nearly half of the sixteenth-century documents that Dijkstra studied, an existing work was mentioned that was to serve as the model for a newly commissioned painting.[49] These sources account for the widespread acceptance of a copying trend, although the new work may have reflected the model only in a loose sense, by—to use a common phrase in these contracts—"equaling or surpassing" the general form or quality of the original. In any case, many of the patrons and purchasers of art in this period seem to

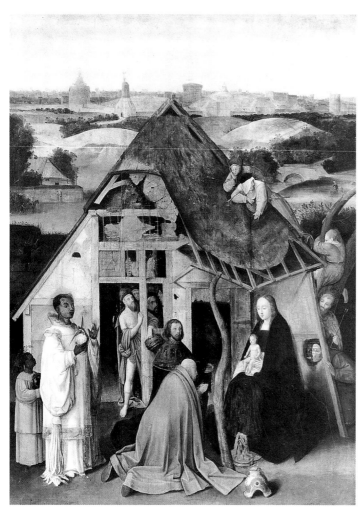

Figure 32. Copy after Hieronymus Bosch. *The Adoration of the Magi.*
Suermondt-Ludwig-Museum, Aachen (GK 0049)

quality, according to the traditional tenets of connoisseurship. This is certainly not the case, as is amply demonstrated by the 1998 catalogue's discussion of the adaptations in function that figured in the structuring of the *Merode Triptych*.[50] A beloved and frequently repeated theme is, of course, the Virgin and Child, which is represented by what may be considered a more conventional configuration first in the panel in the Metropolitan Museum attributed to Dieric Bouts himself, and secondly in two other versions of this composition that have been shown to be "authentic replicas" produced by two different workshop assistants.[51] Another celebrated pair of virtually identical paintings are the Miraflores Altarpiece in Berlin and the New York-Granada altarpiece from the Rogier group. The New York *Christ Appearing to His Mother* displays the high quality evident in both altarpieces and reminds us of how difficult it was to accept the fact that these paintings actually derive from different workshops and are separated in time by as many as five decades. We realize now that we are actually dealing with two authenticated works, Rogier's original in Berlin, and the proportionally reduced copy, commissioned by Isabella of Castile and painted by an artist trained in Flanders and working in Spain at the end of the fifteenth century.[52] From a recent publication about the art market in Castile, it appears that Isabella devised tax laws and organized fairs that encouraged the emigration of foreign artists to Spain.[53] This adds to the historical circumstances underlying what may be the most remarkable example of an exact copy in fifteenth-century Flemish painting.

In the sixteenth century, copying routines may have developed in association with the marketplace and stronger currents of collecting. Traditional connoisseurship again may serve as a touchstone here, for the evaluations of originals and copies in the sixteenth and the seventeenth century do seem closer to our own. The mechanisms of sixteenth-century shops to meet various demands may also contribute information about evolving ideas of

have been more interested in sustaining the qualities of a known work than in investing in a new one.

Several important examples of this copying tradition are in the Metropolitan Museum's collection, and the research related to them was summarized in the 1998 exhibition catalogue *From Van Eyck to Bruegel*. Even though the famous Brussels *Annunciation* no longer can be considered a copy, it does not necessarily follow that the *Merode Triptych* must be one, therefore making it of lesser

Early Netherlandish Painting at the Crossroads

aesthetic quality and productivity. Even a few examples seem to imply that there will be more variation in this tradition than we might expect. With regard to the two versions of a Virgin and Child composition from Joos van Cleve's workshop (Cincinnati Art Museum, and Nelson-Atkins Museum of Art, Kansas City), there is nothing in the layout stage of either work to prove that one could be the duplicate of the other and, in fact, it is much more likely that both refer back to a model drawing.[54] In each work redesigning occurs and the execution differs. In the strict "original/copy" world of connoisseurship, these paintings are hybrids: Neither is totally unique nor wholly derivative. Virgin and Child compositions by Jan van Scorel and his workshop also can elucidate nuances in the making and use of copies. The *Virgin and Child* recently acquired by the Centraal Museum in Utrecht can be assigned to van Scorel on conventional grounds: All stages in the painting process are typical of those of the master. The compositional replica, in Rotterdam, is about one-third smaller, and seemingly of lesser quality. Yet, technical study reveals that both paintings exhibit exactly the same change in composition. The moving of the Christ Child's leg from a vertical to an angled position took place after the underdrawing stage in the Utrecht painting, and at an intermediate paint stage in the Rotterdam panel. While, again, it cannot be excluded that both works relate to a model drawing, it is more likely that the two were painted side by side in van Scorel's workshop.[55]

This shop provides us with another example of compositional replicas: There are two versions of a *Raising of Lazarus* from about 1540, both of which are associated with van Scorel's workshop, and although they are identical in size and composition, they differ markedly in style and in color. Technical analysis shows that the color variations are due to the use of different pigments. The overall painting process is also not the same in both works: Infrared reveals a black-chalk underdrawing with compositional changes in one panel, while there is no detectable underdrawing at all in the other work. This leads to the rea-

sonable conclusion that one panel was produced following van Scorel's shop routine, while the other was painted outside the shop but modeled on the first example, not on a shop pattern.[56] Cases like these will help us arrive at a deeper understanding of the phenomenon of the copy in the sixteenth century by enabling us to gauge the variety of simultaneous methods of production and the extent of their use, as opposed to the repetition of a single model over time.[57]

Accepting the prevalence of copying naturally raises questions about drawings and workshop models. Although finished works surely provided the basis for some replicas, one has to assume that Isenbrant's use of an original object—a banner—for a workshop pattern, as mentioned earlier, would have been the exception to the rule. Copy drawings and other types of drawings employed as models were made and kept as part of the stock of painters' shops in the period, as we have long known from documentary evidence, such as the frequently mentioned lawsuit Ambrosius Benson brought against Gerard David. These patterns formed part of artists' estates and could have been passed on to their heirs. Sharp observers already have made note of such occurrences in existing works. Lorne Campbell has proposed that many, and perhaps all, of Rogier's drawings came into the possession of his grandson, Goswijn van der Weyden; in addition, Campbell recognizes the influence of Rogierian models in the *Virgin and Child with a Donor Couple* (the so-called Kalmhout Donation), a painting from about 1511–15 attributed to this master.[58] It stands to reason, then, that traces of shop patterns also would be discernible at various stages in the painting process, and, in fact, some of the most compelling examples to be revealed through technical examinations occur in the works of Rogier van der Weyden and of artists in his immediate circle. As motifs in the underdrawing reappear only in subsequent paintings, knowledge of them must have been passed on by shop drawings. The Columba Altarpiece is critical in this regard, since the underdrawn position of the Christ Child and the traces of

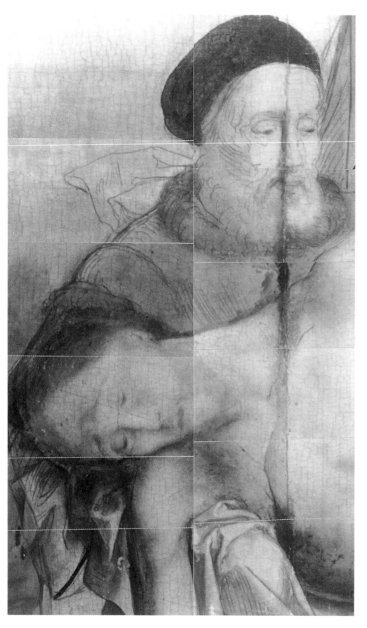

Figure 33. Joos van Cleve. *The Descent from the Cross* (detail). Philadelphia Museum of Art (no. 373). Infrared reflectogram assembly showing underdrawn drapery omitted in the paint stage

a picket fence behind the central figures are repeated in a number of later versions of the same subject by Memling, in his altarpieces in the Prado and in Bruges, and in a triptych by the so-called Master of the Prado Adoration, also a follower of Rogier van der Weyden, who probably assisted in Rogier's studio.[59] Other cases can be cited. The Nativity Altarpiece at The Cloisters, again by a Rogier follower, repeats motifs that exist only in the underdrawing of the *Bladelin Triptych*.[60] In other instances, citations of the model occur in the underdrawing stage rather than in the finished image. In another work after Rogier van der Weyden, Joos van Cleve's *Descent from the Cross* of about 1518–20 in the Philadelphia Museum of Art, the artist included floating drapery in the underdrawing just behind Joseph of Arimathaea's head (fig. 33).[61] This detail is found in Rogier's original, but Joos van Cleve still decided to omit it in the final image, as part of the larger shift to a landscape setting for the event. A recent infrared reflectography study of one of the one hundred and sixty or so four-figure reduced copies of Rogier's *Descent from the Cross* revealed an underdrawn hand that later was omitted in the paint stage.[62] This motif appears in many of the other versions of this composition, implying that it belongs to those elements that make up the prototype. Tracing the reuse of workshop models will thus be essential in studying artistic influence and the dissemination of compositions, but there are questions about the extent to which these patterns were proprietary. Our evidence so far for the reuse of workshop patterns in the late fifteenth century does not suggest that they were widely dispersed or employed by completely unrelated shops.

The fact that additional proof of workshop models can be deduced from sixteenth-century paintings implies that this will also be a rich area for continuing infrared studies. Sometimes the underdrawing may reflect a shop pattern that has been updated during the painting stage—a practice signaled in the *Marriage of the Virgin* in Saint Louis, attributed to the Master of 1518. In this painting, pub-

lished some years ago by Maryan Ainsworth and Molly Faries, the compositional changes concentrated on revisions of costume and ornamental motifs.[63] In some cases, it is the correspondence of an underdrawing and a print that can be traced back to a common source, as revealed by the ongoing study of Jan van Scorel's workshop activity; this also has yielded other evidence of the shop's use of models. Several works related to this artist, of about 1530, show that one shop pattern was actually switched for another during the painting process. In this instance, evidence of the use of models is based on changes in the composition, which were quite radical, relatively speaking; these occurred about the time that Maarten van Heemskerck was van Scorel's primary studio assistant.[64]

Recognition of the existence of artists' workshops, and the visualization of shop practice, are surely among the greatest contributions of technical studies. Although scholarly reaction has varied, and there have been grumblings about unraveling oeuvres and signs of discomfort at having to deal with more complex realities, there is no way back to older paradigms of artistic creativity. Several examples may illustrate this point. The Kansas City panel of the *Virgin and Child Enthroned with Two Musical Angels* by Memling, mentioned above, has been labeled "early." While this is correct in strict chronological terms, painters from this period who had experience as journeymen, and who had obtained the means to set up their own workshops, were already fully competent and mature masters. Memling's shop began by operating largely on the basis of Rogierian models, but its layout procedures soon changed to more streamlined, sketchy underdrawings in chalk. The shifting substructure of Memling's works correlates with different phases in his shop's productivity. This fact must be integrated into any consideration of Memling's personal artistic development— which clearly did not undergo a formative stage in the sense of being a biological model for individual growth. In a talk in 1991, Diane Wolfthal cogently summarized our traditional

ways of characterizing the artistic personality of the "renaissance" painter: in terms of a personal unity of style and progressive development.[65] Technical studies, in a very literal sense, have deconstructed these art-historical ideals. The newspaper review of the 1993 symposium on the historical figure known as Robert Campin captured this best; it bore the headline, "*Analyse löst den Meister auf*," implying that the individual identity of the painter had just evaporated in the face of today's scholarship, which involves technical investigation.[66] Now, there are other ways of asking questions that can bring a new structure to the material and, eventually, provide links to a larger historical context in which to understand workshop activity. The experience to date of the study of the production of painters' workshops suggests that the following aspects of painting technology should be determined: a) the standardization of technique, including any tendencies toward streamlining, or the opposite, and the use of expensive or inexpensive materials, standard or customized panel sizes, or any sudden change of method; b) the first instance, type, and extent of collaboration, including estimates of the size of an atelier over time, and evidence of subcontracting; c) the initial appearance, and continuing production, of replicas, and the methods employed to this end; d) the use of patterns, including single elements, larger compositions, and decorative motifs; e) comparisons of complex altarpieces as opposed to routine work, or commissioned as opposed to non-commissioned works; and f) the identification of works made for the market and/or export.

The pivotal modern study of the fifteenth-century workshop is that by J. R. J. van Asperen de Boer, J. Dijkstra, and R. van Schoute, assisted by J. P. Filedt Kok and C. M. A. Dalderup.[67] Some of the concepts discussed above we owe to this research. To reiterate: This study provided proof of the existence of workshop models, reformulated ideas about originals and copies (regarding, for instance, the Brussels and the Merode *Annunciations*), and (along with new dendrochronological results

provided by Peter Klein) supplied the evidence to date exact copies within the Rogier group (such as the panels in Granada and in New York from the Mary Altarpiece) executed after the death of the master. A monumental undertaking involving the extensive technical documentation of over fifty paintings, including a number of large altarpieces, it has given new shape to the groups of artists associated with the Master of Flémalle, Jacques Daret, and Rogier van der Weyden. Furthermore, in the presentation of masses of new visual material, this study not only challenges scholars with unexpected observations about known works but also provides them with a fresh basis on which to argue and refine the material further. Although the authors state that the determination of authentic works was not their primary goal, they nonetheless deal with this unavoidable issue—in part by enabling an extension of the concept of authenticity, in part by revealing its limits. For instance, the study provided the means of incorporating the Mary Altarpiece in Berlin (the Miraflores Altarpiece) into the group of Rogier's authenticated oeuvre. From the two other key paintings, the Prado *Descent from the Cross* and the Escorial *Crucifixion*, it was found that a unity of style could not be expected in all the works but some characteristic features of the artist's painting process did emerge, which could help to establish a norm for comparison. Then, by using their own infrared documentation of the Miraflores Altarpiece, by building on the previous research of Berlin's curator Rainald Grosshans, and by encouraging dendrochronological study of the relevant paintings, the researchers amassed the material necessary to associate the Mary Altarpiece in Berlin with the documented painting by Rogier van der Weyden known to have been donated to the Charterhouse in Miraflores by King Juan II of Castile in 1445.[68] Rogier's *Lamentation* in the Mauritshuis in The Hague can serve as another example of the authors' method. This painting is not one of the small group of three works that now can be considered as authenticated, but the bold underdrawing has typical

elements, such as the facial features of Mary, which compare well to those of the Virgin in Rogier's Escorial *Crucifixion*. The underdrawing of the painting in The Hague is striking, with assured angular strokes, and the major figures exhibit a type of modification that has been found to be characteristic of the group of core works associated with Rogier van der Weyden. An early paint stage softens forms, as exemplified by the change in one of the Marys' hands to the left of Christ: The thumb has been repositioned to the right, relaxing the former tension of the hand (fig. 34)—a type of readjustment not made to all the figures in this composition. The paint has been applied more thinly to saints Peter and Paul in the upper right, following the underdrawing closely, which to the authors suggests workshop collaboration.[69] Thus, regardless of the debate over the degree to which infrared material is objective (in the sense of a new, visual document) and, at the same time, subjective (in the sense that the material remains subject to stylistic analysis), the authors of this study still have provided us with fresh ways of evaluating works of art. The underdrawing serves not only as an additional stylistic factor but is the key to the understanding of the painting process in general.

The comparisons that led to convincing links among works in the Rogier group just as readily revealed collaboration. Diversity in layout and painting procedures was greater than expected. The Columba Altarpiece, not authenticated but never doubted, was found to have been underdrawn by an assistant, as mentioned above. The authors of the study proposed as many as five hands in the Beaune *Last Judgment* polyptych, although they did not imply that any could be given a name (such as Memling) or even be located again in other works; their identity simply indicated the extent of the collaboration. In this polyptych, master and assistants worked in schemes of horizontal and vertical collaboration, which connotes that collaboration occurred at all levels of the painting process and in all areas of the painting's surface.[70] By virtue of systematic

infrared investigation, this survey made it apparent that the visible traces of collaboration in the works in the Rogier van der Weyden group were of a varied and complex nature.

Consideration of the workshop focuses attention on other practices that can reflect studio routine, such as pouncing. This is a well-known procedure used in the transfer of a design to scale. In panel painting, pouncing developed in relationship to modular units of ornament, and some of the earliest examples to have employed the technique seem—for the moment—to be Italian pictorial compositions from the 1460s and 1470s.[71] Pouncing is frequently difficult to detect, so that any observations about the technique must be based on a concentration of obvious examples. Pouncing may have been erased on occasion after the composition was transferred, it may have been done with white rather than black chalk, or perhaps it was covered over by reinforcing lines. (Breaks in the continuity of black-chalk underdrawings due to irregularities of the ground frequently have been misidentified as pouncing.) Nonetheless, studies up to now have not revealed obvious examples of pouncing in the North as early in date as those in Italian painting. Perhaps it is no accident, then, that most of the overt Netherlandish instances of pouncing discovered so far predominate in the southern Netherlands, particularly in the commercial centers of Bruges, Antwerp, and Brussels, and they tend to date to about—and after—the turn of the sixteenth century.[72] One painter working in Bruges in this period, who is assumed to have supervised a productive shop, was Adriaen Isenbrant. In the works ascribed to the somewhat large and diverse Isenbrant group, pouncing often has been detected. The *Rest on the Flight into Egypt* in the Museum voor Schone Kunsten in Ghent, documented recently, provides a good illustration of pouncing throughout a painting; in this case, it was used in combination with other techniques (fig. 35).[73] Pouncing dots occur only in the figures and drapery of the Virgin and Child, establishing their main contours. The

Figure 34. Rogier van der Weyden. *The Lamentation* (detail). Mauritshuis, The Hague. Infrared reflectogram assembly showing the alteration of the thumb of one of the Marys from an underdrawn position stretched out to the left to a more relaxed angling to the right in the paint stage (the painted thumb is visible as a vague grayish shape).

background at the upper right has been laid out by means of extremely exacting lines that are suggestive of a tracing, while the trees have been sketched in freehand. One can imagine that other types of preparation would have been necessary for the layout or underdrawing stage of this work, such as the selection of

Figure 35. Adriaen Isenbrant. *The Rest on the Flight into Egypt.* Museum voor Schone Kunsten, Ghent. Digital reflectogram composite showing pouncing in the figures

several different compositional patterns and perhaps even the resizing of these models. Pouncing was the Isenbrant shop's way of streamlining one part of the overall painting process, which reinforces what a number of scholars have stressed recently: that the presence of pouncing is indicative only of a short-cut method used in the shop and does not automatically imply that the overall work can be categorized as a copy. The integration of pouncing into the Isenbrant studio's routine characterizes the response of a successful workshop to the social and economic opportunities that prevailed at a given moment.

As collaboration comes to be seen as a normative aspect of fifteenth- and sixteenth-century Netherlandish painting, and once other examples are discovered, this practice also

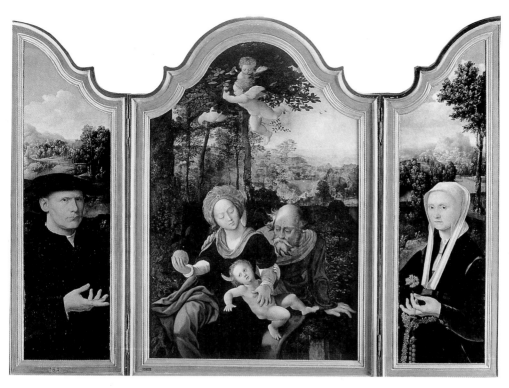

Figure 36. Workshop of Pieter Coecke van Aelst and Dirck Jacobsz. *The Rest on the Flight into Egypt*. Museum Catharijneconvent, Utrecht (no. ABM s67)

may prove to be more complex, with different historical associations and meanings. The joint production of Quentin Massys and Joachim Patinir, the *Temptation of Saint Anthony* in the Prado, is well known because it happens to be described in an early source, a late-sixteenth-century inventory. This example of "prestige collaboration" belongs to a type that appears to have been localized primarily in Antwerp, continuing into the seventeenth century. However, the Prado painting has received undue attention, since there were surely many more occasions of similar collaboration, such as that between Joos van Cleve and a landscape specialist on the *Virgin and Child* of about 1525 (The Metropolitan Museum of Art, Jack and Belle Linsky Collection) and on several other works included in the Metropolitan Museum's 1998 exhibition of Netherlandish painting.[74] On the other hand, the collaboration with a

figure painter, assumed to be frequent in Herri met de Bles's oeuvre, was called into question in relation to certain works discussed at the recent symposium devoted to this artist. Nor was it possible to document the extensive use of pouncing, which also has often been proposed with regard to the paintings of Herri met de Bles.[75] Additional works showing the obvious participation of two separate and independent masters belie yet another form of artistic influence. In these cases, it is the patron who instigated the collaboration. An altarpiece in the Museum Catharijneconvent in Utrecht combines a composition from the shop of the Antwerp painter Pieter Coecke van Aelst on the center panel with wings depicting the donors by the Amsterdam painter Dirck Jacobsz. (fig. 36). The underdrawing of the center panel clearly defines it as a workshop product, and reflectography shows that the portraits

Figure 37. Infrared reflectogram assembly of the Holy Family, showing the precisely executed contours in the underdrawing (detail of the center panel of fig. 36)

on the wings were painted on top of a dark background (figs. 37, 38). The triptych most likely was purchased in a commercial setting, perhaps on the Antwerp art market, with the wings still unfinished, as documents suggest this was a common practice at the time, and then adapted by the patron who commissioned Dirck Jacobsz. to add the portraits to the wings.[76] There are also other examples of altarpieces that combine the work of a South and a North Netherlandish master, which must have resulted from comparable situations.[77] It is interesting to observe that the adaptations to the *Merode Triptych* nearly a century earlier were accomplished within the same, or a related, shop, while similar alterations required in the sixteenth-century work were facilitated by the mechanism of the market.

CONCLUSION

This essay has ranged over a number of critical issues that affect the Early Netherlandish field at large, although it has focused on infrared studies—the predominant method of technical investigation of the last few decades—as well as on certain topics that relate to the function of the underdrawing, to aspects of painting technology, and to the structure of the workshop. That the findings of technical studies often must be explicated by means of specific details, such as a repositioned thumb or a dendrochronological terminus post quem, underscores how this type of research draws us back to the works themselves. Yet, in this field, close study of the paintings has remained especially rewarding, as they have proven to be exceptionally rich sources of information.

References to the Netherlandish art market of the late fifteenth and early sixteenth centuries allude to what may be the next promising direction for technical investigation, and the prospects are good that many painting practices will find a satisfying explanation in that context. The interest of historians of both art and economics in the findings of technical studies is most welcome, for it promises an integration of expertise, which, more often than not, has been the exception rather than

Figure 38. Infrared reflectogram assembly of the female donor, showing that the portrait was painted over a dark background (detail of the right wing of fig. 36)

the rule. Despite the designation of technical study as an auxiliary field, it has influenced scholars of Early Netherlandish painting much more than its categorization as a sub-specialty would imply, and will continue to do so. It has become a major trend in research that has stimulated significant revision—not only of the factual basis of the field but also of our thinking about Netherlandish painting of the fifteenth and sixteenth centuries in general. Like the artists of this period, we have much to gain from collaboration and a willingness to embrace new practices and procedures.

1. See P. Brinkman, *Het Geheim van Van Eyck, Aantekeningen bij de uitvinding van het olieverven* (Zwolle: 1993).

2. See A. Roy, "Van Eyck's Techniques: The Myth and the Reality, I," and R. White, "Van Eyck's Techniques: The Myth and the Reality, II," in S. Foister, S. Jones, and D. Cool, eds., *Investigating Jan van Eyck* (Turnhout, Belgium: 2000), pp. 97–100, 101–5; and M. Gifford's essay (co-authored by S. Halpine and S. Q. Lomax), "Issues Surrounding the Painting Medium: A Case Study of a Pre-Eyckian Altarpiece," in M. Faries and R. Spronk, eds., *Recent Developments in the Technical Examination of Early Netherlandish Painting: Methodology, Limitations, and Perspectives* (M. Victor Leventritt Symposium, Harvard University) (forthcoming).

3. See P. Philippot and C. Périer-d'Ieteren, "Apports des examens technologiques à l'histoire de la peinture," in *Revue de l'Art* 60 (1983), pp. 15–34.

4. See F. Arcadius Lyon, "Infra-red Radiations and Examination of Paintings," in *Technical Studies in the Field of the Fine Arts* 2 (1934), pp. 203–12.

5. See H. Ruhemann, "A Tentative Scheme for Analysis of Painting Technique," in *Technical Studies in the Field of the Fine Arts* 10 (1941), pp. 73–98; for the quote, regarding a painting attributed to the school of Botticelli, see pp. 88–89.

6. See J. Taubert, "Zur kunstwissenschaftlichen Auswertung von naturwissenschaftlichen Gemäldeuntersuchungen," Ph.D. diss. (University of Marburg: 1956).

7. I have been informed by The Detroit Institute of Arts that more in-depth study of this painting is currently under way; earlier publications on the Detroit painting attribute the underdrawing to Verrocchio and the painted angels to the young Leonardo; see E. P. Richardson, *The Adoration with Two Angels by Andrea del Verrocchio and Leonardo da Vinci* (Detroit: 1957); W. R. Valentiner, "A Newly Discovered Leonardo," in *The Art Quarterly* 20 (1957), pp. 235–43. The documents derive from Molly Faries's IRR study of the painting in August 1994.

8. The *Virgin and Child with Saints* from a private collection was included in the Metropolitan Museum's 1998–99 exhibition; see M. W. Ainsworth, "Workshop Practice in Early Netherlandish Painting: An Inside View," in M. W. Ainsworth and K. Christiansen, eds., *From Van Eyck to Bruegel. Early Netherlandish Painting in The Metropolitan Museum of Art* (exhib. cat., The Metropolitan Museum of Art) (New York: 1998), pp. 208, 210, fig. 79a–b. See also C. Grimm, "A Rediscovered Work by Hugo van der Goes," in *The Journal of the Walters Art Gallery* 46 (1988), pp. 77–91, where several infrared reflectograms showing the underdrawing are illustrated.

9. See E. Walmsley, C. Metzger, J. K. Delaney, and C. Fletcher, "Improved Visualization of Underdrawings with Solid-State Detectors Operating in the Infrared," in *Studies in Conservation* 39 (1994), pp. 217–31; and also the article on this topic by J. R. J. van Asperen de Boer, in M. Faries and R. Spronk, eds., *Recent Developments in the Technical Examination of Early Netherlandish Painting: Methodology, Limitations, and Perspectives* (M. Victor Leventritt Symposium, Harvard University) (forthcoming).

10. See B. Heller and L. Stodulski, "Recent Scientific Investigation of the Detroit Saint Jerome," in M. W. Ainsworth, ed., *Petrus Christus in Renaissance Bruges, An Interdisciplinary Approach* (New York, and Turnhout, Belgium: 1995), pp. 131–42.

11. For the Philadelphia painting see M. H. Butler, "An Investigation of the Philadelphia 'Saint Francis Receiving the Stigmata'," in J. R. J. van Asperen de Boer et al., *Jan van Eyck: Two Paintings of Saint Francis Receiving the Stigmata*, Jane Watkins, ed. (Philadelphia: 1997), pp. 28–46; J. R. J. van Asperen de Boer, "Some Technical Observations on the Turin and Philadelphia Versions of 'Saint Francis Receiving the Stigmata'," in J. R. J. van Asperen de Boer et al., *Jan van Eyck: Two Paintings of Saint Francis Receiving the Stigmata*, Jane Watkins, ed. (Philadelphia: 1997), pp. 51–63.

12. See M. W. Ainsworth and M. P. J. Martens, eds., *Petrus Christus, Renaissance Master of Bruges* (exhib. cat., The Metropolitan Museum of Art) (New York: 1994), no. 1; K. Christiansen, "The View from Italy," in M. W. Ainsworth and K. Christiansen, eds., *From Van Eyck to Bruegel. Early Netherlandish Painting in The Metropolitan Museum of Art* (exhib. cat., The Metropolitan Museum of Art) (New York: 1998), p. 43.

13. See E. Hall, "The Detroit *Saint Jerome* in Search of Its Painter," in *Bulletin of The Detroit Institute of Arts* 72 (1998), pp. 10–37; B. Heller, "St. Jerome in the Laboratory: Scientific Evidence and the Enigmas of an Eyckian Panel," in *Bulletin of The Detroit Institute of Arts* 72 (1998), pp. 39–55.

14. See A. van Buren, *Heures de Turin-Milan* (Lucerne: 1996), esp. pp. 331–32, where she also suggests that the painting may be the best replica of Jan van Eyck's original *Saint Jerome*.

15. Coincidentally, Gary Schwartz made reference to the Washington *Annunciation* in an e-mail dated December 11, 1999, about developments in art history in the twentieth century: "Only in one area do I feel that art history has failed even on its own terms. For this defect we truly deserve to be taken to task by posterity. That is, we completely disregard the condition of the paintings we study. We write about them as if they are still the same objects that left the studio of the master. Unless a painting is drastically and visibly mutilated or altered, the entire question of aging and restoration is simply ignored. Knut Nicolaus's recent book, *The Restoration of Paintings*, contains an illustration of van Eyck's *Annunciation* in the National Gallery of Art in Washington. This painting was originally on panel, but at some moment—I assume in the misguided nineteenth century—it was transferred whole onto canvas. This is a heavy operation, and in raking light it is plain to see that it has devastated the surface of the painting. Nicolaus's caption to his illustration picks no bones about it: 'Panel paintings lose their characteristic features and take on those of their new supports when they are transferred totally onto canvas.' The pictorial values we

describe in the painting are simply no longer those that van Eyck created."

16. The painting was exhibited in "Van Eyck's *Annunciation*, the Meeting of Heaven and Earth," at The Art Institute of Chicago, July 10–September 21, 1997, and in "Recognising Van Eyck," at the National Gallery, London, January 14–March 15, 1998. See M. Gifford, "Van Eyck's Washington *Annunciation*: Technical Evidence for Iconographic Development," in *The Art Bulletin* 81 (1999), pp. 108–16; C. Purtle, "Van Eyck's Washington *Annunciation*: Narrative Time and Metaphoric Tradition," in *The Art Bulletin* 81 (1999), pp. 117–25; E. M. Gifford, "Assessing the Evolution of van Eyck's Iconography through Technical Study of the Washington *Annunciation*, I," in S. Foister, S. Jones, and D. Cool, eds., *Investigating Jan van Eyck* (Turnhout, Belgium: 2000), pp. 59–66; C. J. Purtle, "Assessing the Evolution of van Eyck's Iconography through Technical Study of the Washington *Annunciation*, II: New Light on the Development of van Eyck's Architectural Narrative," in S. Foister, S. Jones, and D. Cool, eds., *Investigating Jan van Eyck* (Turnhout, Belgium: 2000), pp. 67–78.

17. See M. W. Ainsworth, in M. W. Ainsworth and M. P. J. Martens, eds., *Petrus Christus, Renaissance Master of Bruges* (exhib. cat., The Metropolitan Museum of Art) (New York: 1994), no. 10; D. C. Sperling, in M. W. Ainsworth and K. Christiansen, eds., *From Van Eyck to Bruegel. Early Netherlandish Painting in The Metropolitan Museum of Art* (exhib. cat., The Metropolitan Museum of Art) (New York: 1998), no. 5.

18. For a summary of the technical investigations as well as other articles on the painting see C. J. Purtle, ed., *Rogier van der Weyden, St. Luke Drawing the Virgin, Selected Essays in Context* (Boston, and Turnhout, Belgium: 1997).

19. For an overview of the paintings in this early phase of Memling's career see M. Faries, "The Underdrawing of Hans Memling's *Last Judgment* Altarpiece in Gdansk," in H. Verougstraete, R. van Schoute, and M. Smeyers, eds., *Memling Studies, Proceedings of the International Colloquium (Bruges, 10–12 November 1994)* (Leuven: 1997), pp. 243–59.

20. See M. W. Ainsworth, "Hans Memling as a Draughtsman," in D. DeVos, ed., *Hans Memling, Essays* (Bruges: 1994), pp. 78–87; M. Sprinson de Jesus, in M. W. Ainsworth and K. Christiansen, eds., in *From Van Eyck to Bruegel. Early Netherlandish Painting in The Metropolitan Museum of Art* (exhib. cat., The Metropolitan Museum of Art) (New York: 1998), no. 10.

21. See M. W. Ainsworth and M. Faries, "Northern Renaissance Paintings. The Discovery of Invention," in *The Saint Louis Art Museum Bulletin* (Summer 1986), pp. 31–37; M. W. Ainsworth, "New Insights into Joos van Cleve as a Draughtsman," in A.-M. Logan et al., eds., *Essays in Northern Art Presented to Egbert Haverkamp-Begemann on His Sixtieth Birthday* (Doornspijk: 1983), pp. 15–17; M. W. Ainsworth, "Northern Renaissance Drawings and Underdrawings, A Proposed Method of Study," in *Master Drawings* 27, 1 (1989), pp. 5-38.

22. See M. Faries, "Underdrawings in the workshop production of Jan van Scorel: A study with infrared reflectography," in *Nederlands Kunsthistorisch Jaarboek* 26 (1975), pp. 89–229.

23. See J. P. Filedt Kok, "Underdrawing and drawing in the work of Hieronymus Bosch: a provisional survey in connection with paintings by him in Rotterdam," in *Simiolus* 6 (1972–73), pp. 133–62.

24. See M. W. Ainsworth, *Gerard David, Purity of Vision in an Age of Transition* (New York: 1998), pp. 7-55.

25. See M. W. Ainsworth, "Northern Renaissance Drawings and Underdrawings, A Proposed Method of Study," in *Master Drawings* 27, 1 (1989), pp. 32–33.

26. See J. R. J. van Asperen de Boer, J. Dijkstra, R. van Schoute, C. M. A. Dalderup, and J. P. Filedt Kok, "Underdrawing in Paintings of the Rogier van der Weyden and Master of Flémalle Groups," in *Nederlands Kunsthistorisch Jaarboek* 41 (1990), pp. 181–201; L. Campbell, *National Gallery Catalogues. The Fifteenth Century Netherlandish Schools* (London: 1998), pp. 407–25.

27. See A. van Buren, *Heures de Turin-Milan* (Lucerne: 1996).

28. See J. P. Filedt Kok, "Underdrawing in the Paintings by the Master," in J. P. Filedt Kok, comp., *Livelier than Life, the Master of the Amsterdam Cabinet, or the Housebook Master, ca. 1470–1500* (exhib. cat., Rijksmuseum) (Amsterdam: 1985), pp. 295–302.

29. The *Crucifixion* in Edinburgh was studied by Molly Faries in February 1995 in conjunction with the Amsterdam exhibition "The Art of Devotion," using the infrared reflectography equipment at the Rijksmuseum, Amsterdam; she previously had studied the Rotterdam panel, in September 1993, using Indiana University's infrared reflectography equipment. For the publication of Faries's infrared reflectogram assembly of the Rotterdam panel see *Van Eyck to Bruegel, 1400 to 1550: Dutch and Flemish Painting in the Collection of the Museum Boymans-van Beuningen* (Rotterdam: 1994), no. 13.

30. See M. W. Ainsworth, *Facsimile in Early Netherlandish Painting: Dieric Bouts's "Virgin and Child"* (exhib. cat., The Metropolitan Museum of Art) (New York: 1993); L. Traversi and J. Wadum, "Un Tableau avec deux enfants s'embrassant au Mauritshuis," in H. Verougstraete, R. van Schoute, and A. Dubois, eds., *Le Dessin sous-jacent et la technologie dans la peinture, Colloque XII (1997), La Peinture dans les Pays-Bas au 16e siècle, Pratiques d'atelier infrarouges et autres méthodes d'investigation* (Leuven: 1999), pp. 99–109.

31. See O. Pächt, "Le Portrait de Gonella, I. Le Problème de son auteur," and D. Kreidl, "II. Le Dessin sous-jacent dans le tableau de Gonella," in *Gazette des Beaux-Arts* 123 (1981), pp. 1-8.

32. See M. Wolters, "De Monogrammist HB geïdentificeerd: Huybrecht Bueckelaer," in P. van den Brink and L. Helmus, eds., *Album Discipulorum J. R. J. van Asperen de Boer* (Zwolle: 1997), pp. 231–37.

33. As cited by F. Haskell in a book review entitled "Compromises of a Connoisseur," in *The Times Literary Supplement* (June 5, 1987), p. 596.

34. See J. R. J. van Asperen de Boer and M. Faries, "*La Vierge au Chancelier Rolin* de van Eyck: examen au moyen de la réflectographie à l'infrarouge," in *La Revue du Louvre et des Musées de France* 40, 1 (1990), pp. 37–49.

35. See R. Billinge and L. Campbell, "The Infra-red Reflectograms of Jan van Eyck's Portrait of Giovanni (?) Arnolfini and his Wife Giovanna Cenami (?)," in *National Gallery Technical Bulletin* 16 (1995), p. 59.

36. See J. R. J. van Asperen de Boer, "A Scientific Re-examination of the Ghent Altarpiece," in *Oud Holland* 93 (1979), pp. 141–214.

37. See N. Veronée-Verhaegen, *L'Hôtel-Dieu de Beaune* (Les Primitifs flamands, I, Corpus de la peinture des anciens Pays-Bas méridionaux au quinzième siècle 13) (Brussels: 1973), p. 90.

38. See M. Faries, "Underdrawings in the workshop production of Jan van Scorel: A Study with infrared reflectography," in *Nederlands Kunsthistorisch Jaarboek* 26 (1975), pp. 89–229; J. P. Filedt Kok, "Underdrawing and Other Technical Aspects in the Paintings of Lucas van Leyden," in *Nederlands Kunsthistorisch Jaarboek* 29 (1978), pp. 1–184.

39. See M. W. Ainsworth, "Schäufelein as Painter and Graphic Artist in *The Visitation*," *The Metropolitan Museum of Art Journal* 22 (1987), pp. 135–40.

40. See J. Dijkstra, "Origineel en Kopie, Een onderzoek naar de navolging van de Meester van Flémalle en Rogier van der Weyden," Ph.D. diss. (University of Amsterdam: 1990).

41. See M. P. J. Martens, "The Dialogue between Artistic Tradition and Renewal," in M. P. J. Martens, ed., *Bruges and the Renaissance, Memling to Pourbus* (exhib. cat., Bruges, Memlingmuseum) (Ghent: 1998), p. 59; J. C. Wilson, *Painting in Bruges at the Close of the Middle Ages* (University Park, Pennsylvania: 1998), pp. 158–59.

42. For the drawing see M. P. J. Martens, ed., *Bruges in the Renaissance, Memling to Pourbus* (exhib. cat., Bruges, Memlingmuseum) (Ghent: 1998), [essay vol.], ill. p. 199; [entry vol.], no. 101, pp. 128–31.

43. See M. Faries, in *Discovering Underdrawings* (forthcoming).

44. See M. Faries, "The First Examples of Titles in Underdrawing," in R. van Schoute and H. Verougstraete-Marcq, eds., *Le Dessin sous-jacent dans la peinture, Colloque VII* (1987), *Géographie et chronologie du dessin sous-jacent* (Louvain-la-Neuve: 1989), pp. 144–46. For another example of this phenomenon see P. van den Brink, "*Da Josef timmert*, Een Antwerps paneeltje in Delft," in P. van den Brink and L. Helmus, eds., *Album Discipulorum, J. R. J. van Asperen de Boer* (Zwolle: 1997), pp. 27–38.

45. See M. Faries and J. R. J. van Asperen de Boer, "Covering-over and Covering-up: Some Instances in the Re-use of Panels in Paintings after Hieronymus Bosch," in R. van Schoute and H. Verougstraete, eds., *Le Dessin sous-jacent et la technologie dans la peinture, Colloque XI* (1995), *Dessin sous-jacent et technologie de la peinture, perspectives* (Louvain-la-Neuve: 1997), pp. 7–17.

46. One such stained-glass roundel is in the Kunstmuseum, Düsseldorf.

47. See F. G. Zehnder, as cited by M. Faries, in "Stefan Lochner's Darmstadt *Presentation in the Temple* and the Paris 'Copy'," in H. Verougstraete-Marcq and R. van Schoute, eds., *Le Dessin sous-jacent dans la peinture, Colloque VIII* (1989), *Dessin sous-jacent et copies* (Louvain-la-Neuve: 1991), pp. 15–24; M. J. Friedländer and J. Rosenberg, *The Paintings of Lucas Cranach*, rev. ed. (Ithaca, New York: 1978), p. 25.

48. See J. Dijkstra, "Origineel en Kopie, Een onderzoek naar de navolging van de Meester van Flémalle en Rogier van der Weyden," Ph.D. diss. (University of Amsterdam: 1990), esp. pp. 1–10.

49. Ibid., esp. chapter I, pp. 7–28.

50. See M. W. Ainsworth, in M. W. Ainsworth and K. Christiansen, eds., *From Van Eyck to Bruegel. Early Netherlandish Painting in The Metropolitan Museum of Art* (exhib. cat., The Metropolitan Museum of Art) (New York: 1998), no. 2.

51. See M. W. Ainsworth, *Facsimile in Early Netherlandish Painting: Dieric Bouts's "Virgin and Child"* (exhib. cat., The Metropolitan Museum of Art) (New York: 1993); M. Sprinson de Jesus, in M. W. Ainsworth and K. Christiansen, eds., *From Van Eyck to Bruegel. Early Netherlandish Painting in The Metropolitan Museum of Art* (exhib. cat., The Metropolitan Museum of Art) (New York: 1998), no. 6.

52. See M. W. Ainsworth, in M. W. Ainsworth and K. Christiansen, eds., *From Van Eyck to Bruegel. Early Netherlandish Painting in The Metropolitan Museum of Art* (exhib. cat., The Metropolitan Museum of Art) (New York: 1998), no. 46.

53. See M.-T. Alvarez, "Artistic Enterprise and Spanish Patronage: The Art Market during the Reign of Isabel of Castile (1474–1504)," in M. North and D. Ormrod, eds., *Art Markets in Europe, 1400–1800* (Brookfield, Vermont: 1998), pp. 45–60.

54. See B. Dunbar, with contributions by M. Faries, in the forthcoming catalogue of Early Netherlandish paintings in the Nelson-Atkins Museum of Art, Kansas City, Missouri.

55. See M. Faries, L. Helmus, and J. R. J. van Asperen de Boer, in *The Madonnas of Jan van Scorel, Serial production of a cherished motif* (exhib. cat., Utrecht, Centraal Museum) (Utrecht: 2000); M. Faries, "Jan van Scorel as Painter/Entrepreneur," in H. Verougstraete, R. van Schoute, and A. Dubois, eds., *Le Dessin sous-jacent et la technologie dans la peinture, Colloque XII* (1997), *La Peinture dans les Pays-Bas au 16ᵉ siècle, Pratiques d'atelier infrarouges et autres méthodes d'investigation* (Leuven: 1999), pp. 1–17.

56. See M. Faries and J. R. J. van Asperen de Boer, "Research during the Jan van Scorel in Utrecht exhibition," in *Simiolus* 9 (1977), pp. 169–82.

57. For a similar discussion of the compositional replicas of Gerard David's *Virgin and Child with the Milk-Soup* see M. W. Ainsworth, *Gerard David, Purity of Vision in an Age of Transition* (New York: 1998), pp. 295–308.

58. See L. Campbell, "Rogier van der Weyden and His Workshop," in *Proceedings of the British Academy* 84 (1994), pp. 6–8.

59. See J. Dijkstra, "Origineel en Kopie, Een onderzoek naar de navolging van de Meester van Flémalle en Rogier van der Weyden," Ph.D. diss. (University of Amsterdam: 1990), esp. pp. 55–65.

60. Ibid. See also M. Sprinson de Jesus, in M. W. Ainsworth and K. Christiansen, eds., *From Van Eyck to Bruegel. Early Netherlandish Painting in The Metropolitan Museum of Art* (exhib. cat., The Metropolitan Museum of Art) (New York: 1998), no. 45.

61. Inv. no. J #373; studied with infrared reflectography by Molly Faries, June 2, 1982, IRR MF 110/32-36.

62. The work studied by Molly Faries, February 10, 1999, IRR MF 1379/1-34, is a North Netherlandish copy after Rogier van der Weyden's (?) *Descent from the Cross*, in Utrecht, Museum Catharijneconvent, Inv. no. ABM s72. See also C. Stroo and P. Syfer-d'Olne, *The Flemish Primitives I, The Master of Flémalle and Rogier van der Weyden Groups* (Catalogue of Early Netherlandish Painting in the Royal Museums of Fine Arts of Belgium) (Brussels: 1996), nos. 14, 15 (for two other versions of this composition, both of which include Joseph of Arimathaea's fingers under the cloth below Christ's arm), figs. 152, 153 (where the fingers are lacking).

63. See M. Ainsworth and M. Faries, "Northern Renaissance Paintings. The Discovery of Invention," in *The Saint Louis Art Museum Bulletin* (Summer 1986), pp. 30–35.

64. See M. Faries, L. Helmus, and J. R. J. van Asperen de Boer, *The Madonnas of Jan van Scorel, Serial production of a cherished motif* (exhib. cat., Utrecht, Centraal Museum) (Utrecht: 2000), esp. cat. no. B; M. Faries, "Attributing the Layers of Heemskerck's Cologne *Lamentation of Christ*," in R. van Schoute and H. Verougstraete-Marcq, eds., *Le Dessin sous-jacent dans la peinture, Colloque X* (1993), *Le Dessin sous-jacent dans le processus de création* (Louvain-la-Neuve: 1995), pp. 133–41.

65. See D. Wolfthal, "The Master of Flémalle and the Myths of the Renaissance" (paper presented at the conference, "The Idea of the Renaissance in the Present Time," Duke University, Durham, North Carolina, April 11–13, 1991).

66. See T. Borchert, in *Frankfurter Allgemeine Zeitung*, no. 109, May 12, 1993, p. 6.

67. See J. R. J. van Asperen de Boer, J. Dijkstra, R. Van Schoute, C. M. A. Dalderup, and J. P. Filedt Kok, "Underdrawing in Paintings of the Rogier van der Weyden and Master of Flémalle Groups," in *Nederlands Kunsthistorisch Jaarboek* 41 (1990); the study included three groupings of 17, 4, and 30 works, for the Master of Flémalle, Jacques Daret, and Rogier van der Weyden, respectively.

68. Ibid., p. 9, no. W12; since the appearance of this article, both Dijkstra and Campbell have included the Miraflores Altarpiece as an authenticated work by Rogier. Campbell stresses this point in his article on Rogier in the *Dictionary of Art*, p. 127: "Only with the discovery that the Miraflores Triptych is unquestionably by Rogier and that the Escorial *Crucifixion* is an exceptionally well-authenticated work has it become possible to take a more critical view of Rogier's output."

69. For the *Lamentation* in The Hague see J. R. J. van Asperen de Boer, J. Dijkstra, R. van Schoute, C. M. A. Dalderup, and J. P. Filedt Kok, "Underdrawing in Paintings of the Rogier van der Weyden and Master of Flémalle Groups," in *Nederlands Kunsthistorisch Jaarboek* 41 (1990), no. W6.

70. Ibid., esp. pp. 29, 184.

71. See M. Faries, in *Discovering Underdrawings* (forthcoming). For a full discussion of transfer techniques in Italian Renaissance paintings see C. C. Bambach, *Drawing and Painting in the Italian Renaissance Workshop, Theory and Practice, 1300–1600* (Cambridge, England: 1999).

72. See J. R. J. van Asperen de Boer, M. Faries, and J. P. Filedt Kok, "Painting technique and workshop practice in Northern Netherlandish art of the sixteenth century," in *Kunst voor de beeldenstorm* (exhib. cat., Amsterdam Rijksmuseum) (Amsterdam: 1986), pp. 106–16, esp. p. 112. Other scholars have dealt with pouncing in Bruges paintings: See, for instance, the discussion of Gerard David's *Virgin and Child with the Milk-Soup* in M. W. Ainsworth, *Gerard David, Purity of Vision in an Age of Transition* (New York: 1998), pp. 51, 245–300; J. Wilson, "Workshop Patterns and the Production of Paintings in 16th Century Bruges," in *The Burlington Magazine* 132 (1990), pp. 523–27.

73. Inv. no. 1914-CE; the painting was studied by means of infrared reflectography by Molly Faries in February 1999. For a recent discussion of the work see T. Borchert, in M. P. J. Martens, ed., *Brugge en de Renaissance, Van Memling tot Pourbus* (exhib. cat., Bruges, Memlingmuseum) (Ghent: 1998), [entry vol.], nos. 44–45, pp. 76–77.

74. See M. Sprinson de Jesus (nos. 69, 70) and M. W. Ainsworth (nos. 95, 96), in M. W. Ainsworth and K. Christiansen, eds., *From Van Eyck to Bruegel. Early Netherlandish Painting in The Metropolitan Museum of Art* (exhib. cat., The Metropolitan Museum of Art) (New York: 1998).

75. See, for instance, M. Faries and S. Bonadies, "The Cincinnati *Landscape with the Offering of Isaac* by Herri met de Bles: Imagery and Artistic Strategies," in N. E. Muller, B. J. Rosasco, and J. H. Marrow, eds., *Herri met de Bles, Studies and Explorations of the World Landscape Tradition* (Princeton, and Turnhout, Belgium: 1998), pp. 73–84.

76. See T. van Bueren and M. Faries, "Care for the Here and the Hereafter: Using Infrared Reflectography in the Study of Memorial Paintings," in H. Verougstraete, R. van Schoute, and A. Dubois, eds., *Le Dessin sous-jacent et la technologie dans la peinture, Colloque XII* (1997), *La Peinture dans les Pays-Bas au 16ᵉ siècle, Pratiques d'atelier infrarouges et autres méthodes d'investigation* (Leuven: 1999), pp. 147–54; as cited in T. van Bueren and W. C. M. Wüstefeld, in *Leven na de dood, gedenken in de late Middeleeuwen* (exhib. cat., Utrecht, Museum Catharijneconvent) (Turnhout, Belgium: 1999), no. 72, where it is also noted that there are three other versions of the composition of the center panel.

77. See, for instance, the triptych with the *Virgin and Child and Saint Anne with the Family Van Beesd van Heemskerck*, with a center panel by the Workshop of the Master of Frankfurt and wings probably by the Master of Delft, of about 1510–20, in *Leven na de dood, gedenken in de late Middeleeuwen* (exhib. cat., Utrecht, Museum Catharijneconvent) (Turnhout, Belgium: 1999), no. 83, where it is mentioned that the triptych may have been bought at the annual market in Delft.

Maryan W. Ainsworth

Commentary: An Integrated Approach

Molly Faries's discussion of the technical investigation of Early Netherlandish paintings provides an excellent overview of the state of research in this field. She has concentrated mainly on infrared reflectography and its use in helping to solve connoisseurship questions as well as to provide insight into workshop practices in the fifteenth and sixteenth centuries. Already, many preconceived notions have been abandoned, and the increasing number of important findings from technical studies of paintings should encourage art historians to return to the primacy of the object. In so doing, we may confirm or refute theories that have been proposed about the wider cultural context of Early Netherlandish painting. In fact, as Faries has indicated, the results of recent investigations have led to so many revisions of basic tenets in the field that we find ourselves at an exciting new juncture. Starting fresh with a *tabula rasa,* we now rely upon these discoveries to determine what direction research will follow.

Of course, the technical investigation of paintings does not solely concern infrared reflectography (although this is perhaps the most significant method to date). Clues about the creation and meaning of a work may be revealed by many aspects of its physical examination. My response to Molly Faries's essay, therefore, is first of all to place her emphasis on infrared reflectography within the context of a broader method of investigation

for Early Netherlandish paintings and, secondly, to suggest a short list of desiderata for future research.

A comprehensive method should begin by scrutinizing the state and condition of the painting and considering the changes that have occurred since it left the painter's workshop. The particular difficulties some art historians—among them, Beenken, Friedländer, and Panofsky—have faced in coming to terms with the attribution of the Friedsam *Annunciation* (plate 10) to either Petrus Christus or to one of the van Eyck brothers are due in large part to their having ignored the condition of the painting. Julius Held and Ludwig Baldass questioned whether the panel had been cut down, but only Eric Larsen mentioned the poor state of the painting—that is, until more recent studies were undertaken. The painting is a fragment, with only the right edge of the panel intact; the other three sides were cut down. The horizontal grain of the wood of this vertically oriented picture suggests that there was once a significant additional section of the composition to the left. Furthermore, portions of the work are extremely abraded. This is especially true of the faces of the Virgin and of Gabriel, where one is trained to focus attention for the identification of a certain master's hand.[1]

Clearly, some paintings have been compromised by their worn state, but those that are in excellent condition ought to be singled out as the archetypes against which problematic pictures may be measured. An excellent example is found in the group of paintings attributed to Gerard David in the Metropolitan Museum's collection. A comparison of the *Virgin and Child with Four Angels*, which has survived in extraordinarily fine state, with *The Nativity with Donors and Saints Jerome and Leonard,* a damaged work that has been transferred from panel to canvas, makes the

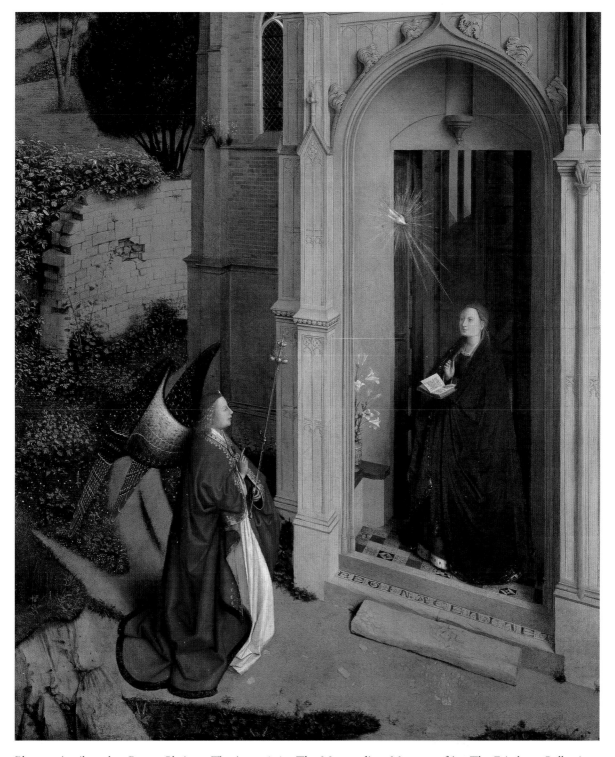

Plate 10. Attributed to Petrus Christus. *The Annunciation*. The Metropolitan Museum of Art, The Friedsam Collection, Bequest of Michael Friedsam, 1931 (32.100.35)

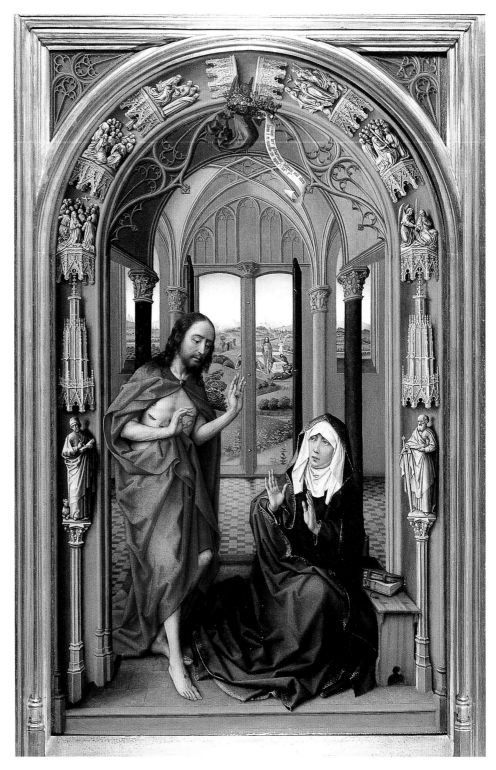

Plate 11. Rogier van der Weyden. *Christ Appearing to His Mother*. Gemäldegalerie, Staatliche Museen Preussischer Kulturbesitz, Berlin (no. 534A)

Early Netherlandish Painting at the Crossroads

Plate 12. Copy after Rogier van der Weyden (possibly Juan de Flandes). *Christ Appearing to His Mother.* The Metropolitan Museum of Art, New York, The Bequest of Michael Dreicer, 1921 (22.60.58)

Figure 39. Shrubbery and the hand of Christ (detail of plate 11)

Figure 40. Shrubbery and the hand of Christ (detail of plate 12)

point.[2] The notable difference between these two contemporary works is one of condition, not one of quality or attribution. Especially troubling for students seems to be the confrontation of an autograph painting in poor state, such as Hans Memling's *Virgin and Child*, with a workshop example in excellent condition, such as the *Salvator Mundi*.[3] Instructive lessons may be learned through frequent visits to large collections like that of The Metropolitan Museum of Art, but for most budding art historians, connoisseurship is a lifelong endeavor that necessitates travel, takes time, and develops gradually. Considering this problem, John Brealey, the former Chairman of the Sherman Fairchild Paintings Conservation Center at the Metropolitan Museum, once shared with me his pipe dream. He wished to compile a list, accompanied by excellent color photographs, that would identify for students the best-preserved paintings by the most important masters of all time that are housed in public collections world wide. Such an undertaking would be thwarted easily by limitations of time and money, however no fault can be found with the aim of the project. Since my introduction to this notion, I have tried to acquaint students with examples of works in superior condition so that they may use them as bench marks against which to judge other extant paintings attributed to a given artist.

Following an assessment of the state and condition of the picture there should be a careful description of it, down to the smallest detail, and a consideration of the artist's technique. If such evaluations had been made earlier, with regard to the authorship of the Miraflores Altarpiece (Berlin, Gemäldegalerie) and the smaller version known as the New York–Granada Triptych, protracted debates over which of the two virtually identical works is by Rogier van der Weyden might have been settled long ago (compare plates 11, 12).[4] A close look at a seemingly insignificant detail of the work—the bushes in the landscape in the background, for example—belies Rogier's handling in the Metropolitan

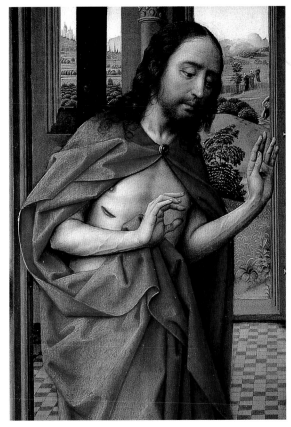

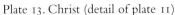

Plate 13. Christ (detail of plate 11)

Plate 14. Christ (detail of plate 12)

Museum's *Christ Appearing to His Mother*
(compare figs. 39, 40). Rogier was a product
of his own time, which preceded the devel-
opment of a naturalistic conception of land-
scape painting. His schematic arc-shaped
strokes form the branches of the shrubbery,
and each tip is touched with a similar
impasto highlight. This characteristic tech-
nique is exemplified by the Berlin panel.
The Metropolitan Museum's painting signals
another, later artist, informed by the firsthand
observation of nature. Likewise, the deeply
saturated reds and blues, built up in a series
of glazes in the Miraflores Altarpiece, are
achieved by means of an abbreviated tech-
nique in the Metropolitan Museum's version,
where the reds of Christ's garment result from

a mixed layer that tends more toward a pinkish
tone (compare plates 13, 14). While the execu-
tion of the Metropolitan Museum's picture
eliminates it from consideration within the
oeuvre of Rogier van der Weyden, it does
offer clues to the true identity of its painter.
Documentary evidence suggests the possibility
that the artist was Michel Sittow or Juan de
Flandes, and that the panel was part of a trip-
tych likely commissioned by Isabella of
Castile. Among the documented works by
Juan de Flandes is a panel of *The Beheading of
Saint John the Baptist,* from a contemporary
polyptych of scenes from the Life of Saint
John. Although further comparative research
must be carried out, it is interesting to observe
again a certain insignificant detail: a shrub

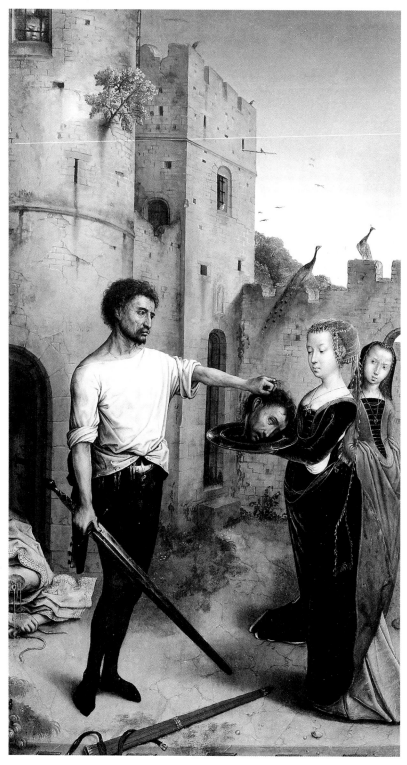

Figure 41. Juan de Flandes. *The Beheading of Saint John the Baptist*. Musée d'Art et d'Histoire, Geneva (no. CR 365)

Early Netherlandish Painting at the Crossroads

growing out of the wall behind the executioner (fig. 41). In technique and handling, the shrub is remarkably close to that in the Metropolitan Museum's *Christ Appearing to His Mother* (see fig. 40). Furthermore, the oak boards used for some of the panels that comprise the Saint John polyptych come from the same tree as those on which the *Christ Appearing to His Mother* was painted. This provides additional evidence for the attribution of the Metropolitan's painting to Juan de Flandes.[5] Such a realignment of authorship, however, is not the conclusion of this investigation but, rather, the beginning of research into the meaning of Isabella's commissions from Netherlandish painters and their function at her court in Spain.

One other groundbreaking example should be mentioned. In a recent reconsideration of the *Christ Crowned with Thorns* in the National Gallery, London, Lorne Campbell determined through study of details of the painting's execution and handling that it is not by Aelbert Bouts, as was long supposed, but by his father, Dieric.[6] The reattribution of the work now provides a prototype for Aelbert's many more exaggerated versions of this theme, while pushing the origin of this emotionally charged image further back in time. This finding again draws attention to the need for a reevaluation of the categorization of paintings proposed by Max J. Friedländer in his monumental fourteen-volume series on Early Netherlandish painting. His helpful grouping by subject of stylistically related works now requires greater scrutiny. The versions of Gerard David's *Rest on the Flight into Egypt*, for example, are not all of the same date, nor do they show David's handling and execution in every case.[7]

Students often seem to be amazed at how much information can be gleaned from the rather straightforward analysis of a painting's surface. This is a fundamental exercise that ought to be part of the initial stages of any investigation of a work of art—one that, of late, has received less attention due to preferences for other, more theoretical, approaches. In-depth research into the stages of the evolution of a painting may involve study through the microscope, X-radiography, infrared reflectography, dendrochronology, and perhaps cross-section or pigment analysis, the results of which are rarely ends in themselves. They can only be properly interpreted when significant additional comparative material becomes available from paintings with secure attributions. Even here, however—as can be shown in the case of Gerard David—the documented works do not invariably present the most typical manifestations of the artist's execution and handling.[8] The working practices revealed by David's *Justice of Cambyses* panels and his *Virgin among Virgins*, dated 1498 and 1509, respectively, are more the exceptions than the rule, probably because of the large size of the paintings and their complicated compositional requirements. Therefore, it goes without saying that the more comparative material that is made accessible, the greater the likelihood is of reaching reliable conclusions. In terms of this approach, much work still needs to be done. More or less comprehensive technical studies of the oeuvres of Petrus Christus, Rogier van der Weyden, the Master of Flémalle (Robert Campin), Hieronymus Bosch, Simon Marmion, Gerard David, Lucas van Leyden, and Jan van Scorel have been published so far, but only partial and inconclusive material is available as yet for some of the most renowned exponents of Early Netherlandish art, such as Jan van Eyck, Dieric Bouts, Hugo van der Goes, and Hans Memling. The personnel and the financial resources required to carry out this type of research are considerable. Future work will undoubtedly necessitate collaboration among specialists and effective institutional backing of the sort that the Rijksbureau voor Kunsthistorische Documentatie (RKD) in The Hague hopes to provide. The RKD has initiated this effort by taking on the responsibility of housing and organizing the archives of underdrawing material documented by J. R. J. van Asperen de Boer and by Molly Faries for use by the community of scholars in this field.

To return to the question of methodology: Equipped with the mass of new information derived from the careful and detailed study of the physical aspects of the painting in question—its state and condition and its technique and handling, closely scrutinized down to the most minute details—one can begin to consider other factors. Among these are how the subject matter is presented, questions about the patronage, and the extenuating circumstances and the context in which the work was made, including its artistic milieu. Although such questions perhaps seem to be straightforward and traditional, they may be more fully evaluated now due to the fresh information disclosed by the foregoing technical investigation of the paintings. It is in this area that many discoveries are still forthcoming.

An example may be found in the works attributed to Jan van Eyck. The refined and exquisitely finished surfaces of his paintings reveal no hint of the numerous changes made by the artist in reaching the final form of his compositions. Yet, recent studies of the *Virgin and Child with Chancellor Nicolas Rolin*, the *Portrait of Giovanni (?) Arnolfini and His Wife*, and the *Annunciation* all show various alterations from the preliminary up to the final stages of the painting. Aside from the considerable insight such new information provides about van Eyck's working methods, it raises additional interesting questions about other issues—namely, the ongoing dialogue between artist and patron that led to certain revisions from the original concept. At the very least, such revelations about the underlying paint layers cast further doubt on Erwin Panofsky's notion of a preconceived iconographic program illustrated by objects that turn out not to have been included in the initial underdrawing but to have been added only at a final stage as an afterthought.[9] Viewed in a broader sense, these disclosures offer hints about the patron's priorities insofar as the specific meaning of the painting and his or her relationship to it are concerned.

Of course, there are limits to the answers that can be ascertained by the technical investigation of a painting. It cannot tell us precisely which Arnolfini family members are represented in the famous National Gallery, London, portrait by Jan van Eyck,[10] but it can be helpful, however, in other situations where documentary evidence already has yielded pertinent information about patronage or the likely identification of portraits within a narrative theme. *The Exhumation of Saint Hubert* by Rogier van der Weyden and assistants includes numerous portraits that have been connected with the donors of the chapel in the church in Brussels for which the work was created. Not planned for at the outset, the portraits were added at a late stage and were fitted somewhat inharmoniously into the middle ground of the painting, as revealed by X-radiography and infrared reflectography. Archival and technical information in tandem has made it possible to identify these figures with reasonable accuracy as the founders (along with their family members) of the Chapel of Saint Hubert in the Church of Sainte-Gudule in Brussels.[11] A similar situation exists with the panels of *The Justice of Cambyses*, of 1498, by Gerard David (see figs. 8, 9). Here, technical investigation (X-radiography and infrared reflectography together) has shown that fifteen heads were replaced or added in a late reworking of the two paintings—eight in the *Arrest of Sisamnes* and seven in the *Flaying of Sisamnes*. According to documents in the Stadsarchief Brugge, fifteen aldermen were elected in the year preceding payment for the completed work—seven were reelected from the previous year, while eight were new members. This may suggest—although it does not prove—that the altered heads represent the aldermen who were chosen in the two election years immediately preceding David's final adjustments to the diptych.[12] It probably shows David's compliance with his patrons' request to update these important works for public display in the Aldermen's Chambers at the Town Hall. Furthermore, it provides visual confirmation for the document that specifies a final payment for the large panel with portraits.[13]

It is not always a simple matter to identify the stage in the life of a painting at which a certain addition was made, but invariably it is important to attempt to do so. The grape arbor that was painted behind the throne of the Virgin at a considerable interval after Hans Memling had completed the *Virgin and Child with Saints and a Donor* signals the importance in the early sixteenth century of the cult of the Eucharist;[14] it is, thus, an indicator of the painting's evolving meaning for continued devotional practice. The much later addition of halos to the heads in Petrus Christus's *Portrait of a Carthusian* and *A Goldsmith in His Shop* altered the intentions of the painter and the patron, and their more recent removal has allowed for reconsideration both of the artist's achievement and of the identification of the figures.[15] On the other hand, we have made some false assumptions about other so-called added features to paintings. Before David's *Nativity with Donors and Saints Jerome and Leonard* had undergone a full technical investigation, the kneeling patrons on the wings were thought to have been changed later into Saints Catherine and Anthony Abbot with the addition of attributes: a wheel and sword for the female and a pig for the male. However, X-radiography clearly indicates that these attributes were planned from the outset, and that the donors of the altarpiece must have requested that they be represented as their patron saints.[16] This draws attention to the little-studied phenomenon of portraits in the guise of saints in Early Netherlandish painting as an important indication of devotional practice and self-identification in this period.

Clues to the provenance of a work often are sought in documents and in official seals or papers attached to the reverse of the painting. If a work still has its original frame, any inscriptions on it might furnish information about the painting's initial location. Increasingly, other evidence is drawn from the type of ground preparation of a panel (for example, a southern European gesso or a northern European chalk ground), the identification of the wood of the support, or the details of manufacture of the original frame. A close analysis of how a painting was produced—the retracing of the step-by-step procedures of the artist—also can yield heretofore unknown facts about the intended destination of the work. Although the methods for this type of investigation have long been in place, it is surprising how relatively seldom art historians use the results of technical investigations to try to answer questions of provenance. A simple examination of the wood type (oak) and the ground preparation (chalk, or calcium carbonate) of Gerard David's Cervara Altarpiece suggests that it was painted in northern Europe. However, every other aspect of its production indicates that David had the specific details of the high altar of the monastery of San Girolamo della Cervara near Genoa in mind when he carefully planned and executed the design.[17] Not just the iconographic program but also the perspective scheme; the scale of the figures, adjusted according to their placement within the altarpiece; and the modulation of color—all were conceived with the Italian spectator in mind, who would have viewed the ensemble of seven panels from below and at a considerable distance. The details of the underdrawing and of the execution in paint confirm that this work was intended to be site specific: David must have had privileged information regarding its eventual location either from firsthand experience or from written instructions conveyed by an intermediary.

Another case with a different outcome involves the panels representing *Rhetoric* and *Music* by Joos van Gent and his workshop (London, National Gallery). Until recently, these were thought to have been part of the decoration of Federigo da Montefeltro's *studiolo* at his ducal palace in Gubbio. After close visual and technical scrutiny, Lorne Campbell argues that the London panels could not have been made for this *studiolo* but possibly for another ducal residence.[18]

The method of comprehensively evaluating paintings, mentioned in the foregoing discussions—and including technical, archival,

and biographical information—so far is a rarity in our field. It requires the attention of an art historian who is trained in the technical examination of works of art and/or collaboration with conservators. Yet, this approach to the study of paintings has the potential to revise the history of Northern Renaissance art in a number of key areas. If I were to propose a short list of topics for new research, the following would be foremost among them:

1. Still ripe for investigation is the significant number of works that were commissioned in the Netherlands for export to Italy and Spain. We need to know more about where these works were to be displayed, what workshops specialized in their production, and how artists adjusted their conventional styles and working methods to accommodate this increased output. Artists who trained in the North but traveled to seek their fortunes in southern European territories have not been given their due. Juan de Flandes, Michel Sittow, Joos van Gent, and Petrus Christus II are among those whose works may reveal significant information about how they adapted their styles and painting techniques to appeal to what they perceived as the demands and interests of their new clients. Such studies have the potential of leading to more informed judgments not only about the transfer of the Netherlandish style throughout Europe but also about a more specific chronology of changing tastes.

2. Although the artists just mentioned often received commissions from kings, queens, and dukes for works intended for specific locations, numerous other Netherlandish paintings were made under different circumstances for quite another clientele. Still little studied or understood are those paintings that were created for the open art market. In an increasingly competitive environment, artists collaborated on certain standardized types of paintings that became popular among a growing middle class with expendable income. Elsewhere in this publication, Filip Vermeylen and John Michael Montias have discussed the economic impact of this phenomenon. Their documentary sources, however, need to be bolstered by the technical evidence supplied by paintings of the period. The result of a collaborative effort between historians of economics and of art could shed light on one of the still unstudied and yet major schools of painting of the early sixteenth century—Antwerp Mannerism. Such a seemingly large number of artists devoted to a specialized and burgeoning industry must be explained in economic terms. The practical considerations of the matter—just how these artists managed to produce large quantities of paintings for sale on the open market and for export—will likely be found in the details surrounding the manufacture of the paintings themselves.

3. A contemporary movement—if these styles of painting in the early sixteenth century can be called movements—is one termed "Archaism." Not all pictures that have been given this label actually fall into the category, but those that do, such as Jan Gossaert's copies of Jan van Eyck's works, need further elucidation. How close to the technique of van Eyck are these paintings? Who was their audience and for what locations were they created? Again, an interdisciplinary study of archival documents (especially inventories), export/import records, and dealers'

accounts, along with the technical examination of individual works, will doubtless afford additional clarification of this elusive topic.

4. Also on my list are a number of "intermedia" studies. I refer specifically to a consideration of the relationship between drawings and underdrawings, between painting and printmaking, and between paintings and manuscript illumination. To some, these topics may seem to be very straightforward or to cover areas that have already been worked over, but I am not interested in the relatively banal exercise of identifying stylistic sources for a painting's composition or motifs. I am more concerned with the impact of these interrelated disciplines on workshop production in the fifteenth and sixteenth centuries, and on how various mediums served at different times as conveyors of style from one location to another. This probably influenced how artists then may have perceived their creative roles as craftsmen, and how one preeminent medium gave way to another. I suspect that the answers to these and other questions are rooted in the practicalities of the daily operation of the workshop, as well as in the impetus provided by economic factors—namely, the changing art market.

I would like to explore these three main "intermedia" studies briefly. In an article published in 1989, I proposed a method for studying Northern Renaissance drawings and underdrawings together for mutually beneficial results.[19] Although this essay was published in *Master Drawings*, there is little evidence that drawings specialists embraced its message. In fact, meaningful dialogues between drawings and paintings curators are less frequent than they should be. Moreover, curators of drawings

collections in major institutions have opined that a drawing on paper and an underdrawing on a grounded panel cannot be compared. Paintings specialists view the matter differently, and they are the ones who continue to make discoveries about the precise function of drawings *vis-à-vis* paintings, the accurate attribution of drawings, and the changing style of drawings as they are related to underdrawings in a given artist's workshop. Particularly because of the paucity of surviving Netherlandish drawings, this area of inquiry is in need of development. The most recent addition to the literature concerns the study of the drawings by Gerard David and their place in David's working process.[20] This issue could not have been elucidated without the evidence provided by the underdrawings of David's panel paintings. We look forward with enthusiasm to the first collection catalogue of drawings in which individual entries take into account underdrawings in their arguments: This is the catalogue of Early Netherlandish drawings in the Berlin Kupferstichkabinett that Stephanie Buck recently has completed.

In a will drawn up in Aix-en-Provence in 1498, the painter Bernardin Simondi (who worked with the Netherlandish painter Joos Lieferinxe) bequeathed various patterns to his colleagues and assistants: One received a book of prints of the Passion of Christ and of the Twelve Apostles; he left his own sketchbook to Joos Lieferinxe; and he further stipulated that "twelve of my separate designs . . . and all my stencil patterns," a wood lay figure, and pounced patterns were to be given to the others.[21] The book of prints, Lorne Campbell suggests, was by Schongauer, an artist whose works were widely circulated at the time. Many an article has identified Schongauer—or, later, Dürer—as the source for a composition or a motif in a Netherlandish painting. In fact, the mediums of printmaking and of painting had a symbiotic relationship, yet its precise nature has not been studied beyond the question of sources.

Molly Faries entered into this territory briefly in an article entitled "Some Remarks on the Inter-relationship of Underdrawings,

Drawings, and Prints,"[22] yet I suspect that there is much more to be done. It remains to be seen what influence prints had on the underdrawings and the aesthetic quality of paintings. The works of certain German artists are, in some regards, very much like their prints. Hans Leonhard Schäufelein, for example, completed his paintings with "overdrawing," modeling the figures in black paint with parallel strokes and cross-hatching. The end result approximates a hand-colored woodcut.[23] In other cases, underdrawings by such artists as Joos van Cleve or Pieter Coecke van Aelst are executed with the style and precision of a woodcut—interestingly, at a time (the early sixteenth century) when the location where they worked (Antwerp) was the printmaking capital of Europe. Does this imply the influence on painting of a prevailing aesthetic derived from prints? Suggestions of these connections that go beyond simple source identifications are plentiful and beg a closer look. Such interrelationships, when further investigated, may lead to the proper identification of printmakers who now are known only by their monograms. Recently, Nicholas Stogdon proposed that the printmaker called the Master FVB might well be Frans van Beeke.[24] If this turns out to be true, then an association might be established with Joos van Cleve (alias Joos van der Beke), whose early works borrow motifs from the Master FVB. Hitherto unknown origins for artists or correspondences in their early training may yet be discovered through the investigation of stylistic links between paintings and prints, particularly when working procedures are taken into account.

In one of the most fertile areas for research—the relationship between panel painting and manuscript illumination in the fifteenth and early sixteenth centuries—work has only just begun. Despite the obvious interrelationships of these two mediums, especially in Bruges and in Ghent in the latter half of the fifteenth century, new findings have remained elusive. How many and which panel painters actually were illuminators or vice versa? In the absence of definitive archival documentation, more or less compelling arguments may be made in the cases of Petrus Christus, Simon Marmion, and Gerard Horenbout, for example.[25] Although the names inscribed in the Bruges illuminators' Guild of Saint John and Saint Luke do not include Gerard David, he is often identified as having worked in that medium, too.[26] Not enough attention has been paid to the crossover in the arts, and, more importantly, to the reasons for this phenomenon. I would suggest that the answers lie partly in the technical and stylistic investigation of manuscript illumination, if carried out with the same scrutiny as that applied to panel painting. Little infrared reflectography of miniatures has as yet been undertaken, but this could bring a wealth of new information about the interrelationship of the arts in addition to attributions in the field of drawings. As with our research on panel paintings, the technical findings must be placed in the context of the creative environment, which includes changes in the economy or the art market.

Just one example may suffice to illustrate where this type of research may lead. Simon Bening, an illuminator active in Ghent and Bruges, was particularly inspired by the works of Gerard David, from which he incorporated motifs, as well as the latter's facial types of the Virgin, into the landscape settings of his own signature miniatures. In time, and—it is important here to note—with the advent of the printing press and the growth of a printing industry, which began to supersede illuminated books, Bening's paintings on parchment increased in size. Some of his illuminations were adhered to panels and displayed as triptychs,[27] thereby approximating the conventions of panel painting. Little notice has been given to a reference by the sixteenth-century jurist and historian Dionysius Harduinus to Bening as a painter in oils as well as an illuminator. This should not come as a surprise, for perhaps Bening sought a means by which he could guarantee himself a livelihood in painting as the demand for manuscript illuminations waned. A panel painting in the Metropolitan Museum with a David-like Virgin and Child before a Bening-like landscape recently has been attributed to Bening (plate 15).[28] Further

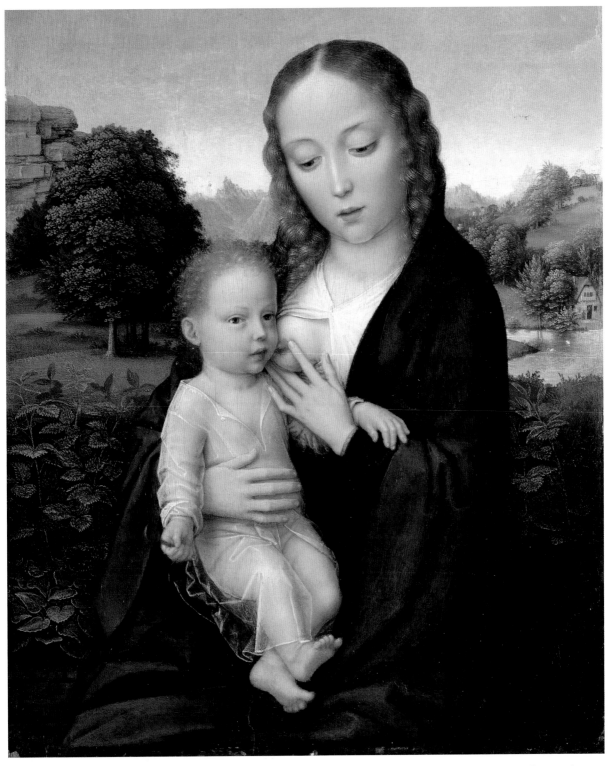

Plate 15. Attributed to Simon Bening. *Virgin and Child*. The Metropolitan Museum of Art, New York, The Friedsam Collection, Bequest of Michael Friedsam, 1931 (32.100.53)

work along these lines may help to clarify the evolution of the closely related fields of manuscript illumination and panel painting in the Late Medieval and Early Renaissance periods. Although art-historical literature usually cites panel painting as the more innovative art, which, in turn, influenced manuscript illumination, this was not always the case; it remains a more complicated matter that has yet to be fully investigated and resolved.

These are but a few of the issues that might be pursued now, as a result of the bountiful and rich new material from the technical investigation of paintings. As we have learned so far, more and more of our preconceived notions are being challenged by close visual scrutiny of paintings—that is, by placing primacy on the study of the work of art itself. It is to be hoped that we might be able to keep open minds and let the material lead us in the direction of these new and exciting avenues of inquiry.

1. For a full discussion of the attribution history of this painting see M. W. Ainsworth and M. P. J. Martens, *Petrus Christus, Renaissance Master of Bruges* (exhib. cat., The Metropolitan Museum of Art) (New York: 1994), no. 10.

2. Illustrated in M. W. Ainsworth and K. Christiansen, eds., *From Van Eyck to Bruegel. Early Netherlandish Painting in The Metropolitan Museum of Art* (exhib. cat., The Metropolitan Museum of Art) (New York: 1998), nos. 80, 81.

3. Ibid., nos. 55, 56.

4. For a review of these arguments and the associated bibliography see ibid., no. 46.

5. See ibid., p. 219, for further discussion and literature.

6. See L. Campbell, *National Gallery Catalogues. The Fifteenth Century Netherlandish Schools* (London: 1998), pp. 52–55.

7. See M. W. Ainsworth, *Gerard David, Purity of Vision in an Age of Transition* (New York: 1998), pp. 245–52.

8. Ibid., pp. 57–91.

9. See J. R. J. van Asperen de Boer and M. Faries, "*La Vierge au Chancelier Rolin de Van Eyck*: examen au moyen de la réflectographie à l'infrarouge," in *La Revue du Louvre et des Musées de France* 40, 1 (1990), pp. 37–49; R. Billinge and L. Campbell, "The Infrared Reflectograms of Jan van Eyck's Portrait of Giovanni (?) Arnolfini and his Wife Giovanna Cenami (?)," in *National Gallery* [London] *Technical Bulletin* 16 (1995), pp. 47–60; M. Gifford, "Van Eyck's Washington *Annunciation*: Technical Evidence for Iconographic Development," in *The Art Bulletin* 81 (1999), pp. 108–16; C. Purtle, "Van Eyck's Washington *Annunciation*: Narrative Time and Metaphoric Tradition," in *The Art Bulletin* 81 (1999), pp. 117–25; E. M. Gifford, "Assessing the Evolution of van Eyck's Iconography through Technical Study of the Washington *Annunciation*, I," in S. Foister, S. Jones, and D. Cool, eds., *Investigating Jan van Eyck* (Turnhout, Belgium: 2000), pp. 59–66; C. J. Purtle, "Assessing the Evolution of van Eyck's Iconography through Technical Study of the Washington *Annunciation*, II: New Light on the Development of van Eyck's Architectural Narrative," in S. Foister, S. Jones, and D. Cool, eds., *Investigating Jan van Eyck* (Turnhout, Belgium: 2000), pp. 67–78.

10. See L. Campbell, *National Gallery Catalogues. The Fifteenth Century Netherlandish Schools* (London: 1998), pp. 174–217.

11. Ibid., pp. 407–27.

12. See M. W. Ainsworth, *Gerard David, Purity of Vision in an Age of Transition* (New York: 1998), pp. 70–72.

13. See H. J. Van Miegroet, *Gerard David* (Antwerp: 1989), p. 334.

14. See M. W. Ainsworth and K. Christiansen, eds., *From Van Eyck to Bruegel. Early Netherlandish Painting in The Metropolitan Museum of Art* (exhib. cat., The Metropolitan Museum of Art) (New York: 1998), no. 11.

15. Ibid., nos. 21, 22; see also M. Wolff, in Charles Sterling et al., *The Robert Lehman Collection II: Fifteenth- to Eighteenth-Century European Paintings, France, Central Europe, The Netherlands, Spain, and Great Britain* (New York and Princeton: 1998), no. 12; H. van der Velden, "Defrocking St. Eloy: Petrus Christus's *Vocational Portrait of a Goldsmith*," in *Simiolus* 26, 4 (1998), pp. 242–76.

16. See M. W. Ainsworth and K. Christiansen, eds., *From Van Eyck to Bruegel. Early Netherlandish Painting in The Metropolitan Museum of Art* (exhib. cat., The Metropolitan Museum of Art) (New York: 1998), no. 80.

17. For a full discussion of this issue see M. W. Ainsworth, *Gerard David, Purity of Vision in an Age of Transition* (New York: 1998), pp. 177–201.

18. See L. Campbell, *National Gallery Catalogues. The Fifteenth Century Netherlandish Schools* (London: 1998), pp. 267–92.

19. See M. W. Ainsworth, "Northern Renaissance Drawings and Underdrawings: A Proposed Method of Study," in *Master Drawings* 27, 1 (1989), pp. 5–38.

20. See M. W. Ainsworth, "Designing Solutions: David's Drawings and Workshop Practice," in *Gerard David, Purity of Vision in an Age of Transition* (New York: 1998), pp. 7–55.

21. Cited in L. Campbell, *National Gallery Catalogues. The Fifteenth Century Netherlandish Schools* (London: 1998), p. 27.

22. In R. van Schoute and D. Hollanders-Favart, eds., *Le Dessin sous-jacent dans la peinture, Colloque V* (1983), *Dessin sous-jacent et autres techniques graphiques* (Louvain-la-Neuve: 1985), pp. 144–58.

23. See M.W. Ainsworth, "Schäufelein as Painter and Graphic Artist in *The Visitation*," in *The Metropolitan Museum of Art Journal* 22 (1987), pp. 135–40.

24. See E. Haverkamp-Begemann et al., *The Robert Lehman Collection VII: Fifteenth- to Eighteenth-Century European Drawings, Central Europe, The Netherlands, France, England* (New York and Princeton: 1999), p. 123, n. 28.

25. For discussions of these artists as panel painters and illuminators see M.W. Ainsworth, *Petrus Christus in Renaissance Bruges, An Interdisciplinary Approach* (New York and Turnhout, Belgium: 1995), pp. 33–65, 176–80; M.W. Ainsworth, "Afterthoughts and Challenges to Modern-day Connoisseurship," in *Petrus Christus in Renaissance Bruges, An Interdisciplinary Approach* (New York and Turnhout, Belgium: 1995), esp. pp. 207–12; M.W. Ainsworth, "New Observations on the Working Technique in Simon Marmion's Panel Paintings," in *Margaret of York, Simon Marmion, and "The Visions of Tondal*," T. Kren, ed. (Malibu: 1992), pp. 243–55; G. Hulin de Loo, "Comment J'ai retrouvé Horenbout," in *Annuaire des Musées Royaux des Beaux-Arts de Belgique* 2 (1939), pp. 3–21.

26. See D. G. Scillia, "Gerard David and Manuscript Illumination in the Low Countries, 1480–1509," Ph.D. diss. (Cleveland: Case Western Reserve University, 1975); H. J. Van Miegroet, *Gerard David* (Antwerp: 1989), pp. 75–89; M.W. Ainsworth, in M.W. Ainsworth and K. Christiansen, eds., *From Van Eyck to Bruegel. Early Netherlandish Painting in The Metropolitan Museum of Art* (exhib. cat., The Metropolitan Museum of Art) (New York: 1998), pp. 277–78, no. 74; M.W. Ainsworth, *Gerard David, Purity of Vision in an Age of Transition* (New York: 1998), pp. 20–23, 33–44; M.W. Ainsworth, "Simon Bening and Gerard David," in *In Memoriam Maurits Smeyers* (forthcoming, 2002); M.W. Ainsworth, in *Flemish Manuscript Illumination from Charles the Bold to Charles V* (exhib. cat., The J. Paul Getty Museum and the British Library, London) (forthcoming, 2003).

27. See C. Scaillierez, "Entre Enluminure et peinture: À propos d'un Paysage avec Saint Jérome Pénitent de l'École Ganto-Brugeoise récemment acquis par le Louvre," in *La Revue du Louvre* 2 (1992), pp. 16–31.

28. See M.W. Ainsworth and K. Christiansen, eds., *From Van Eyck to Bruegel. Early Netherlandish Painting in The Metropolitan Museum of Art* (exhib. cat., The Metropolitan Museum of Art) (New York: 1998), no. 83; M.W. Ainsworth, "Simon Bening and Gerard David," in *In Memoriam Maurits Smeyers* (forthcoming, 2002).

Photograph Credits

Copyright A.C.L., Brussels: figs. 8, 9; Jörg P. Anders Photoatelier, Berlin: fig. 3; Art Resource, New York: fig. 7; Bayerische Staatsgemäldesammlungen, Munich: figs. 13, 14; The Detroit Institute of Arts: fig. 18; Molly Faries: plates 5, 6, 8, 9, and fig. 25; Galleria Sabauda, Turin: fig. 11; Anne Gold, Aachen: fig. 32; Ruben de Heer, Utrecht: fig. 36; The Metropolitan Museum of Art, New York, Photograph Studio: plates 1, 2, 3, 4, 10, 12, 14, 15, and figs. 2, 5, 40; Joe Mikuliak, Philadelphia: fig. 10; Musée d'Art et d'Histoire, Geneva: fig. 41; Museo del Prado, Madrid: fig. 4; Museum of Fine Arts, Boston: fig. 22; National Gallery, London: fig. 1; National Gallery of Art, Washington, D.C.: fig. 19; Nelson-Atkins Museum of Art, Kansas City, Missouri: fig. 23; Philadelphia Museum of Art: fig. 6; Rhein. Bildarchiv, Cologne: fig. 28; Staatliche Museen Preussischer Kulturbesitz, Gemäldegalerie, Berlin: plates 11, 13, and fig. 39.

Infrared reflectography

J. R. J. Asperen de Boer and Molly Faries: fig. 27; J. R. J. Asperen de Boer/Stichting R.K.D.: fig. 34; Molly Faries: figs. 17, 24, 26, 29, 31, 33, (and digital composite) 35, 37, 38; Molly Faries/Stichting R.K.D.: figs. 20, 21; F. Arcadius Lyon, Straus Conservation Center, Harvard University: fig. 16.